GIRL ARCHAEOLOGIST

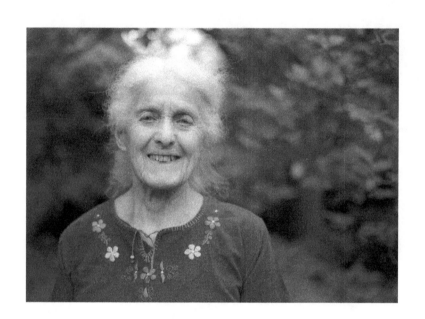

# GIRL

# ARCHAEOLOGIST

## Sisterhood in a Sexist Profession

ALICE BECK KEHOE

University of Nebraska Press

LINCOLN

Library of Congress Cataloging-in-Publication Data
Names: Kehoe, Alice Beck, 1934– author.
Title: Girl archaeologist : sisterhood in a sexist profession /
Alice Beck Kehoe.
Other titles: Sisterhood in a sexist profession
Description: Lincoln : University of Nebraska Press,
[2022]
Identifiers: LCCN 2021035778
ISBN 9781496229366 (paperback)
ISBN 9781496231093 (epub)
ISBN 9781496231109 (pdf)
Subjects: LCSH: Kehoe, Alice Beck, 1934– | Women
archaeologists—United States—Biography. |
Archaeologists—United States—Biography. | Sexism in
anthropology. | Indians of North America—Great Plains. |
BISAC: SOCIAL SCIENCE / Archaeology | BIOGRAPHY &
AUTOBIOGRAPHY / Women
Classification: LCC CC115.K44 A3 2022 |
DDC 930.1092 [B]—dc23
LC record available at https://lccn.loc.gov/2021035778

Set in Whitman by Laura Buis.

Frontispiece: Alice Beck Kehoe. Courtesy C. J. Kehoe.

*To Ruth Bader Ginsburg*

# CONTENTS

# ILLUSTRATIONS

Alice Beck Kehoe                                    Frontispiece

*Following page 96*

My first memory is of walking with my mother on a white sidewalk, green grass beside it, sun shining. We turned down a slope into a dark and stony tunnel, through it, up into the sunlight again. The dark! The cool damp! Then the bright sun! Thrilling!

It was a toddler version of archaeology, my life. The security of family, of sun and greenery; the lure of the dark unknown, stepping confidently where I'd never been before, rising with new knowledge. If I had been a boy, my road would have been clear: college, grad school, opportunities presented by professors, a tenured job with fieldwork support, grad students of my own creating my legacy. But I was a girl.

Looking back from my eighty-sixth year, I see that little girl with Shirley Temple curls (oh, how it hurt when Mother combed out the tangles). Memories follow of me and my playmates galloping around the grove of trees at the end of our block: we were cowgirls on the Wild West range, like Dale Evans in the movies we watched. I remember, too, the afternoon when my mother sat me down to learn tatting. I wanted to go outside, the tatted doilies looked stupid and ugly. Mother insisted that girls must learn needlework. That afternoon I was so clumsy that Mother let me go. It was a scenario often repeated, training to stay in the house, training in dull tasks, because I was a girl.

The world I grew up in was a man's world. Girls prettied themselves to be married, to keep house and raise children. In high

school I took chemistry and physics, and no boy would date me, The Brain. In this book, I'll tell how I fought my father to let me go to college. How I managed to become a field archaeologist, by marrying one. How finally I achieved professional recognition in a world radically changed from my childhood.

My mother should have been happy in old age. She was financially secure, both her daughters welcomed her into their pleasant homes. Instead, she was bitter. She had devoted herself to being her father's Happy Little Lina, then to be the silent homemaker keeping her husband comfortable. Widowed, her principal skill was vacuuming the house. After she died, at ninety-eight, my sister Sue and I found the notebook with her poems. Her poetry had been praised by a teacher, we knew. We saw that as soon as she married, she stopped writing poetry. Sue and I wept.

Women's lives were warped by subordination to patriarchy. With my mother's repression constantly before me, I would not let myself be bound, be crippled like Chinese women had been. Against my father's authority, I broke through to the life I craved, outdoors, intellectually excited, discovering the past through archaeology. And more: I had marriage, three sons. Patriarchy is still powerful, but laws curb its practices. I found a sisterhood of feminists, strong bright women archaeologists, anthropologists, and ethnohistorians. We in my generation walked through many a dark and stony tunnel. We've come into a very different world. This is my story.

### Women, Feminism, and Gender

When I was writing my essay "Women in the Plains" for a collection on archaeologists' evidence of women in the past, the editor kept badgering me, "Is what you were doing second-wave feminism or third-wave feminism?" Hey, we're talking about troweling away soil, grain by grain, in the hot sun, uncovering flakes of stone or maybe a tiny bead. Waves are thousands of miles away.

That editor's question is typical of academics who put theory above evidence. It's not "feminism" that drives women archaeol-

ogists to be alert for indications of women in the ancient places we dig. For us, feminism is the position that women matter as much as men. Women have the same capabilities as men, outside of ejaculating semen. Regarding that, the Blackfoot figure the real power is to grow a baby from that quick spray of minuscule sperm. Feminists don't reject men; we reject men's rejection of us from so many fields of activity. Long denied business capital and the learned professions, including archaeology, women were given no option but labor to provide men's physical needs. Unwaged household labor freed up enormous capital for capitalists. Restricting women's opportunities narrows competition to favor empowered men, as Sophia Jex-Blake wrote in 1872 in her argument for admittance to a medical degree at Edinburgh University. It's the same situation as the practice of filling skilled trades, such as police and fire departments, with sons and nephews of employed men, preventing African Americans and immigrants from entering these better-waged jobs.

Feminism in archaeology should mean sisterhood, women respecting and helping other women. For several years at Society for American Archaeology meetings, an increasing group of women gathered for dinner, the "Old Broads" in contrast to the "Old Boys" network. Eventually, the event drew several dozen women and a local member booked a relatively expensive restaurant. When the bill came at the end of the meal, some of the grad students couldn't pay their share. One was sitting across from me. She leaned over and whispered, could I possibly lend her the difference between the cash she had and that bill that included wine she hadn't expected? Of course I could. Same as I'd help my sister Sue. Several years later the young woman had her PhD and a job and wanted to repay me. Like I would with Sue, I thanked her and told her I didn't need repayment. That young woman became a close colleague, a leader of women in archaeology and of archaeological interpretations considering the likely presence of women in our sites. Her work is truly scientific in attention to data, as it at the same time humanizes the remnants of ancient commu-

nities. Sisterhood, for her and me, covers both women we meet
and work with and those women like ghosts in the sites today.

There's a term, "standpoint," that in one word says what a
woman archaeologist can present. Where you stand in the world
frames what you see and hear and feel. Literally—are you a white
man standing in your private comfortable office? Or are you the
immigrant woman standing in the hallway with her cart of clean-
ing tools? Are you standing on the south side of the thirty-foot
steel border wall, or on the north side in the nice shopping mall?
Standpoint is discussed today by philosophers, particularly women,
pushing at the gates kept by white men in management positions.
We keep reading famous books by men secluded in, as Virginia
Woolf knowingly put it, "a room of their own." Outside the door,
women cleaned, cooked, washed clothes, shopped for grocer-
ies, cared for children, for sick people. Who is to be praised, the
highly privileged man or the women he exploits, usually with-
out realizing that's what he does? Standpoint opens our eyes to
the crucial effect of social position upon not just experience but
also knowledge. No human being escapes the limitations of their
stand in their society.

Perhaps the most startling example of the difference stand-
points make is the story told by African American legal scholar
Patricia J. Williams in *The Alchemy of Race and Rights* (Cambridge
MA: Harvard University Press, 1991, 14, 155). When she was a
girl, she confided in her mother that she wanted to be a law-
yer. Her mother encouraged her, reminding her that her great-
great-grandfather was a lawyer. Patricia felt chilled to the bone.
That man, her great-great-grandfather had *purchased* her great-
great-grandmother, *an eleven-year-old girl, to practice sex upon
her* in preparation for his marriage to a young lady. That man's
children he had begotten upon Sophie, the slave girl, remained
enslaved. Picture how the household looked from the standpoint
of the wealthy master, compared to how it looked to the young
girl forced to endure his sexual demands.

Alison Wylie is a philosopher who insists on standpoint anal-

ysis in archaeology. She worked on an archaeological project as a student (not far from the Gull Lake bison drive site I worked, as it happens), inspiring her to study philosophy of science in a field no one else had looked at, archaeology. Even though Alison is tall, can look men straight in the eye, it took years for her innovative probes into archaeological methods and thought to be recognized as valuable philosophy of science. She is still, as I write, the only philosopher to specialize in analyzing archaeology. Men go into philosophy of science for physics, for evolutionary biology, for evaluating the great men of science of the past. Alison was a grad student when I met her in the 1980s; at the time I was researching the social context of the beginning of scientific archaeology. Our friendship continued as archaeologist Jane Kelley obtained for her a postdoc position at the University of Calgary Institute for Humanities, where Jane had been writing *Archaeology and the Methodology of Science* with a woman philosopher there. Standpoint, that of an educated *woman*, is obvious in the approach these women, and I, have taken in our work.

Women archaeologists in the 1970s began to raise notice of how so much of archaeology is excavating in ancient homes, around cooking hearths, uncovering tools that women must have used. My favorite example of men archaeologists' blindness to ancient, as well as today's, women is the standard practice of calling all thin V-shaped pointed stone artifacts "projectile points," that is, arrow or dart tips. They're always pictured with the pointed tip up. Look close, you see that one edge near the tip is made thin and sharp, while opposite it on the blade, the edge has been lightly ground to reduce sharpness. (So you can press on that edge to push the blade deeper into what you're cutting.) Turn the object sideways, lo and behold, it's the same shape as those little kitchen knives we use every day. I had to take mine to my husband Tom to show this to him, as he never did anything in the kitchen except raid the fridge. We're half a century past those bad old days of only housewives cooking; many men are in their kitchens cooking today, yet they don't *notice* the essential functional tool. A lit-

tle progress has been made, nowadays many archaeologists call the artifacts "points," leaving off "projectile"; still they don't show students how remarkably similar these very old stone blades are to my mom's "little yellow knife"—if it was missing, she couldn't make a meal. Mine is the little brown-handled knife. Recognizing women's tools is in my hands. Women's standpoint is essential for interpreting archaeology. In this memoir I describe again and again how being a woman enriched my professional knowledge, at the same time it obstructed my professional advancement.

There's no heartrending melodrama in my memoir, no drugs, no drunkenness, no abject poverty or beatings or jailings. Not even crying jags. My life has been more about making lemonade when all you're given are lemons. The lemonade you're about to imbibe isn't sweet, but it's free of manufactured additives. It's the true account of a life that began in an age very different from the twenty-first century. It's an account of persistence, of walking down unmapped paths with a diversity of friends, and finally of being applauded for "enduring work" (says my award plaque) in archaeology and anthropology. And, many young women have told me, for being a role model of a woman with a family who was always, also, an archaeologist.

### Note for Reading My Story

By inclination and by circumstances, I've ranged widely within the field of anthropological archaeology. Some of my projects have been excavations, some have been learning from contemporary First Nations (American Indian) people, some have been research into historical archives and other data bases. Personal circumstances—marriage, motherhood, job—intrude into professional life. I've structured this book into chunks of time with their events and activities, instead of running along strictly chronologically. To fellow professionals, I've been two persons, the archaeologist and the ethnographer-ethnohistorian. They cohere totally in my mind: I'm a born synthesizer. In academia, it's highly unconventional and suspect. Overall, my life, like my garden, hasn't been

formally laid out, no buzz-cut lawn, no flower arrangements in preplanted baskets. Native and invasive and bought plants bloom in their seasons, overlapping, hosting a variety of bees and butter-flies. As my Blackfeet friend once explained to me, "Things will happen when they happen." That's what you'll see in my story.

GIRL ARCHAEOLOGIST

# Born into a Man's World

Early in September 1934, thirty-year-old Roman Beck, standing on a street corner, was hit by a taxi whose driver fell asleep at the wheel. Rushed to a hospital, Roman's left side was put in a cast from hip to foot, pelvis and leg broken. Would he survive? Mother, wife, and mother-in-law rushed to his side, keeping vigil.

Three weeks later, Roman's wife gave birth to a daughter. It was a day before Roman's birthday. His wife remembered, bitterly, that Roman's mother seemed to care more for her injured son, still in hospital, than for the new baby. The baby was me.

The Becks were poor, even though Roman had a law degree from NYU. In the depths of the Depression, few law firms were hiring, and certainly not hiring Jewish young men. Roman eked out a living by writing briefs for practicing lawyers. In spite of lack of money, now drastic with the heavy costs of the auto accident, my mother, nicknamed Patty, stayed in the hospital for two weeks after giving birth. Long bed rest was standard in 1934. I stayed in the hospital nursery, fed from a bottle, brought to my mother for a little visit each day. When Mother returned home, she had no milk for me. She never found out that the prolonged separation in the hospital had dried up her milk.

All I can recall from my earliest years (see fig. 1) was walking one day in the garden apartment development we lived in, in the Queens borough of New York. We—my mother and I—walked down through a tunnel under the street. So exciting! Short, dark,

musty, stone-walled, then into the sunshine again! Prefiguring archaeology? Not really, I've never excavated ruins with tunnels. Delight at the never-before-experienced sensations? Yes. Fear in the tunnel? No. Fear is not in my nature.

Next memory: I was three, riding in the open rumble seat in the back of Mother's little car. Uncle Jack, her younger brother, rode with me in the rumble seat (no seat belts, of course, not yet). Mother, Daddy, and I were moving to Washington DC. Daddy at last had a real job, a good job, in Franklin Roosevelt's New Deal. The president had created the National Labor Relations Board; he had no reluctance about hiring Jews, and young Jewish professionals abounded in Roosevelt's Washington. We moved into a two-bedroom apartment in a new garden apartment village in Arlington, on the Virginia side of the Potomac. Young families like ours lived in most of the apartments, and the lawns teemed with kids my age.

Mother was happy. Her lawyer husband, brilliant in her eyes, worked for our great president in the progressive government fulfilling the Social Democrat vision her parents had risked their lives for, back in Lodz, Poland. Their political activities had endangered them and forced them to emigrate. In Arlington we were solidly in a middle-class American community, no Old Country accents, no immigrant relatives embarrassing us with hugging and tears and ethnic cooking. Mother took me across the Potomac to a public library in Georgetown, to borrow children's books. I remember sitting on her lap outside on a lawn, watching the picture book as she read to me.

Then her mother came to live with us, in the two-bedroom apartment. Grandma Martha did no cooking or housework, she occupied herself with criticizing Mother's inefficiency. She of course shared my bedroom. I had my dollhouse, my doll's cradle with Betsey Wetsey in it, my picture books; Grandma had the other half of the bedroom. We hardly noticed each other.

World War II expanded to America, creating tension, anxiety. Grandma moved to New York to keep house for her son, Moth-

er's younger brother, Uncle Jack, who was classified 4F, not phys-
ically fit enough for the army. Flat feet or something . . . he was a
healthy though not athletic young man. Later in the war, Grandma
went to work in a Manhattan garment factory, answering the call
for women to replace men drafted to fight. She loved her job as
quality-control inspector, minutely examining each piece pro-
duced to find the tiniest flaws, just as she supervised Mother in
the Arlington apartment.

My sister Susie was born in April 1941. Grandma's disdain for
Mother no longer dominated our apartment (nor did we have to
listen to Arthur Godfrey on the radio every morning, Kate Smith
singing "When the Moon Comes Over the Mountain"). Susie's care
seemed to occupy Mother constantly. Vaguely, I remember her try-
ing to manage with ration coupons, and us saving scraps of soap
in cheesecloth bags. She no longer had her little roadster: when
she was pregnant with Susie, she was driving with me, stopped at
an intersection with the main street just north of our apartment,
started across but was hit by a speeding car. Ours flipped entirely
over and over again to land upright. Mother threw herself around
me. I was okay; she had a couple of broken ribs. The car could
not be salvaged, at least not in wartime. Mother always insisted
that the accident had not affected Susie in the womb, but I won-
der: Sue always wants to be with people, she isn't really comfort-
able alone. Had that frightening experience, as a six-month-old
fetus, made her feel insecure?

I started kindergarten and caught an ear infection. No anti-
biotics yet, it worsened, pus flowing out my ear. I'd been in hos-
pital before, age three, to have my tonsils removed; that was a
common treatment for children with colds and sniffles. All I can
recall from that first hospital stay was the room filled with stuffed
toys and flowers, for the other little girl in the room, and Mother
telling me I shouldn't envy her, for she was very sick. The sec-
ond hospital stay, I remember nothing more than being in bed,
the pus, Mother bending over me. The operation to cut out the
infected mastoid bone in my left ear left me deaf in that ear and

prohibited from submerging it under water lest water get into my skull—one reason I've never been a good swimmer. My parents suffered more than I, fearing, with cause, that I might die; I had no fear, for Mommy was with me. Sulfa and then penicillin came onto the market a year or so after my operation, curing those ear infections without surgery—as Mother often remarked.

First grade was my introduction to school. We lived on the border between school districts, with an elementary school right across the highway (the highway where our car was hit). That was in the other school district, but kids on our side of the highway were allowed into first grade. My teacher was a cheerful young woman. How happy I was, learning to read and write and play organized games. Only, my stomach was upset each morning. At my annual checkup with the pediatrician, a young man, I remember Mother telling him that I was not as happy in school as I professed. Obviously it was my repressed fear that made me nauseous, as she knew from reading psychology. The doctor looked her straight in the eye: "Do you give her a full glass of fresh orange juice first thing in the morning?" "Yes!" beamed my mother. "Don't!" he said. "Citrus acid upsets an empty stomach." Why do I remember this doctor visit so vividly? Evidence-based practice challenging accepted general notions, that "orange juice is good for children." Mother cut out the orange juice.

Beginning second grade, I had to attend Woodrow Wilson School, in our allotted district. Seems like it was a mile away, down the hill through the apartment development, to Wilson Boulevard and its little strip mall of neighborhood shops and the movie theater. Always hating to get up in the morning, I dawdled and then had to run down that hill to the school. Ran home, uphill, for lunch, back down after a fast lunch at home, uphill again at 3:30. Ran alone, my best friends not with me: Beverlee's parents had bought a house in Silver Spring, Maryland, and Kay went to Catholic school. Halfway, I might catch up with Robert who lived in the next section of the development. Robert and I were Jewish, like many of the civil service employees in our Colonial

Village apartments. Woodrow Wilson School held an all-school assembly every Friday morning in its gym. We marched around the gym loudly singing, "Onward Christian soldiers, marching as to war!" I still remember the words. Christians are soldiers, Christians go to war, okay. Forty years later, it hit me that Jesus of the Gospels was a radical pacifist, and I began researching for what became my book *Militant Christianity*. So far as I know, none of the Jewish parents at Wilson School protested. Their generation kept quiet and tried to look and sound Anglo.

Beverlee, Kay, Robert, and I used to play cowboys-and-cowgirls in the small grove of trees between our and Robert's sections. We galloped and galloped round and through the trees, cracking our invisible whips and shouting to our imagined horses. Just like the cowboys and plucky girls in the Roy Rogers–Dale Evans matinee movies we watched on Saturday afternoons, tickets a dime plus we got a nickel for an ice-cream cone. We walked down by ourselves, same walk as for school, the theater bulging with kids. We saw a cartoon each Saturday, and the newsreel. We saw the horrors of war on the screen.

War on the home front. Our families that had struggled through the Depression, now tried to cope with men away, with rationing, saving grease and scraps of soap. My father worked long hours and weekends, the Labor Board constantly negotiating to keep war production flowing in spite of older workmen disliking all those colored men and those women taking the place of their sons and nephews off to fight. Uncle Mel, my father's younger brother, was in the army, so was handsome Cousin Paul. Uncle Mel's young and movie-star-beautiful wife Judy stayed with us when Mel was on furlough near Washington. Trains were full of soldiers, personal travel discouraged, even my summer visit to my grandmothers in New York.

The summers I was six and seven, 1940 and 1941, I went to New York to spend a week with each of my grandparents, Mother's mother, Martha, in Manhattan and Daddy's mother, Jenny, and stepfather in Bayonne, New Jersey. Grandma Martha lived

in an apartment building next to the George Washington Bridge, and let me explore on the Hudson shore below the bridge and eat in the Automat on Broadway. That was where I put nickels in the slots, then little doors opened and I took out dishes of mac-and-cheese, like magic (you could see people on the other side putting dishes in the slots, if you craned your neck). Grandma Jenny lived in an upper duplex and played mah-jongg with pretty tiles, and I could go to Grandpa David's store on the corner, where he sold Mogen David wine to neighborhood Jews and Chianti to Italians, and soda pop from a big open cooler near the door, to neighborhood kids. Cream soda from that cooler, oh so cool and delicious! Then the visits stopped, because of the war. All I really understood about war on the home front was that our grassy play yard at Woodrow Wilson School was plowed up by a man with a white draft horse, to make a Victory Garden.

With his part in the fight against Hitler concluded, my father left the Labor Board in 1947 to join a law-school classmate, Murray, in partnership in Lower Manhattan. They specialized in maritime law, locating near the waterfront where clients had their offices—only by coincidence near Wall Street. Murray was an extroverted hard-drinking glad-hander who brought in business, while Dad specialized in their clients' contract negotiations with maritime unions. Dad told us that he succeeded by being the only man at the negotiations who didn't drink; everyone else ended up under the table, and when they came to, Dad would hand them the contract he said they had agreed upon. We could picture Dad, the courteous intellectual Jew, at the long table between the tough Irish tugboat owners and the tough Irish seamen. When I was fourteen and fifteen, I sat in the law office answering the phone for two weeks while the secretary took her summer vacation. The rather dark suite of offices, with narrow, tall windows admitting only slanted light, felt oppressive. No one told me what the lawyers were doing; I was only a girl, fit for answering phones. Never, never would I want to work in an office as a secretary.

We moved from the apartment in Arlington to the lower floor

of a duplex in Mount Vernon, New York, just north of the Bronx.
My parents thought it a good choice, a park with a playground
down the street, a k–8 school a few short blocks away, a block far-
ther the neighborhood grocery, bakery, and a mom-and-pop corner
store selling every other everyday thing we'd need. Dad was afraid
to buy a house. He had been traumatized by his father-in-law, my
grandfather, committing suicide when his house was foreclosed
and the family about to be evicted. Oh sure, that was the Great
Depression 1932, but couldn't we fall into another Depression?
Renting was safer. When we moved into the duplex, the owners,
living upstairs, were a Jewish family with two kids a bit older than
me (I was eleven). After a couple of years, they sold the house to
a childless couple: Joe worked in the Navy Yard, in New York, in
the office, and his pretty, blond, slightly plump wife stayed home.
They furnished their upstairs flat with heavy drapes and carpets,
and kept a chow dog sitting on the front stoop. Such a friendly
dog, my sister and I loved to hug it, but its dark-purple mouth and
tongue hanging out frightened people. We noticed that several men
would visit at night, taking care not to leave boots or umbrellas in
the entrance. Sometimes a man would visit in the afternoon. One
day when my father was getting a ride to a meeting of the West-
chester Oil Dealers Association, whom he advised, our landlady's
red-haired mother was talking with her on the front walk. Dad's
client asked him, as he got in the car, "What is that woman doing
talking in front of your house?" "She's our landlady's mother, lives
in New Rochelle." "Roman, don't you know who that woman is?
She's the top madam in Westchester County!" Soon after, Joe was
arrested for embezzlement, and then arraigned also for running a
gambling den in the flat. Our pretty landlady, whom Mother liked
because she kept the hallways so clean, sold the house.

The new owners were a couple, Jewish again, with a thin, shy
daughter in grade school. The crippled husband worked for his
father-in-law as a parking lot attendant; the wife of course stayed
home. We often heard yelling from the upstairs. Thin Myra cried
and trembled. Finally, a couple years on, a social worker came to

the house and took Myra away; she was so underweight and troubled that her teacher reported it. In those days, to take a child from parents, the neglect or abuse had to be drastic.

Mother became frightened that our landlady might harm us. For once in her life, she challenged Dad, demanding that he buy a house for us. She threatened to move out with us children if he did not; she went with her brother Jack looking at houses for sale in Westchester County. Dad capitulated. We knew the tenants who moved in after us, a middle-aged man and his mother. A couple months after we left, the mother was napping in a corner when the landlady let herself in, saw a dressmaker dummy by the dining table, and slashed it over and over with scissors from the table. In the corner, the old lady shrank back, stunned, watching in horror. They moved out at once.

Our Mount Vernon neighborhood was more or less lower middle class, skilled tradesmen and employees. It was on the wrong side of the tracks. Nicer, newer houses were on the west side of Mount Vernon, near the boundary with all-white, all-Christian Bronxville. At A. B. Davis High School on the west edge of downtown Mount Vernon, girls from the nearly Bronxville neighborhood would have nothing to do with girls from the east side of Mount Vernon. In any case, I wouldn't have been popular because I was The Brain, the girl who got As and took science. Many years later a distinguished mathematician came to lecture at Marquette in Milwaukee where I taught, and I recognized his name, the boy who had been my classmate since fifth grade through high school, and my lab partner in our chemistry and physics classes. We had lunch the day after his lecture, and he confessed to me that he would have liked to date me, but the other boys warned him he would lose face if he settled for The Brain.

I bore another stigma in high school: I rode my bicycle to school. A proper, normal girl would ride the special buses the city transit system provided to take students to the high school. On the buses the kids could flirt, the boys boast, girls giggle. To me, those buses seemed so degenerate, compared to bicycling in the open

air, hard pushing up the hills, controlled thrills coasting down. My parents had bought me a one-speed Schwinn when I was in junior high. It was the heaviest bicycle in the store, a boys' model with a bar, chosen because my parents believed its weight would make it more stable and safe. I bowed to their choice, rejoicing in that I at least had a bike, I could ride away and away! To this day, my calf muscles attest to pushing that Schwinn up the hills.

A few times I cried in my room because I had no boyfriend. Once, my mother came in and sat on the bed beside me, assuring me that when I got to college, I would get dates. That evening when my mother came into my room while I was crying was one of the only two times I recall her sitting and talking directly with me. The previous time was when I first menstruated, not quite twelve years old. After providing me with Kotex pads and belt, Mother sat me on a chair opposite her on another chair, and told me that all men always wanted women, so I must be careful when near men. I was shocked. "But not Daddy?" "Yes, Daddy too. All men."

In those Eisenhower years, it was easy for a child to be ignorant and oblivious to sex. When I got to high school, boys seemed so awkward, unformed, I felt no attraction to them. One rainy day when I had taken the bus from school, at my stop a boy in my class and I tried kissing, to see what it was like. Duh! Like nothing. Attracting boys was never on my mind. I didn't wear makeup. I didn't wear clothes that accentuated my figure. I didn't walk like a girl. I looked straight at people, didn't cock my head down a little with boys. Girls mostly talked about movie stars and movie magazines, so I spent little time in girl groups. I read a lot, all the classics. In spite of my sheltered life as a middle-class girl, I always felt pulled out of the house, into the wild.

My parents' idea of being out in the countryside was a dairy farm in the Catskills, which for a few years boarded a couple of families on vacation, for us a week or two. Mother stayed in the house and its yard, along with the other family's mother. Dad and the other father walked a bit on the country road, coming back to describe the great view from the hill bordering the valley. I think

I was twelve when I went walking on my own, to the hill, up a trail, soon a nice view of the valley, trail continued up, I continued until at the pass, there was indeed a wonderful view, my first view of mountains from a high pass. An epiphany, beauty sublime. When I returned to the farmhouse and reported my hike, the two fathers were a little concerned that this girl had gone so far, farther than the men. They frowned, and that was the end of talking of that. No more for me of telling excitedly about hikes, mountain views, ecstasy outdoors.

Back home in Mount Vernon, I rode my bike all the time. On weekends I rode my bike all day, to the beach on Long Island Sound about five miles away, or south along a bicycle path beside a highway into the Bronx, to Pelham Bay, at that time a fishing village. Dunes lay along the bicycle path. Sometimes I walked into the dunes, looking at the plants and bits of shells; on one of those walks away from the highway, when I was thirteen and "a woman," I encountered a pack of boys. They surrounded me and I felt trapped by menace. Holding the heavy bike tightly, I rammed through the pack and ran to the edge of the highway. The boys did not follow. Of course I never told my parents of this incident. They never asked where I went, gone for most of the day on those weekends. I was a good girl, there was no need to pay attention to me.

Saturday mornings I biked to the public library. One landmark in my life was being allowed at last to go into the adults section, up a few steps from the children's section. On that higher level I browsed all the shelves, reading classic nineteenth-century novels—the Brontës, Jane Austen, Victor Hugo, Dickens—and history. One day I took out a thick book by A. L. Kroeber, *Anthropology*. Every page, seven hundred of them, was fascinating. Anthropology was a subject that covered *everything* that interested me: people of all kinds, ways of life, linguistics, arts of the world, inventions and their impacts, the pasts discovered by archaeologists. Anthropologists worked outdoors, in every part of the world. When I returned the book to the library, I knew what I wanted to do when I grew up.

Kroeber's book was like a map to my future world. A couple years earlier, when I was in ninth grade, my science teacher had assigned us to prepare a folder about "My Career in Science." No matter whether the student wanted a career in science, and girls as well as boys had to do the project; our teacher was a woman. I chose archaeology, using my family's *National Geographic* magazine as a source. One day the teacher told me that the American Museum of Natural History (AMNH) in New York was having a Saturday morning series of talks by curators about careers in the sciences: there would be one by the archaeology curator, and I should tell my parents that I should go. Dad wasn't about to repeat his commute on Saturday, just to take a daughter to a museum, and Mother said she had housework and the younger children, couldn't go. I was fourteen; the parents looked at each other, and Dad said I was old enough to go by myself, if I wanted to. My first time traveling alone to New York City, a landmark, a thrill. The subway from Grand Central Station, across and uptown to the museum, all by myself. I was there in the auditorium, I watched as a lithe outdoorsman stepped to the stage, the archaeologist. Not only did he talk; he showed home movies of his latest dig, in Peru, the Huaca Prieta (Dark Site). His wife and two little boys were in the films: she was digging, the little boys were playing in the sandy soil beside her. *This archaeologist had a wife and children and they were digging the site with him, in faraway Peru.* I still recall the scene in the film, Peggy Bird with Junius, a curator I would assist only two years later when the museum's Anthropology Department needed a typist for a couple summer months, and I got the job.

Later, in high school, another archaeologist, alumnus of our high school, gave an assembly talk about his dig in Afghanistan. Only a graduate student then, he too showed film of his project, mostly he and a couple other bronzed, bare-chested young men pushing their jeep out of mud and out of sand. The next day all the girls talked about going to a dig. I was scheduled to tell our career counselor what I planned to do, and when I said "archaeologist," she laughed as she said, "Yes, you and all the girls here."

That I had such an ambition before our alumnus had appeared, she would not believe. It happened that my last year at Barnard, he was working up his Afghan material for his Harvard dissertation, using a room in the American Museum, and I, as student aide there, was assigned to assist him. It was boring to draw profile outlines of potsherds all day long, but instructive to see how excavation materials were organized and studied. I particularly remember one day when he startled me by throwing a book across the room, exclaiming "He's wrong, wrong, wrong!" It was a new book by the famous British archaeologist Sir Mortimer Wheeler, who had made his reputation excavating in India. In his book, Wheeler claimed that digging in the area of a bazaar was a waste of time, and that instead, archaeologists should work on the defensive walls of a town. That infuriated my boss, trained as an anthropologist, as we were in America, to look for evidence of how people lived, not for war defenses. His outburst confirmed for me that archaeology could fulfill my interests.

In my senior year in high school (fig. 2), I was a finalist in the national Westinghouse Science Talent Search, doing well on its exam and submitting a research essay on possible transpacific voyages between Asia and America before Columbus. When I was typing in the American Museum during the previous summer (see chapter 2 about this dream job), I had heard about an exhibit on transpacific similarities in the museum, and saw its catalog. I was too shy and respectful to talk to the curator who had organized the unorthodox exhibit, but my essay caught the attention of the Science Talent staff, as it stood out from the bulk of the students' submissions on physics and math. Among the forty finalists invited to Washington for several days of interviews, visits with scientists, and the climax award in the White House Rose Garden, presented by President Truman himself, about one-third were girls. Mother excitedly took me shopping to buy a ladies' tweed suit, stockings, Cuban-heeled pumps, a hat, white gloves, and lipstick.

In Washington I was taken to the Smithsonian to talk with a woman archaeologist, Betty Meggers. Dr. Meggers shared the

office of her husband who was a Smithsonian curator—the MRS. ticket to fieldwork for women. Some years later, after his untimely death, she was allowed to continue in the office, working on their joint research. Coincidentally, she was open to the possibility of pre-Columbian ocean crossings and contacts, did publish on it, and we later met at conferences. Since I was not a winner of the top cash awards, the Washington trip was forgotten as soon as I put the suit, the pumps, the hat and gloves into the back of my closet. Boys in my science classes knew their physics and math were superior to mine, archaeology was only something in the *National Geographic*, and my parents seemed to see my trip as a reward for being a good girl in school.

### Crises with my Father

College was not in my future when I was a girl. My father was a liberal secular American-born Jew—cue "Jew" here, as he firmly believed that women must not be educated. Like my mother's father, who after all was raised in nineteenth-century Poland, mine strictly upheld patriarchy. Women should be trained to be home-makers, working with their hands; men, out in the business world, do the thinking. My mother should be my role model, never chal-lenging her man, retreating into vacuuming or the kitchen when he rebuffed conversing. That *brrrrr* of the Electrolux was her sound.

At sixteen I challenged my father, insisting I would go to col-lege. Dad stood firm, the pater of the house. He would pay for me to attend the finest secretarial school, Katherine Gibbs, so that I could train for the highest position suited to a woman, legal sec-retary. In case, he explained, I might be widowed and forced to earn a living for myself and my children. My father was a man, experienced and well educated. He knew what I must do to ensure a safe life. When I stood my ground, stood in front of him, stand-ing up straight, looked him full in the face, he stood straight too, unmoving. There could be no argument, for as a man, he knew what was good for us. We had to trust him, children and women could not match his masculine judgment.

My father did not realize that he had betrayed his role years
before, when he chose to sacrifice our little dog Skippy in order to
teach us obedience to authority. Never, ever, will I forget Skippy
desperately straining against the powerful arms of the man pushing
him into a cage in a van. Skippy's widened eyes caught ours. They
are in front of me as I write, stopping my breath. This is the story:

When I was twelve, my sister and I persuaded our parents
to let us have a dog. Fox terriers were popular then, so it was
a fox terrier puppy we brought home from the Humane Soci-
ety shelter. Skippy was cute and friendly and eager to please, a
favorite of all the children on our block. One afternoon I put
on his leash and Susie and I took him for his walk. Around the
corner, we passed a middle-aged woman. Skippy jumped up,
his paws outstretched toward her, mouth open, expecting to
be patted. The woman pulled her skirt away and swung at his
head with her heavy purse, knocking it against her thigh; Skip-
py's teeth grazed her thigh. He didn't bite her, there were no
tooth marks, just a scratch. The angry woman complained to
the police that the dog bit her. The town animal-control offi-
cer, a burly ex-marine, came to the house to tell us we had to
tie Skippy up for fourteen days, to see whether he was rabid.
We did. On the fourteenth day, the man came again. Skippy was
clearly healthy. The man said he was taking Skippy away. Both
my parents came outside to talk with the man, pointing out the
dog was healthy and had not attacked the woman. Neighbor-
hood children clustered around, telling the man Skippy was a
good dog. The man was adamant. He put Skippy in a cage and
drove away. We knew he would kill our little dog. Susie and I
and our friends were crying, our parents looked stern. My father
spoke: "This man is in authority. He is like a police officer. We
must obey the authorities."

That lesson I never forgot: obeying authorities can cause an
innocent to be killed. My father, as a lawyer, knew that the regula-
tions about dogs should have left Skippy with us—he was healthy
and leashed. Dad could have, and should have, told the man that

he did not have grounds to impound our dog; Dad could have, and should have, written to the city that our pet was illegally taken from us. Instead, he sacrificed our pet to teach us not to question authority. The lesson I learned was to resist. A life could depend upon it.

There's more to the death of Skippy: A couple months later, the local newspaper headlined that the man had been dismissed and was facing possible legal action. An ex-marine, he neglected his duty to inspect dairy and meat plants in the city. Instead, he seized many pets and with his bare hands, strangled them. I shall always see Skippy's bright face, so happy, his tail wagging non-stop. My father betrayed us, the children he supposedly loved. He was complicit in the brutal death of a member of our family. Never again could I trust his judgment.

Now, finishing high school, I would be the sacrifice. The Pater would kill my spirit, strangle my soul, to make me respect Authority.

At twelve, a kid, I could not save our bright little dog. At sixteen, though legally a minor, I would stand my ground. The standoff happened in the dining room, Dad's face glowering, reddening, muscles tensed, Mother huddled against the wall, wringing her hands. "I will go to college! All the girls go to college!" "No, you will not! College women are nothing but wh—wh—sluts!" Dad's mouth had formed that word clearly: "whores." It was a word he would not utter before decent women.

Sluts. He and Mother were friends with Abe and Ruth. Abe had been in high school with Mother, Ruth was the woman in the NYU class of my father and Abe. Over and over I had heard Dad say that Ruth was a slut, what do you expect of a woman who went to college? Ruth was a social worker, Abe an engineer. They had lived in Brazil and in the West before settling in the New York area. One day we drove to visit them. The house was modern, with a Japanese look, wood walls not plastered, sparely furnished, a tranquil look. On the drive home, Dad talked about how poorly furnished Ruth's house was, how obvious it was she

was no housekeeper, a slut, what do you expect of a woman who went to college? I thought, but could not speak, how comfortable it would be to live in Abe and Ruth's uncrowded house, the beauty of the wood, the openness. How Ruth and Abe sat together conversing with Dad, Mother as always not daring to speak much. Then, somewhat later when I was arguing about going to college, Ruth and Abe's daughter dropped out of college to live with a boyfriend and became pregnant. Proof for my father, See! The mother was a slut, the daughter a whore.

Gritting my teeth, I refused to accept that judgment. Yes, I was disturbed that the young woman had chosen a guy over a superb college, and disturbed that she would get pregnant without marriage—could she manage to care for the baby, a new human being? But so what? So her parents were more liberal than mine. She hadn't had to battle patriarchy. I would go to college and I would finish college and I would not be lax with guys.

Dad finally capitulated. He would not forbid me to go to college provided I lived at home and was home every night by seven p.m. and he did not pay for my college. Age of majority then, in the 1950s, was twenty-one; he had legal power to keep me in house arrest. I knew that, and accepted the conditions. I felt I had won the battle. He felt he had asserted his authority. Neither he nor my mother paid any attention to my college years. They attended my commencement ceremony because my grandmother Martha wanted to go. She loved the pageantry.

We lived within commuting distance of Manhattan; my father commuted each weekday to it. New York State at that time had no state public colleges, and instead offered tuition scholarships good for any accredited college in the state. High school seniors took the Regents exam to qualify for the scholarships. Of course I, The Brain of my high school class (said the boys), qualified for a Regents. I won also a smaller scholarship gift in a competition sponsored by a Westchester department store. That would pay for textbooks. During the summers I earned money as a typist. That paid for commuting. Packing lunch from home saved that

expense. I even managed to pay fare and five dollars to go to a stable in New Jersey on fall Saturdays, to learn to ride. A classmate, Toby Armour, had discovered this opportunity. Sarge, who ran it, was a retired mounted policeman, and for our five dollars, had us ride the boarded horses, instructing us in English saddle. A girl's dream, horses.

## College

Barnard was my college. To be an anthropology major, I had few choices. Within commuting distance of Mount Vernon, for a woman, it was Barnard or Hunter, and Hunter took only New York City residents. Barnard was, and is, the women's college of Columbia University, one of the Seven Sisters of the men's Ivy League colleges. Years after I graduated, all the Sisters but Barnard began admitting men, as the men's colleges including Columbia opened to admitting women. Barnard still enrolls only women. Its faculty has both women and men, the men necessarily respecting the students and their women colleagues, producing for me an atmosphere marvelously relaxing. As in high school, I had no ambition to achieve academic honors, I just got mostly As; reading, learning, writing, discussing were joys. The schools, Barnard and Columbia, had mixer dances to help students find dates, and I went to one and was asked out by a grad student studying Russian. He took me to hear jazz. After a couple of dates, I was getting bored and he was too obviously interested in more than listening to jazz. Enough of dating.

On my first day at Barnard, I signed up to be an anthropology major, in spite of classes in anthropology being open only to sophomores and above. Next to me another young woman was signing up for anthropology. We were both disappointed that we had to wait a year to study our desired subject. She was Dena Ferran, a dorm student from Massachusetts (fig. 18). That day we became lifelong friends, progressing through Barnard, then Harvard, then careers as archaeologists and mothers. Our Barnard professor Nathalie Woodbury and her husband at Columbia, Richard Woodbury,

were the teachers who most strongly formed us as archaeologists. Nat was a tall, thin woman with a patch over one eye, from a childhood accident; Dick was a bit shorter, wiry. Both insisted on data before theory, a standpoint never popular in the ivory towers of academic prestige. Dick's solid work ethic and clear thinking propelled him into being editor of our leading archaeological journal, *American Antiquity*, and on to president of the Society for American Archaeology, the highest office in our profession. Dena Ferran Dincauze (her final, married name) (see figs. 18 and 19) was eventually herself editor of the journal and then elected president of the Society for American Archaeology, and as she proudly told friends, the first grandmother to hold that office.

At Barnard we flourished in its women-centered security, stretching our limbs in sports and minds in small classes with fine scholars. Discussion was expected. Out in the world years later, I found that was far from the norm, particularly for women. Over and over at conferences, people would look daggers at me when I asked a question or contributed a comment. One evening at an American Anthropological Association annual meeting's Archaeology Division event, a feminist colleague ran over to me, grinning. "Gotta tell you! At the board meeting just now, the president proposed a resolution to ban questions and comments after our invited lecture. Everyone asked why? 'To shut up that Alice Kehoe,' he said. Of course we all refused to accept the resolution." Funny follow-up was that the lecturer was another feminist archaeologist, Liz Brumfiel. During her presentation, she used a slide diagramming her argument. I noticed a gap in it and after she finished, stood up and suggested data she could add. A few minutes afterward, I went into the women's restroom and there was Liz. She embraced me, telling me she was grateful for the comment and would use it in the published version of her talk. Needless to add, the male president who wanted to silence me couldn't see our sisterly comradeship in the ladies' room.

We in my Barnard class were four serious anthropology majors, Dena, Liz von Till (Warren), Alice Ann Stofer (Johnson), and me.

Dr. Gladys Reichard, the only, and aging, professor of anthropology at Barnard, died suddenly of a heart attack during the summer between our sophomore and junior years. Nat Woodbury, dryly witty and bright, took over the limited anthropology classes taught at Barnard, and we majors took most of our anthropology credits across the street at Columbia. There, Dick Woodbury taught Dena and me archaeology, how to reason from excavations and artifacts toward soundly scientific explanations. Nat, in Barnard, filled in what we should know of the history of anthropology, training us to do research and evaluate. Dear Nat and Dick . . . he, invariably kind and supportive; she, so happily married yet so much her own person . . . they had no children, and as they aged, Dena, living near them in Massachusetts, became like a daughter to them and I like a loving niece.

Barnard was, and is, an oasis in a patriarchal world. We imbibed its invigorating spirit, our minds freed and hearts warmed with friendships. My time, Class of '56, had no legal protection against discrimination, on the basis of sex or of religion or of race. Ivy League quotas limiting Jews had died, without fanfare, only a year before '56 entered. It would be twenty years before the American Anthropological Association and the Society for American Archaeology were stirred by feminists. Looking back, Barnard in the 1950s was intellectually far ahead of its era for women, while stuck in the decorous proprieties for young ladies. Those who lived in the dorms had strict curfew, with gates locked at midnight, stranding latecomers on the streets until six in the morning. Their dates would take them to the men's lodgings for the night, or they might take refuge with classmates who lived in apartments nearby. My senior year, after I turned twenty-one and could leave my parents, I rented a room from a classmate whose family lived close; many a weekend the bell would frantically ring a little after midnight, and we would take in those waifs. Other proprieties included skirts, not pants, to class; a room near the front door in the dorms where, and only where, a resident could talk with a man, watched by the receptionist; and an expectation,

though not a rule, that if a student married (or became pregnant), she would drop out.

Commuting weekdays, home each night and weekends, my first three years at Barnard are memories of classes. Exhilarating classes, young women speaking up, professors listening intently to us, many professors themselves women, firm in their scholarship and supportive of our efforts. My senior year, living nearby, I could have dinners with my friends, I joined the Gilbert and Sullivan theater group to paint scenery and enjoy the rehearsals, and I became close to a young married grad student in anthropology, Dody Giletti. My dearest, closest friend.

Dody never finished her graduate work in anthropology; she constantly gave priority to others' needs—husband, mother, professors she assisted, day care and schools in Providence, Rhode Island, where her geochemist husband taught at Brown. Her talent for exact expression supported her part-time business as a wordsmith; her distressing experience diagnosed as needing asylum care when she simply was exhausted from overwork led to our collaboration on a paper arguing that "spirit possession" is closely correlated with vitamin deficiencies and diets inadequate due to poverty and/or sumptuary rules on eating in which women eat only after men have completed meals. Our paper was favorably reviewed by medical authorities, while loudly denounced as contrary to accepted, patriarchal, interpretations. Our paper was in press in *American Anthropologist*, our leading journal, when Dody succumbed to cancer in 1981, age fifty.

Along with Barnard, I worked one day a week in the Anthropology Department of the American Museum of Natural History, the first three years as a volunteer, the last year as a student aide to earn the ten dollars I needed for each week's rent of my room. My life at the AMNH launched me into archaeology, so lively a man's world. So dangerous for a young woman.

# Launched into Archaeology, Where Sexism Ruled

My first job was totally a dream job. At sixteen I was legally able to work. I could type. I should phone a temp employment agency to get a summer job typing. Enough months or years typing and I would be ready to marry a man who would earn our living while I kept house and kids. That was the life career for middle-class girls. My mother lived that life. To me, she seemed imprisoned.

What did I do? I wrote a letter to the Anthropology Department of the American Museum of Natural History. Did they need a typist during the summer? I could do forty words a minute. My father scoffed, "That's ridiculous. The museum would never hire a girl like you. It's a waste of a stamp to send that letter." Mother took a deep breath and said, "We can afford a three-cent stamp. Let her send the letter." Dad shrugged. Not worth imposing his patriarchal authority; let another man slap me down.

To everyone's surprise, a letter came back. Dr. Harry Shapiro, chairman of the Anthropology Department, told me to come in for an interview. He had at last secured some funds to have the catalogs of the anthropology collections typed up from the hand-written entries of the fieldworkers. Some had been awaiting for forty years, big ledgers with the single, fragile records of the specimens. Hardly believing it was happening, I took the commuter train into New York and the subway uptown, went into the vast halls of the museum and onto the staff elevator to the anthropology floor, walked along the long corridor lined with metal stor-

age cabinets smelling like mothballs. Dr. Shapiro was a handsome man (he had rowed for Harvard) with a kind face. He asked me to sit at one of the secretaries' desks and type some pages. Helen and Jane, the department secretaries, watched me. I passed the test. Dr. Shapiro told me to come in at nine o'clock on the first Monday in July. Could it be true?! Working in the fabulous great museum, working in the *Anthropology* Department? Somehow I floated all the way home. My father's reality was not the only reality in our world.

For six weeks of the summer, I typed the catalogs, two carbon copies under the top sheets. I shiver now when I remember how easily those priceless records could have been destroyed when there were only the originals in the labs. The entries were fascinating, every imaginable, and some unimaginable, artifact, with its place of collection, name of the society it came from, date, and collector. Famous names I had read in A. L. Kroeber's massive textbook *Anthropology*. Their actual handwriting! And the famous places and societies. Every day was a thrill, and a solid foundation for anthropological studies.

Margaret Mead had many entries in the Pacific catalogs. Polynesian words are practically all vowels, strings of *oo* and *aa* and *ee* and *ii*. Often I was uncertain whether it was an *a* or an *o*. I had to take the big catalog upstairs into Mead's tower office, where she worked at a cluttered desk, two or three women at other desks, graduate students I suppose. Mead would look up when I put the ledger on her desk, glance at the entry, tell me the spelling, and look down again at her work. At the end of the day, we might meet at the staff elevator. She completely ignored me. She was a very busy professional.

The men in the Anthropology Department disliked Mead, referring to her as Maggie. So far as I could tell, she was never invited to any department picnics (as I was), never joined the rest of the staff in brown-bagging lunch in Junius Bird's capacious lab. Bird's wife, Peggy, told me that their boys and Mead's daughter went to the same private school, where other parents, believing

the girl lived with a spinster aunt and a housekeeper, invited her for sleepovers with their daughters so she could experience some family life. I felt that Mead reciprocated the men's coldness upon anyone climbing up her tower stairs from the department below, even me. There was only one other woman curator, a gray-haired specialist in Tibetan culture who stayed in her office beyond the last of the men's.

I, as a young girl, was very welcome in the department, welcome in the lunch group and, once the catalogs were done, to help the men curators. Junius Bird, the archaeologist who worked in Peru and whose family films of his dig there had thrilled me at his lecture just a few years prior, was notorious for his unflagging interest in women. His lab assistant was his mistress, and he worked her hard. Peru's dry desert preserved fabrics, requiring him to learn something of fabric techniques, from women, the scholars who researched fabrics. His face shone when he recounted how he had been the only man in meetings with dozens of women specialists. I spent a week or so in Junius's lab, where he explained to me the technique of twining that most of the ancient fabric makers (presumably women) had used. That knowledge I have used throughout my own research, where impressions of twined fabrics in the clay of American Indian pots are the only record of that craft in sites that aren't in the dry deserts that preserve textiles. Junius didn't know that, not long before, he had opened to me the goal of becoming an archaeologist. Once, Junius attempted to grab me. I ran from him. We ran round and round a big table, both of us laughing, until he stopped. Was I frightened? No, of course not—the door was open and I could have run out into the corridor. It was kind of pleasing that this Casanova, who was indeed a very sexy guy and bright, would notice me. Here with real men, I wasn't the untouchable Brain.

So, during the summers when I was sixteen and seventeen, I worked in the American Museum Anthropology Department, after the catalog typing helping archaeologists Junius Bird and James Ford. That second summer, it was mostly assisting Ford

with the artifacts brought back from a dig in Alaska years earlier. Everything had been preserved in permafrost, then in cool storage; when opened in the lab, everything stunk of rotting seal oil. Coming home on the commuter train after work with those artifacts, I always had a nice big space around me. A couple years later, I asked Ford if I could come along on his excavation at Poverty Point in Louisiana. Mrs. Ford would be in the camp, wouldn't that make it okay to have a young woman along? Two days later, Ford told me he couldn't take me. Eventually I learned that his drinking unleashed grabs at women, leading to a prohibition against women, other than his wife, in his camps. Sad, for Poverty Point is one of the greatest sites in North America, the earliest of the monumental mounds, earlier than any in Mexico, and James Ford was a top-rank archaeologist with a sound understanding of how to be scientific in our field. Untrammeled drinking of hard liquor, such as he did, was common in his generation.

Once I entered Barnard, I continued to volunteer as a student aide in the American Museum one day a week, while using the summers to gain field experience. First, a field school. Arizona had a well-known annual one at a Pueblo site. Another well-known field school was in southern Indiana, not glamorous like a Pueblo, but free. Since I was paying for my schooling, I chose Angel Mounds in Indiana. That summer its excavation was not in the thousand-year-old town or its mounds, but on a bluff along the Ohio River where American Indian burials were eroding. They were bundle burials, the bodies having been exposed to decay and defleshed, then the bones neatly wrapped into bundles and interred in the cemetery a thousand years ago. Excavating them was slow, so as not to damage the bones, but interesting to learn human anatomy. We were on top of the high bluff, with the Ohio River below and the Green River flowing into it from Kentucky just at that point, with a wonderful vista and cool breezes. There were only six of us, four men and me and another young woman, invited by Mr. Black, the director, to come so that I would not be the lone woman in the group.

We lived in the barracks of the field school at the Angel Mounds site, enjoyed a local woman's cooking, easy living, Saturday nights with fried baby catfish sandwiches and beer at the roadside tavern. One of the young men was into Scientology and was vegetarian, telling us very seriously of the memories of his birth the Scientology teacher had brought him to, and on into memories as a fetus. He did outgrow this vulnerable innocence and became a respected regional archaeologist. One of the men was a vet (World War II), older than the rest of us, and didn't continue as an archaeologist. A third man was a medical student, who taught us the difference between the clean dirt we worked in in the farm field and the dirty dirt in towns, so we no longer worried that we couldn't wash our hands before eating our lunch sandwiches. The fourth man (Jamie) was twenty, an anthropology major at a Wisconsin college, and had a great sense of humor, memorable when one Sunday he was whooping around in a big tree near the Angel Mounds entrance when a carload of locals drove in, gaped, screeched around, and fast drove out. Crazy Tarzan archaeologists! Jamie went on to Harvard where he pulled a memorable practical joke on a prof by planting a joke artifact in his site; in time became well known for his sophisticated analyses of artifacts. What happened to the other young woman, I don't know. This little chance group of six was a good cross section of archaeology students. Our teacher and excavation director, Glenn Black, had been a jazz musician in the 1930s when the New Deal WPA relief program hired him to direct archaeology projects, a means of employing jobless Depression workers at low cost. Black was meticulous and sensible, taught each of us with care; he gave me the foundation of field skills I needed for my profession. It was a good summer, never mind the weeks outside of the field school when I was back home, typing as a temp in local offices to earn my commuter fare and other school expenses.

Next summer, I was nineteen and halfway through college. I signed on to an archaeological field school run by Southern Illi-

nois University. It was free and would be in Durango, in north-western Mexico. This girl archaeologist was going far from home this time—farther than she imagined, it turned out. No kindly Glenn Black supervising six serious students; Durango was the Wild West.

It began with traveling by bus to Carbondale in southern Illi-nois, to meet up with the group for the journey to Mexico. I was to ride with the university botanist, Esther, in her car. Ed would be her other passenger, a big hunky, stolid stockcar racer. By night-fall we were in Palestine, Texas. The three of us went into a motel. Its desk clerk could not understand why we asked for two rooms. "There's two double beds in the room," he said, "two double beds, you only have to pay for one room." Esther, a pale, thin professor in her thirties, insisted Ed must have another room. Clerk shook his head, spendthrift northerners. . . . The next night we were in Durango, a small city. The field-school students were housed on a floor of the local hotel, boys in one big room and girls in another. In the mornings we were taken out to the site, on top of a nar-row ridge along the local river. A very little pyramid stood at the end of the ridge, overlooking an open plain. J. Charles Kelley, the Southern Illinois archaeology professor and project director, believed this little pyramid was the most northern of Mexican pyramids, and along a route linking Mexican civilizations to the American Southwest pueblos. He was a heretic for supposing a link. Orthodox archaeologists were sure that the pure and peace-ful Pueblos had developed their adobe houses and their cornfields entirely on their own, never mind that the corn had to have been carried north from Mexico where it was domesticated from its wild ancestor, teosinte.

Kelley seemed to spend most of his days in town, dealing, we were told, with endless negotiations with local authorities. At the site, the field director was a Texan named Bill. Bill brought along his blond bombshell wife Dawn, pleasingly a little plump, squeezed into the tightest jeans at a time, 1950s, when even tour-ist women wore skirts in Mexico. Hunky Ed was Bill's other com-

panion. He did no work, just stood around blankly all day. Bill told the girl students that any who would sleep with Ed, would be excused from work the next day. So far as I could tell, there were no takers. The girls, like the boy students, were from southern Illinois farms and small towns, uninterested in Mexico or its archaeology or dumb hunk stockcar racers. Betty was the liveliest of the SIU girls, pretty, with a good figure. The boys clustered around her couldn't know that at night, as we girls got ready to sleep, Betty's padded bra and padded hips came off her boyishly slender body. To wear such padding all day every day troweling under a hot sun seemed to me a strange submerging of self. That was what it meant to conform to the role of girl.

With Bill trying to flirt with the girl students and Ed standing so stolid day after day, doing nothing, I felt uncomfortable on the ridgetop. Compared to Angel Mounds, it wasn't a field school, just a dig. No one gave us background on Mexican archaeology or the significance of our daily finds. Our Mexican co-director Román Piña Chan would look at what Betty eagerly showed him and say kindly, "Es nada" (It's nothing). "I found another *nada!*" Betty would shout. I volunteered to go wash potsherds on the riverbank, along with a local mestizo farmer hired to wash them. All day we crouched by the water, chatting as we rinsed the thousands of sherds, my two years of Barnard Spanish enough to converse in. Day after day he described life in his village, his farm, and especially interesting, the doings of the *brujos* (sorcerers) always threatening their welfare. I never thought to write up notes.

Outside the hotel and the excavation was what made this summer forever memorable. Just below our site on the ridgetop, Hollywood stars filmed a western. We watched heartthrob Robert Wagner, in skintight riding pants, hoisted up on a horse by two little Mexican guys—in those pants, he couldn't lift his legs enough to swing into the saddle. His character was in love with an Indian maiden played by Debra Padgett, a forgettable actress always accompanied by her mother. Jeffrey Hunter, another

heartthrob, was the maiden's noble Indian brother, ready to fight alongside the cowboy against the desperadoes. Hunter, an Irish American from Milwaukee, was fair-skinned and blue-eyed; every day, the makeup people gave him brown contact lenses and colored brown his lean, muscular, very exposed body. Unlike the rest of the movie people, Hunter was interested in the archaeology project, walking over every noon to see what had been uncovered, and joining me and my friends for a sack lunch. We—Mel, Elmo, and I—didn't like the lunch provided by the hotel, so instead we went into town to the grocery, El Número Once (The Number Eleven), to buy bread, peanut butter, milk, and cookies. Our freeloading lunch guest would make himself two sandwiches and gobble cookies, never paying us anything. We were too polite to point out we were poor students, and he surely had a good salary.

Mel was twenty-three and a medical student. He was Jewish and looked like Danny Kaye, one of my favorite actors. We fell in love. Elmo was a gangly farm boy, an siu undergrad aiming to be a geologist. He hung with Mel and me, wide-eyed at Hunter's near-nakedness, at much of our conversations, at El Número Once, eager to learn about life and science. Our trio connected with a local rancher's nineteen-year-old daughter, June. The family were Texans, and June was elated to find young Americans to befriend. On weekends she picked us up to ride at the ranch. The first time, I was put on a mare that spooked, galloping wildly through an orchard and meadow until she was tired enough to come back to June. I lay low along her neck, trying to calm her as the orchard branches whipped over us. Everyone respected my horsemanship (bless you, Sergeant, for teaching me to ride my freshman year at Barnard).

We were friends also with three young geologists prospecting in the area. Little Joe was Texan, Bruce and the third guy Canadians. They lived in a lovely Mexican house with a garden atrium and a cook, though their parties were just beer busts. Each had a local Mexican lady friend. One day Joe invited me to go with him

in his jeep to look at an old mine, just the two of us, way out into the countryside. Trust Joe? The image of his lady friend arising in my mind persuaded me that Joe wanted no more than a friend along. Way out into the rangeland we went, bouncing along ruts of trails. Suddenly Joe whipped out his pistol, two sharp shots! A jackrabbit dead. We stopped, he skinned it, built a little fire, spitted it; soon we were eating it for lunch. Back into the jeep, we reached the mouth of the mine high on a mountain. "You can't go inside," Joe warned me. "Women are bad luck in mines." In he went, into the dark narrow tunnel. Coming out, he shook his head, nothing to prospect in that mine. Into the jeep again, barreling along, getting to the guys' house an hour after dark. A fun excursion . . . thank goodness I wasn't the sexy babe men couldn't resist. Still, I wasn't unattractive . . . rather, I was exploring a world that wasn't either-or, man (dominant, intelligent) or woman (subordinate, silly).

After the field school ended, June came with Mel and me to see Mexico City. She guided us to the zocalo, to Chapultepec, to markets and a nightclub where the doorman goosed every woman coming in—the first and only time I experienced that—and to Teotihuacán. Its magnificence had not yet been restored as it would be by the 1970s. Grass covered most of the facades of its pyramids, the Avenue of the Dead through its center was hardly paved, sherds and the little green obsidian blades it had mined and marketed could be picked up as one walked. Truly the great capital a millennium and a half old was in ruins, yet it overpowered us. Tiny us craning our necks looking up the mountainous hulk of the Pyramid of the Sun, awestruck us staring at the grand proportions of the Pyramid of the Moon, weary us trudging on and on along the avenue to the elaborately carved temple with Quetzalcoatl feathered serpent heads alternating with goggle-eyed warrior Tlalocs, our souls were captured by the mute proof that an empire could indeed bring mountains to Mahomet. That day sunk "Teo" deep into my consciousness, to surge up the next summer when I saw Cahokia for the first time.

The summer I was nineteen came to an end. *Broken Arrow*, the movie western, was released among the forgettable films; during its obligatory scene of Indians attacking the circle of covered wagons, you can see in the background the ridge we were on with its little pyramid. I returned to Barnard from Mexico, and on the first day of the semester, I met my Spanish *profesoras*, happily greeted them, telling them in my now-fluent Spanish that I spent the summer break in Mexico. Both their faces registered horror. "How did you pick up that atrocious drawl?" Mel and I corresponded for a few months before deciding that as long as he was determined to remain in his southern city to practice as a doctor, like his father, we should not marry: I wouldn't want to be a doctor's wife, politely attending ladies' charity luncheons, and I could not, very definitely could not, live anyplace as hot and humid as the South. I treasure the memories of that summer romance, my first relationship with a man I could love, who felt love for me.

My final summer in the field as a student, before my senior year at Barnard, was at Modoc Rock Shelter in southern Illinois. Its nearest town was the village of Prairie du Rocher, a 1722 settlement of French colonists along the Mississippi. Quite remarkably, they had preserved French customs of the founders' time, and the villagers looked quite French, smaller and dark-haired compared to the German-descended settlers of most of southern Illinois. The rock shelter was a large, shallow opening in the white-stone bluffs. In winter it must have been pleasant; in summer it was an oven. We got up at dawn, worked until eleven, took a break until two, its midday heat was so intense. Jim, one of the young men, tried wearing a bath towel as a kilt, less hot than pants. Locals drove slowly past, gawking at the guy in a skirt. The field director was a marine vet, muscular, shirtless, always offering a hand to us women, letting us feel how strong he was. None of us women wanted his attentions; for one thing, he had a wife back home.

Among us women, archaeologist Bettye Broyles was really annoyed by this guy. Bettye had recently divorced her bandleader

husband, deciding to become an archaeologist instead of a girl vocalist. Our antagonist lusted particularly after the experienced girl singer. Drama! Bettye was directed to dig at the rock wall near the opening of the shelter, where the clayey deposits over millennia had hardened into rock. She stood on a ladder, chopping with a pick at the wall. We other women usually were stationed together at the screens, trying to pulverize the excavated lumps enough to see artifacts embedded in them. The project director, a smaller man who had been a cook in the marines, let his big marine buddy harass Bettye and annoy us other girls as he pleased. Because I had two years of field experience already, I got paid eighteen dollars a week as a field assistant, although I worked the same as the other women. The men on the crew were mostly students, oblivious to the experiences of the women, which were, after all, normal for the time.

One weekend, most of us (not Bettye) piled into the project van for a weekend at Cahokia, near St. Louis. We went to the magnificent ruins with the earthen pyramids rivaling the largest in Mexico, not to mention Egypt. One of the pyramid mounds was being excavated. The archaeologist, Preston Holder (who would be my boss a decade later), had as his field assistant a very buxom young blond woman, her breasts barely contained by her loose halter top. Well, it was so hot there in the Midwest summer sun. She was so friendly to us, she offered us as a crash pad the house where she was staying. There we went for supper and beer, and some guitar and singing, and pairing off into the bedrooms. Our marine field director got the Cahokia gal. Left in the front room were Jim (the kilt-wearer) and I. Ahem. We actually were a pair, two Jewish kids, both twenty, liked each other and enjoyed heavy petting in the evening back in camp, but . . . we were not into casual sex. We hadn't expected that. I slept on the couch and Jim, gallantly, on the floor.

What happened to the buxom young woman at Cahokia, or other women at Modoc, I never knew. Our horny ex-marine coauthored a few field reports, disappearing from archaeology after

the 1960s. Bettye finished her PhD, was hired as state archaeologist in West Virginia, and did very well, her manner and accent from its bordering state Tennessee endearing her to local artifact collectors. She worked for years to chart and protect West Virginia's heritage, married happily, and retired to acclaim. Archaeological field camps draw a wide variety of people, from the footloose looking to earn a little for a few weeks, to seriously dedicated students of archaeology, and the living together makes for the whole gamut of human relationships.

Jim was intrigued, at Modoc, by the salvaging and analysis of pollen from the soils in the rock shelter. He did two PhDs simultaneously at Southern Illinois University, one in archaeology and one in botany. With those, he collected and analyzed pollen from a number of sites in Mexico and in the United States. At first he was welcomed; then his conclusions so frequently were at odds with the project directors' interpretations that Jim came to be anathema in the Midwest. Supposedly, corn appeared there only about a thousand years ago, in the Late Precontact Mississippian period. Jim found some, not a lot but some, corn pollen in occupations as much as three thousand years old. He found corn in a rock shelter in Oaxaca, Mexico, dated seven thousand years ago, and evidence that riverbanks there had been cleared for planting. When archaeologists told him he was wrong, he did not back down but explained patiently how a paleobotanist works. That only made the orthodox "scientists" angrier. One started a rumor that Jim didn't keep his lab glassware clean, that the corn pollen was from Southwest sites, left in unwashed beakers—a serious accusation. Midwest project directors refused to publish Jim's reports. By the end of the 1980s, Jim, who taught at Arizona State University, was working only with Southwest projects. A new, improved method of radiocarbon dating developed about that time, and cultural resource management archaeology added thousands of sites to the Midwest records. More evidence of corn in earlier time periods began to pile up. Jim had described, not reliance on corn as

in the latest period, but cultivation of small amounts of corn, possibly as a snack food.

Cahokia, as the irrefutably agricultural First Nation in the precontact Midwest, loomed in my mind for more than its cornfields extending to the far horizons. Seeing its pyramids a year after seeing Teotihuacán, I could not let go the obvious, literally overwhelming, similarities in the mountainous mounds and enormous avenues and plazas. Until the 1960s it was taken for granted that there would have been some connections, if only occasional travelers, between Cahokia and Mexico; then this was denied as "unscientific" by an ambitious wave of younger archaeologists (my generation, but not educated by the Woodburys). Where were the "hard" data proving the connections? Mounds? So what, your kid can make a sand castle. Plazas? Just stretches of flat ground (actually, Cahokia's had been built by spreading special soil over one-third of a mile). Stone tools were "hard," and those at Cahokia were uninteresting hoe blades and adzes. Many years later, historians of science revealed that this twist of "science" was part of the Cold War campaign to channel research monies into what became called STEM, science-technology-engineering-math, to build overwhelming U.S. military might. With a few comrades, Jim of course, I stuck to the obvious, in time finding that the Osage Nation's historians said their forebears had built and ruled Cahokia, until enemies, climate change, and (I think) the collapse of Cahokia's trading partner in Mexico, at the great city of Cholula, forced the Cahokians to take refuge up the Missouri in the state of that name, in a more defensible region.

The challenge of proving Cahokia was indeed a powerful state between 1050 and 1200 continues. One memorable episode in my life came from it in 2012, when a Mexican American in Chicago and a Mexican television film producer contacted me about their project to make a documentary about Cahokia for Mexican television. Correspondence about Cahokia developed into a week trip to Mexico to film where Cahokians may have traveled

there. Kick-starter funds limited how much could be done; hence, one week for the trip. We went to Tamtok (fig. 15) in northeastern Mexico, a large, little-known precontact city with plazas and mounds, of its own regional style, not that of Cahokia or Teotihuacán. Next we drove south to El Tajín, a well-known ancient city near the Gulf of Mexico port from which a principal route led over the mountains into central Mexico, Hernán Cortés's route. Unhappily, a hurricane was raging at the time. Miguel, the younger man, drove, hour after hour in pitch darkness and powerful gusts of wind and rain along the Sierra Oriental Mountains. At last, at last, hours after we might have arrived if the weather were good, we saw lights at the edge of a town. "Motel." Miguel, totally exhausted, turned into it, stopped at the office, went in. He was arguing and arguing with a youth inside, then an older woman came in, more arguing. Finally, the youth came out with Miguel and directed him to park in an enclosed garage stall—all the parking spaces were enclosed under the motel. The outside door was pulled down, and we went to our rooms directly from the garage stall. Each room had a large bed, a large mirror reflecting it, no top sheet or covering, and a large pornographic painting above the bed. Umm, hmm, the arguing had been about the possibility of renting the rooms for an entire night, instead of by the hour. Well, no one was trysting in that hurricane. The youth went out for us and brought back three large greasy hamburgers. We slept well; it was quiet inside and dry. Weather clearing, we went on to Tajín, then to Teotihuacán, and having lost a day to the hurricane, didn't get to Cholula, and went home. Disappointedly, Miguel and the producer were unable to raise funds to finish the project. For me, the trip was both fun, the guys introducing me to their families and real good food where tourists never trod, and profitable in seeing a new important site, Tamtok, and revisiting other great precontact cities.

Funny, but Cahokia and funky sex are hooked together for me. The first visit to Cahokia, ending with Jim and me left while the others went into bedrooms together. Then the hurricane-

battered motel in Mexico, where I was bothered by the picture in my room showing a young girl, maybe thirteen, lying naked and vulnerable. It still bothers me. And in between, the 1998 conference at Cahokia that my "girl archaeologist" colleague Patricia and I attended. Pat did her dissertation work on Cahokia ceramics, so knew the area, and said she'd book a hotel room for us. I arrived by train from Milwaukee in the evening, we ate dinner and then Pat drove us to a hotel. It was booked full. So was the next, and the next. The whole cluster of big highway hotels before the bridge over to St. Louis. A clerk told us that the state high-school athletic finals were being held nearby, every room was booked long before. Go to St. Louis? We decided to try the older motel we had passed on the road that led to Cahokia. I went in, yes, said the young man from India whose family's dinner gave off delicious smells just off the office. Could I see the room? Sure, we went out, he opened one and it looked clean, okay, but did he have one with two beds? He looked askance at me. Then I realized the rates were by the hour. Like Miguel years later, I had to argue for a night's rate. When I got the key, Pat and I prepared quickly for sleep. We got onto the wide bed, she clicked off the light. Suddenly the room blazed with fluorescent hearts. Red hearts, green hearts, blue hearts, yellow hearts, all over the walls, the ceiling, the rug. We laughed ourselves breathless. Pat, ever ingenious, figured out the next night which switch was for the light show, and we enjoyed it briefly then. We did wish we had our husbands with us.

Jim and I continued to be close friends until he died at eighty-two, the two of us knowing scientific method better than many archaeologists as they denied or ignored our work. This friendship lay within the world I was slowly creating, where women and men were quite aware of each other's sexuality, but xx versus xy chromosomes did not wholly determine our activities and relationships. It was a man's world where a man had a research *career*, as Jim did, and a woman could do archaeology, but if she had a family, no one recognized her work as a career. Sixty years later,

as Jim and I sat talking for hours, our last meeting, those once-huge differences between us had faded. Women plot careers, and men no longer claim that theirs exempt them from life's chores. Withal, lust and love, titillation and tenderness, still lie around field camps.

# Achieving the MRS. and Fieldwork, with Toddlers

First plane ride, June 1956! Taking off from LaGuardia, landing in Chicago, up again in another turboprop to Great Falls, Montana. There, the acting director of the Museum of the Plains Indian would meet me. What with air turbulence and smoking on the plane (my family is genetically unable to process nicotine), by the time I got off in Great Falls I was absolutely woozy, hoping I wouldn't puke on my attractive blue sheath dress. The man who met me was a blur. He drove through dark night to a little town, Browning, and escorted me into Haggerty's Hotel. In the morning, clanking radiators woke me in the narrow room designed for traveling salesmen.

The man who had picked me up returned to take me to breakfast. Oh, he's young—boyish, even. He explained that he had been hired in 1954 to do archaeology on the Blackfeet Reservation, and when the director of the local Museum of the Plains Indian became ill and took medical leave two years later, he, Tom Kehoe, had become acting director. His budget allowed for an assistant curator during the three summer months that the museum was open to the public—that way, open seven days a week, there would be a trained anthropologist available in the lobby every day. The only other employee in the museum was its maintenance man, who was a local Blackfeet.

Tom had sent notices of the assistant curator position opening to the few colleges then offering anthropology majors, and

had suggested a young woman major would be especially suitable. Nat Woodbury, my Barnard prof for my senior year, told me to apply; Dena, one of the other anthro majors graduating that year, already had a Fulbright student fellowship to Cambridge in England, and the third, Ann Stofer, was going to be in a field project in her native Kansas. Nat wrote a strong recommendation for me, ending it with a note that I could cook. ?? How did Nat know that? Why would she say that? (Answer: she didn't know, though she did know that out in Montana, a girl archaeologist who could cook would have an advantage.) Tom's application form was a government form asking height and weight as well as résumé, and he added that a recent photo should be included. He selected me.

Walking up the street toward the museum on the edge of town, I felt the sublime beauty of the Front Range of the Rockies before us. Their still-snowcapped ridges and peaks rose into the purest blue sky. I had loved walking in the Catskills the few times our family had spent a vacation week at a farm there, had found a trail that led through forests onto a ledge along a pass, sat blissed in the expansive view. Now those forested, more ancient eastern mountains shrank in the vista of the Rockies. My soul had found its home.

The Museum of the Plains Indian was built in the late 1930s under Roosevelt's New Deal and is run by the federal Indian Arts and Crafts Board. It's a handsome brick building in wide lawns always struggling against the dry climate. Inside, its main hall displays fine clothing and tools collected by the heirs of the Great Northern Railway founder, "empire-builder" James J. Hill. From today's perspective, Hill was an agent of U.S. Manifest Destiny policy, breaking through with his railway the remnant of Blackfoot homeland left to them as a reservation. He and his son Louis Hill supported taking the western portion of the reservation to make Glacier National Park, cutting the Blackfeet off from timber and game they relied on to live. The Hills built large hotels for tourists arriving on their railroad, employing Blackfeet for only the most menial jobs, or to dress up in finery for the tourists to

"meet" and photograph on the very green lawn of the hotel near-
est the railroad. Leftovers from the hotel kitchen were given to
those Indian families camped in tipis on the lawn. The museum
in Browning was designed to display leftovers from the Plains
Indians past.

My job was to stand at the lobby desk five days a week, greet-
ing tourists, seeing that they signed the guestbook (that log of
numbers of visitors justified annual allocation of funds to the
museum), answering questions they would ask—mostly, which
way to the restrooms? (Turn left.) Joe Schildt, the janitor, would
lounge at the doorway once he'd finished morning cleaning. Tour-
ists would ask him where they could see the Indians, and when
he answered he was Indian, they would be surprised: no buck-
skin, no feathers. He spoke English! Tom manned the lobby on
my two days off; otherwise he would take care of paperwork or
get in some hours of archaeological survey and testing, the rea-
son he had been hired three years previously. Because we never
had the same days off, we could only eat dinner together, and Tom
could drive me, in the long light evenings of northern summer,
into the foothills for a picnic. Still, we were together all day most
days. The only other young people in town who had any college
education were a few working in motels or restaurants, and the
Yakama woman who was the extension agent for the area; Tom
had dated her. I was the only woman sharing Tom's interests in
archaeology and Indian history, and also his enjoyment hiking
the Glacier Park trails. Together on the high grasslands rimmed
by jagged peaks, our attraction to each other deepened.

Come September, I phoned my parents, "I'm not coming home.
I'm going to marry Tom Kehoe. Here in Browning, on my birth-
day. September 18." Out rushed my parents, riding the Empire
Builder train for thirty hours to rescue their virgin daughter from
this cowboy in Montana. Tom and I met them at the East Glacier
station, the slowly setting sun glorifying the mountains. We drove
them to the best local restaurant, the Elks Club in Cut Bank. Steak
was what one ordered there. Tom was wearing his one and only

suit, the suit he'd bought for his grandfather's funeral. Nervous in front of the parents-in-law-to-be, he pushed his knife a little too hard into the Montana steak. Down slid the plate onto his lap. My mother hastened to go to him with a napkin; my father grinned. This boy could not have seduced their daughter.

Boyish as Tom looked, although twenty-eight, he had calculated to gain me as his wife. The Indian Arts and Crafts Board had not stipulated that applicants for the summer temporary job at the museum in Browning needed to send in the government form he had demanded. Under threat of perjury, the form required we write in our height, weight, send a photo, as well as list prior experience and education. Tom had stated in his cover letter that women with an anthropology degree would be preferred for the position. Five or six responded. Some months after we married, Tom showed me the set: with my photo, height, and weight, I was the prettiest, and far and away the most experienced, with three field seasons and five years of museum work. I was a mail-order bride. When in person I showed myself both nice and capable, Tom took care to be an agreeable companion, respectful of my interests in archaeology and the Indian people we lived among. Our drives while the setting sun flared gold and crimson along the mountaintops ensnared me to love the pure and glorious land, and fall in love with the man living there. That with him I could do fieldwork in this country was a clincher.

The wedding was in our cottage attached to the museum. Our couple dozen guests were local people, Blackfeet and others, all quite exotic to my parents (fig. 3). Bob Scriver, justice of the peace, performed the ceremony. Bob was a taxidermist transitioning into a sculptor of western bronzes (rodeo cowboys, noble savages) that would one day make him rich. Famous in town as an announced atheist, out of friendship for us, he had gone to each of the churches requesting a copy of their marriage rituals and put together the best parts of each. Mr. Greco, town baker, made us a delicious all-butter wedding cake. I wore a pretty dotted Swiss dress, blue dots on white, I had bought at a shop back

home in Westchester (fig. 4). Tom had on his one suit, the trousers cleaned.

The night before the wedding, Bob had asked us to come over to his house to talk about the ceremony. His wife Jeannette (second of his four wives) mentioned that she had just read that single children had more divorces than people with siblings—"Are either of you single children?" Uncomfortable silence. Tom said he was. Jeannette, embarrassed, stammered something about of course that's just in general. . . . But it was true. Growing up an only child, small for his age, thought to be a fragile baby, nourished with goat's milk to make him stronger, Tom was the center of his mother's devotion, particularly after his parents divorced. When he was in high school, before she left for work at six thirty in the morning, she laid out his clothes, his breakfast, and lunch for school. Tom never outgrew that deep-seated expectation of being coddled like a prince. When we married, he expected the same attentions from me. I insisted we were two adults, and I would not do for him what amounted to babying. He resented when our children were given that care, cried one Christmas because the boys' piles of gifts under the tree were higher than his pile. After that, the boys and I put his presents on top of a big carton so his pile would be highest. The boys thought that was a joke. When in the 1980s he became diabetic without realizing he needed treatment, he "self-medicated" his low-blood-sugar depression by finding a lady friend. She was so concerned, so sympathetic, poor Tom. . . . We divorced. Jeannette had prophesied it.

So on my twenty-second birthday in 1956, I thought I had everything I could want. A husband—in that Eisenhower era when girls married at nineteen, dropping out of college if they were students, to support their young husbands by working secretarial jobs. And my husband was an archaeologist who wanted me to work with him in the field. A husband who was, like me, accepted for graduate study in anthropology at Harvard. (Technically, I was accepted at Radcliffe, as Harvard did not yet enroll women. Before I finished my studies, it at last formally accepted women

in its graduate programs.) We would enter together the next year, 1957, Tom first finishing up his University of Washington master's degree by completing his thesis, and I beginning adult life below the Front Range of the Rockies, those glorious mountains out beyond my kitchen window, the prairie wind always blowing along the rangeland stretching southward.

Our nice brick cottage, attached to the Museum of the Plains Indian by a breezeway, was at the edge of the town of Browning, agency town for the Blackfeet Reservation. A few blocks of relatively decent houses lay between us and Main Street with the post office, stores, a movie theater, and up the hill, the Indian Service hospital. Agency Square was like a frontier post, buildings built of large logs set around an open block like a parade ground. Buttrey's grocery, where the white people shopped, was at one corner. I bought groceries at the bigger, brighter Blackfeet Tribal Store on Main Street—it was white owned but catered to the Indians, putting a long wooden bench alongside its plate-glass window, inside in winter and outside in summer, for the elders to sit and chat the day away. Blackfoot was the language people spoke, and walking along the streets I couldn't understand what I might overhear. Nearly all the Blackfeet in the 1950s were bilingual.

Our closer neighbors Bob Scriver and Mae Williamson befriended us. Bob's father had run Scriver's Mercentile, one of several dry-goods stores in Browning selling clothing, hardware, anything not perishable. Bob's brother Harold took over the store, where we bought jeans and jean jackets for our boys, real cowboy clothes, indestructible—I'm still wearing the jackets since the boys outgrew the teenage-size ones. Bob rebelled against the staunch white Methodist society of the Browning shop owners. He went to Eastman School of Music in Rochester, New York, during World War II led an army band performing in USO's, started teaching music in Browning Public Schools but soon grew impatient and started a taxidermy shop. Bob's talent for sculpture was first exercised on molding mounts for hides, gradually usurping his time as he tried making western bronzes and

selling them for thousands of dollars. He employed local Black-
feet men, often men who had been picked up drunk on Saturday
night and pushed into the crowded little town jail. On a reserva-
tion that, like most, had been allocated marginal land and had few
jobs, Bob was respected for offering work, a respect that brought
him requests from hard-up people to buy their medicine bundles,
pipes, and other holy objects. Saying to himself that by buying
them he ensured they stayed with the Blackfeet people, though
not in ceremonial use, he had them ritually transferred to him so
there would be no contesting his ownership. For a few years, Bob
proclaimed himself a follower of Blackfoot religion, said he had a
religious vision of a badger guardian spirit, created a tipi painted
with badgers and put it up in powwows. Eventually, feeling age
upon him, Bob sold his Blackfoot collection to the Provincial
Museum of Alberta in Edmonton, the northern end of Black-
foot territory. It paid him a million dollars. Great outcry that the
Amskapi Pikuni (Montana Blackfeet) holy bundles and pipes were
sold out of their country; it didn't matter that Alberta Blackfoot
were related, that the Provincial Museum lent holy objects to be
used in ceremonies and then returned for conservation. Bob was
declared a traitor, a money-grubber (which he was, hoarding his
earnings from sculptures, insisting his wives man the shop and
sew buckskin jackets to sell in it). For us, Bob was the man who
knew everyone's family ties, reservation history, and a hell of a
lot about ecology. The ranch he bought a few miles out of town
at the edge of the foothills is now an ecology education center.

Mae Williamson was an *inawa'sioskitsipaki*, a leader-hearted
woman. Such women are strong, intelligent, committed to work-
ing for their families and their people. Her parents were a Black-
feet mother, trader father; she and her siblings were brought up
speaking Blackfoot very correctly, to be capable of traditional
leadership. Mae was the first woman elected to the Blackfeet
Tribal Council and one of the organizers of the North American
Indian Days annual Blackfeet powwow in Browning. When Tom
came to the reservation, she pitied and befriended the very boy-

ish young man whose mother had died and whose family was far away in Wisconsin. When, in September, we told our Browning friends that I was staying to marry Tom, Mae approved: she had gone into the basement of the museum where I had a cot and noticed the alarm clock beside the cot was a daily wind-up and was correct on time; therefore, I had slept in the basement and not with Tom in the cottage and I was a Good Girl. Mae and I became friends, in the auntie-niece relationship favored on the reservation, sharing attentions from Dog Sam, the beautiful golden-brown rez dog Tom had found abandoned in the museum parking lot the year before I arrived. Each morning after we gave her breakfast, Sam trotted down to Mae's house for a bowl of oatmeal. Sam had made it clear to me, as Tom and I courted, that she was his first wife, in Blackfoot the Sits-Beside-Him Woman, pushing herself between us on the sofa. Mae, like most Blackfoot, respected rez dogs' intelligence and adaptability. Respect for others' independence is a general principle among American First Nations people. For a young American woman such as me, respect was a new experience.

That first year of marriage was eventful. Cold was no problem, Tom bought me, by catalog, an L. L. Bean down jacket, and Browning enjoys chinooks, warm winds blowing along the Front Range from time to time. We occasionally brought elders to the museum to interview them on tipi rings and bison drives, the two kinds of archaeological sites visible on the reservation. Comfortable in leather chairs, in the warm museum office, the elder and the interpreter relished the opportunity to talk about olden days, what their grandparents had told them. I took the opportunity of free time to read up on anthropology, preparing for graduate study. Tom applied his evenings to study German, to pass the graduate exam in German required by the University of Washington for graduate degrees; he had failed his first try, a common happening.

Toward the end of that winter, early 1957, we drove to Seattle for him to retake the exam. Our first day out was horrible, with a ground blizzard all the way across the passes through the Rock-

ies to Spokane. Finally we reached a motel and tumbled into the bed. Tumbled—Tom was on top of me, worked up to relieve all the stress with sex. "Tom, wait! I could get pregnant!" He didn't seem to hear me. I did get pregnant. He did pass the German exam, a real bugger, that second time.

Some weeks after our brief break in Seattle, I felt woozy in the morning. Started to make Tom his bacon and eggs breakfast, a highlight of marriage for him, and had to put the spatula down and retch. Same thing happened the next morning. Tom asked around and heard lots of people in town had the flu, so he got some pills from the drugstore for me. I didn't take them; whatever it was, it wasn't flu, because I felt better later in the day. I talked with Mae. Yes, I was pregnant. We would have a baby.

Tom did not show joy. Quite the contrary, he angrily accused me of tricking him, he never wanted a kid; yes, he had said he did when he was courting but that was just to get me as wife; his best friend Big Tom who had married a high-school sweetheart had warned him that wives trick men into getting babies for them. I cried. A couple days later, Tom blew his top at noon, I cannot recall about what, yelled at me Get Out! and raised his hand against me—I grabbed my down jacket and purse and ran out. Standing on the front step, about to weep, I saw the door slam again. Dog Sam was kicked out. She looked up at me and smiled, us co-wives together, what do you want to do, it's a lovely sunny day! Dear Sam . . . my real partner in the house, always honest and straightforward and loving. Well, I had my purse. We walked together to the grocery on Main Street and I bought a sandwich and drink for me and a hunk of liverwurst for Sam, for us to eat sitting on the warm bench alongside the elders. In the afternoon we returned to a quiet house, our house, we two co-wives. Tom couldn't hurt us.

About the same time, Tom and I neared another crisis. Tom handed me a sheaf of tiny pages from the shirt-pocket notebook he used. "Here's my paper for you to type." "What paper?" "Here." "It's not a paper." "You type it up." "You mean, I do the writing?"

"Yeah." "Then I'm coauthor?" "No, it's my paper." "Wait a minute! You want me to write your papers. Like that prof you and the other grad students say is so stupid, he couldn't get tenure until he married the brightest of the grad students and then bingo! published and got tenure. You and the other students know his wife wrote them. You all tell everyone how stupid that prof is! DO YOU WANT EVERYONE TO GOSSIP ABOUT YOU LIKE THAT? Everyone says that your wife wrote all your papers?"

Tom stood still. Then he picked up the little sheaf of words and phrases. "Write a paper, and I'll type it," I declared. "I'll copyedit and help with style. But the paper has to be yours, sound like you. If I do the writing-up, it will sound like me. If we work on a paper together, I'm coauthor. That way, no gossip." Tom nodded. A few days later, he came back with a written paper. Too many declarative sentences one after another—easily fixed. The typed paper definitely was, and sounded like, Tom's work. My own second paper in our principal journal, *American Antiquity*, was published in 1960 as coauthored with Tom. (My first, in 1959, was from independent research.) It came out of our collaborative work analyzing the masses of butchered bison bones in the several layers of the Boarding School bison drive site, near Browning. Our peers could clearly see we both were professionals, each working on research and writing it up, and our names together when the article came out of our collaborative work. No gossip belittling Tom.

For me, coming direct from my undergraduate college, although with several graduate-level credits from courses I took at Columbia as a senior, after three semesters in residence at Harvard, I needed six more credits to advance to dissertation level. Living in Cambridge while attending Harvard was fiendishly expensive. I asked our professor, J. O. Brew, if I could do an independent research project on my own, out in Montana, to gain those six credits. He understood. The project was to find and analyze potsherds from the northwestern plains: there were said to be none; nomadic people couldn't carry clay pots around, it was said.

In Montana, Tom and I had been driving around to see avocational collectors of artifacts, assessing and taking notes on their collections and usually going out with them to see the sites they knew. Tom and I had seen a few sherds in the avocational archaeologists' collections we examined. I followed up with these collectors (one of them told me he had thought "them things were dried up orange peels and wondered who was eating oranges out there on the range"). During one memorable drive, the local collector spotted a coyote on the far horizon and picked up his pistol from the seat and shot out the window, left hand holding the wheel as he continued driving the gravel road. The bullet whizzed over my toddler's head, as he sat on my lap. Then when we were preparing a campfire dinner with our host and another avocational archaeologist, my little one toddled to the van and reached for the loaded pistol laying on the hood. Like lightning my mom's hand cracked out, grabbing my baby. For our hosts, it seemed like nothing to get steamed up about.

Other visits were calmer, and it was rewarding to see so much of Montana, from the east-central semidesert around Jordan to the beautiful intermontane valleys. Years later a professor of archaeology at a western university came up to me at a Society for American Archaeology meeting to say, "You probably don't remember visiting my dad to see his collection." I glanced at his name tag, "Are you Paul's son? Yes, I do remember, we were there a couple of days, very fine and well-documented collection." "Well, I was like the fly on the wall, the teenager just fascinated by how you and Tom analyzed Dad's collection, so much information. I said to myself that day, 'I'm going to be an archaeologist!' and I am." Not only that, he's an excellent and well-respected archaeologist.

An exception to the friendly cooperation I enjoyed was the professor of archaeology at the University of Montana in Missoula. I wrote to him asking whether I could see the sherds in his lab there. He brusquely said he was too busy. A year later Tom and I went to a conference in Missoula. That professor saw me, came over, and with a lecherous grin told me I would be welcome to

come see his sherds that evening. "I'll check with Tom that he'll be free," I said. "No, not Tom, just you. This evening." I told him No. I felt nauseated.

Quite a different reception was given us by the archaeologist at the Glenbow Institute in Calgary. I had known him slightly at Columbia. He was happy to have our company and put out for me collection drawers with potsherds from a survey he had done in Alberta with an older archaeologist from Colorado, a woman well known for her expertise in Paleo-American ancient spearpoints. Several years later, after I had published my analysis, the doyen of ceramics in archaeology east of the Rockies angrily accused me of plagiarizing the report he had given to the Glenbow. Tom and I looked so astonished that he composed his face and asked, "Didn't Dick show you my report?" "No, we had no idea." Then he grinned. "Typical. Okay." He remained my secret friend from then on.

Out of the months of looking at avocationals' collections and the little in other Montana and Alberta museums at the time, 1958, I wrote a paper describing the several different styles of pottery recovered in the northwestern plains, giving them names. The project was significant because at the time, many anthropologists believed that none of the Plains nomadic peoples made pottery. Besides submitting the paper to Prof. Brew for the six credits, I sent a copy to Richard Woodbury, my kindly Columbia professor. He praised it, sent me some notes for improving it, and urged me to prepare it for publication, to send to our leading journal, *American Antiquity*. He also recommended it to the journal's editor, his successor in that position. It was accepted and published in 1959. By rights, the types and names I published for native ceramics in the northwestern plains, the first such analysis published in a scientific journal, should have been accepted and used by subsequent archaeologists. Instead, names proposed several years later by two men writing dissertations on Alberta archaeology are used, neither of the men citing my paper. Only a young woman writing a master's thesis at the University of Saskatche-

wan recognized my priority and used both my types and my rec-
ommendation to take note of the impressions of cloth on most
of the potsherds. When the young woman's professor objected,
she adamantly insisted on recognizing my work. Her thesis was
not published and her later work has been on another topic. Ah
well, we were only girl archaeologists.

My first presentation of my work in a professional conference
was the pottery study, in 1959. I'd attended several conferences
earlier, in the audience. One, the Plains Archaeology Conference,
was usually in Lincoln, Nebraska, where the Smithsonian's River
Basin Surveys had its headquarters. Sessions in 1958 were all in
the Nebraska Historical Society Museum auditorium, seating
about two hundred. I took my baby and sat in the back row, many
back from the men clustered in the front rows. One of the senior
men, a full-time River Basin Surveys archaeologist, saw me as he
was coming into the room. He stared, went up toward me, and
said, "What are doing with that baby here?" I said, "He's sleep-
ing." The man snapped, "What will you do when he wakes up?" I
replied, "I can nurse him if he's restless." The man totally freaked
out. Ran out and came back with two young men, ordered them
to take me out. They physically lifted me and the baby and pushed
me out the door. The senior man, incidentally, was known to be
gay; Tom told me that young men on his crews were cautioned
that he might solicit them. That was tolerated. A baby was not.

With the pottery study, I prepared slides on my classifications to
make an illustrated paper. This conference was the Central States
Anthropological Conference, held in Madison, Wisconsin. Close
to my in-laws in Janesville, I could leave my toddler with them
for the day. For the session with my paper, I sat on the stage in
an auditorium, with three older men and one young one. All the
pottery papers were very dull to listen to. For want of something
to keep me awake, I admired the well-built, blond, handsome
young man sitting opposite me. He noticed me too. His name was
Lewis Binford. Like me, he was making his first research presen-
tation at a professional meeting. If it were not for his good looks,

I would never have remembered him. Ten years later, with considerable assistance from his third wife, he launched a drive for fame under the tag "New Archaeology." Unlike his simple pottery report in 1959, "New Archaeology" was pseudoscience tailored to look like the physics that was getting National Science Foundation money. Immune to this game, I never fell for it. It caused a schism in American archaeology, with me, Tom, and many of our real colleagues pushed to the sidelines.

In fall of 1959 Tom obtained a new and excellent job as provincial archaeologist for the province of Saskatchewan, I think the first province to have a full-time provincial archaeologist, and we moved to Regina. With all he had to learn for this pioneering job, he had little time to read anthropology classics for his Generals oral exam at Harvard. As I describe in the next chapter, he did not pass the exam. Each of us, Prof. Brew too, recognized with disgust the class act just performed. A Harvard professor cared nothing for so lowly a job as provincial archaeologist for someplace no one had heard of. In fact, a Harvard professor cared nothing for anyone who required a job, anywhere; Harvard salaries were incredibly small, for they were meant to be only tokens for gentlemen who lived from their trust funds. Brew had no family fortune and he was consistently low man on the totem pole. The oral exam performed the necessary task of discouraging, even disengaging, hoi polloi. How did I do so well? I was a married woman with a kid, I would disappear; my committee could enjoy discussion with a bright Barnard girl and there would be no consequence. I could hand in a dissertation if I wanted to, someone would sign off on it.

We were done with Harvard, both of us, at the end of 1963, with three semesters in residence, 1957–58 and the fall of 1960. Did we go to the commencement ceremonies in 1964 when my PhD was officially awarded? No way, let them mail my diploma to me. It sits in a tube on top of a bookcase in the back room. Tom's career was never affected by his refusal to read irrelevant material in the list for the Generals oral exam. He had graduate

study proving his professional preparation, and he was a man. He looked like an archaeologist. For me, having a PhD from prestigious Harvard never seems to have given me any advantage—being only a woman was what was noticed.

I'll tell more about Harvard's "benign" neglect of working-class men (Tom) and all women in the next chapter, and describe the fieldwork with Indians that I was forced to do instead of archaeology. Those experiences with Indian people were immeasurably enriching to me as a human being, and led me into much wider research, but they deflected me from the archaeological fieldwork that I had planned and prepared for. Harvard actively denied me credentials as an archaeologist. Nevertheless, I persisted.

### Excavating a Fur Trade Post

Done with Harvard requirements by 1963, I could get back to archaeological fieldwork, to discovering what had been unknown to scholars, and doing that outdoors, literally in the fields.

First off, after ending our engagement with Harvard, we wanted to excavate the fur trade post we had chosen for my dissertation project. Two years visiting Indian peoples to learn about their religions had been exciting and deeply moving, yet uncovering the past still drew me on. The idea of a fur trade post attracted me, cabins at the edge of a forest. When I roamed as a girl in Mount Vernon, I liked to go into patches of woods still remaining at the edge of town. I found collapsing cabins and clambered around in them, discovering the local past. Tom, as provincial archaeologist, appointed me to direct excavations (fig. 6) of the fur trade site threatened by the rising reservoir of the Saskatchewan Power Corporation's new Squaw Rapids (renamed E. B. Campbell) Dam.

François' House, as the post was called, had been built on the south bank of the Saskatchewan River close to Nipawi, a traditional rendezvous for Cree. Their camping ground was a broad field on top of the bluff, overlooking miles of the river curving around a flat below. To the south were the bison plains, to the north across the river was boreal forest with moose. François LeB-

lanc, a trader from French Canada, built the trading post in 1768 on a terrace above rapids in the river, below the Nipawi bluff. LeBlanc was partnered by James Finlay, a Scots businessman settled in Montreal. LeBlanc's young wife and their little son accompanied him; Finlay left his white wife and children in Montreal and, on the long trip west, picked up a Saulteau Indian woman to be his companion. She would become pregnant while they were in the post, later delivering the boy they named Jacques Raphael Finlay, called Jaco. Jaco and his half brother James Finlay Jr. both worked for the fur trade when they grew up. A team of paddlers, of whom we know nothing, came with the traders and lived in a back room of the post.

At this time, 1963, few fur trade posts had been excavated. Saskatchewan's heritage program wanted to develop several for tourism, so Tom hired a young archaeologist to work at Fort Carlton that summer. He stayed with us at François' House for a couple weeks, to observe how I conducted the project. Another young man, fresh out of Beloit College in Wisconsin, was hired as my field assistant. Both the young men went on to do significant archaeology, one in Panama and the other in the Southwest. We used an abandoned farmhouse on the bluff above the site as our camp, with Ruby, a local young woman, coming in days to cook, wash and number artifacts, and keep an eye on our toddler second son. Our older boy came down to the site with us, or played in the farmyard with his little brother. Tom visited weekends when he could, driving the long distance from Gull Lake where he was completing excavation of its deep series of bison corrals.

To do the digging, I hired local men, all middle-aged. Much like my friend Joe Douquette, who introduced me to the Sioux Wahpeton community where I found my dissertation information, these men, although white, could not find employment in the now-mechanized farms of the area. They were intelligent (well, I had to dismiss one who wasn't), hardworking, and good-humored. Among them, Mr. Lehne was especially discerning, identifying for me the unique texture of dirt floors swept with

twig brooms—like in the settlers' cabin he grew up in—and who became an archaeology lab assistant in the Saskatchewan Museum of Natural History. A farmer whose son was Tom's assistant was crew director. All the men were of the "Dirty Thirties" generation growing up in the extreme poverty of the 1930s Dust Bowl, when fierce sandstorms of dry soil killed all the crops. The University of Saskatchewan accepted bushels of wheat as payment for tuition, but no wheat survived. It was a remarkable generation of self-educated citizens, some achieving professional status after World War II opened opportunities. Working with such avocational scientists around the province, Tom and I founded the Saskatchewan Archaeological Society to coordinate their activities; it's still going strong today.

François' House had been a challenge to the Hudson's Bay Company's (HBC) royal monopoly on the Canadian fur trade. "The Bay" demeaned independent traders, calling them "pedlars." LeBlanc, an experienced voyageur, surprised an HBC visitor by welcoming his Indian customers informally into his post, instead of keeping them outside and the entrance guarded. Records mention Madame LeBlanc and Finlay's Indian "country wife" in the post, so I wasn't surprised to find some artifacts that an Indian woman might have made and used—sherds of some small clay pots, a few bone and stone tools—especially just beside the outer wall where a woman might sit in the sun and the breeze, working as she watched the little LeBlanc boy play. In my report on the site, and in a paper in a regional journal, I made this observation regarding the Indian artifacts.

Not long after my report was published, two breakthrough books came out focusing on the "country wives" of the fur trade, until then seldom mentioned. One of these authors, Jennifer Brown, was an anthropologist, the other, Sylvia Van Kirk, a historian. A small group of us feminist anthropologists and ethnohistorians working in fur trade research formed in the early 1980s, with Jennifer mentoring several. Quite quickly, the topic morphed from recognizing women in the fur trade, to recognizing that the Indian

country wives and their "half-breed" offspring became, in the nineteenth century, some of the Métis buffalo hunters, groups who spoke a language combining French or English and Cree, the languages of their two parents. Descendants began to demand that Canada recognize them as indigenous, equivalent to Indian First Nations. Our fellow feeling, as women, for the women glimpsed in the fur trade records burgeoned into a major national movement for social justice for these descendants.

Two summers completed the excavation of François' House, which seemed to be a rebuilt post of 1773 for the traders returned from the East a couple years after enjoying the profits from their first year at Nipawi. Their first post was likely the close-by remains called Finlay's, by the historian who had looked for and discovered the site of François' House; he had supposed the two traders did not share a building, but our excavations indicated logs had been salvaged from "Finlay's" site, probably to use in rebuilding the post after the two-year hiatus. Only one episode spoiled these seasons of my own archaeological project: the second year, when Tom came for weekends, he angrily accused me of having an affair with his assistant. Angrily, he made what should have been love, feel more like rape. I was astounded. Not only had his assistant never visited except with Tom, but I didn't even like the man. He was a good assistant, an avocational archaeologist wanting to learn from Tom, uncomplaining in the field and dependable when instructed, but I found him narrow, not very bright, polite when thanking me for providing lunch but otherwise never saying anything. I didn't even see him as at all attractive. And he was married, with several kids. Tom's anger seemed utterly incomprehensible. Only years later did I hear that the man was a womanizer, did have an affair with a woman archaeologist, and his wife divorced him when their kids were grown. What had seemed utterly irrational came from Tom hearing gossip of the man's affair, and assuming that I was the only woman archaeologist in Saskatchewan. I learned that summer how the tragic heroines of drama felt when unjustly accused of infidelity.

## Collaborating with Tom, Again

Our last summer in Saskatchewan, before the change in govern-
ment ended (for a while) the province's heritage program, we spent
at a bison kill site in a ravine, camping above it on the ridge. Tom
had tested the site after shown it by the local avocational archae-
ologist, using as his crew a young man he had met when record-
ing sites in the eastern part of the province. Eugene Gryba, from
a large farm family of Ukrainian immigrants, was eager to learn
archaeology, and everything taught in university. He not only
caught on quickly; he thought out what he was taught. Against
the odds of his rural upbringing, he completed a university and
most of a graduate program in archaeology, and then like Tom,
didn't complete the PhD. Like Tom, too, Eugene had too clear
an understanding of what he should be studying, versus what a
professor considered classics. As with Tom, social class differ-
ences underlay the professors' arrogance. Eugene has worked in
cultural resource archaeology (aka contract archaeology, a busi-
ness) in some of the toughest field locations in the northern for-
ests, gradually building a reputation culminating in an honoring
session at a Canadian Archaeological Association annual confer-
ence. Remaining close friends with Eugene all these years, I was
so happy to see one after another younger archaeologist enthu-
siastically testify to Eugene's superb skills and accomplishments,
and thank him earnestly as the mentor who taught the critical
knowledge needed to evaluate heritage issues and demands—
not least, the importance of working collaboratively with First
Nations people.

For that site in the ravine, we camped in tents and I cooked,
again (fig. 10). This time we had a small, cheerful crew of Saskatch-
ewan young men and one young woman, several of whom became
professionals in the burgeoning business of contract archaeol-
ogy. There was pottery in the occupation layers in the site, indi-
cating it had been more than a slaughtering place. Some of the
sherds had been stamped while damp with a checkerboard pat-

tern, similar to pottery in central North Dakota to the south of Saskatchewan, raising the question of long-distance relationships a thousand years ago. We never found any human remains, nor any artifacts likely to have been used in rituals, so none of the several First Nations in Saskatchewan had any particular concerns over our work or what we recovered and deposited in the Saskatchewan Museum.

Quite the opposite marked the most unusual site we excavated, the Moose Mountain Medicine Wheel. We had mapped, in 1961, the array of stone lines that covered a hilltop overlooking the broad Regina Plains, once a glacial lake in southeastern Saskatchewan. Those few days of mapping I remember because stirrings of morning sickness announced our son would have a sibling, like his brother a wanted child but conceived before we had planned to do so—in our marriage, no sooner had we discussed when we might have a child, than behold it was conceived. One other bit of the experience at Moose Mountain was that our pencils disappeared. Tom was annoyed that his assistant hadn't packed pencils; his assistant was puzzled and said that he had. We clung to the pencils in our hands, put them in our pockets so no more would go missing. We were miles and miles from even the rail depot with its one enterprise, a pub. The Great Pencil Mystery was cleared up when we asked the Saskatchewan Museum naturalist about it, and he explained that even the minute traces of salt from our hands as we held the pencils would attract small animals such as gophers that would seize them and take them to their burrows to lick the salt. Sure enough, years later when we excavated a sounding trench through part of the large central cairn, we found the pencils in crevices between the stones of the cairn.

We had a couple of other events with animals in the field. At François' House one morning as I came into the site, the local workmen told me that a mother bear and two cubs were in the thicket on one side of the site, eating chokecherries. We should be careful that the little boys did not play too close to the thicket. I was about to say that they would stay at the farmhouse, when

the men assured me that they could play on the far side of the site, with the men working between the back dirt pile that was like a sandbox to them, and the bear. The men would keep alert to her movements and be ready to vacate us fast if she came toward them. She and her cubs stayed in the thicket for three days, then left, peacefully.

At the site in the ravine, we were surprised to see, every morning at nine, a herd of salamanders walking over the ridge and down into the ravine. They apparently moved back up and over the ridge at the end of the day, after we left our trench. None of us knew salamanders lived in little herds like that, or moved with the sun. Our second son was three that year and had the idea of tying a string around the neck of a salamander and leading it around as on a leash. He enjoyed his pet (who knew whether it was the same or another salamander each day?), and the rest of us were amused. One day, one of the young men stepped backward, accidentally on top of the little black animal. Our child saw with horror that his play had cost a life. He was heartbroken, very quiet all the day, and never interfered with the animals again. Many years later I happened to meet a world authority on salamanders, mentioned our surprise at our site, and learned that southern Saskatchewan is the northern boundary for salamanders, with its tiger salamander the largest living of its species. These manage in the grasslands by living in moist ravines, and he was not surprised that ours moved over the ridge when the sun hit the slope and then back when the sun set. There is an Indian boulder figure of a tiger salamander in the region of our site that delighted him when I sent him a copy—the outline is accurately the tiger, he said.

We kept in touch with our Canadian colleagues after we left Saskatchewan and in 1972 accepted work in the National Museum of Canada's Urgent Ethnology Programme. Designed to record customs of First Nations that seemed in danger of being forgotten, it provided a modest sum for field expenses and to reimburse the First Nations participants. Our project was in central Saskatch-

ewan in the boreal forest area near Pelican Rapids, on Jan Lake where the family of two noted Cree crafts artists, Mr. and Mrs. Noah Custer, camped for the summer. We camped nearby, walking to their camp nearly every day for six weeks, photographing the elder couple's methods of work, and observing daily life in this traditional summer camp (fig. 11). Photographs and notes are archived in the museum, now titled Canadian Museum of History, and available online.

Our work with the Custer family was what is known as ethnoarchaeology, watching living people constructing what would become the archaeological record after they're gone. The Custer camp was composed of the elder couple, their adult sons, daughter, and daughter-in-law, and their grandchildren with the married son. Three tents had each its cooking fire outside, one tent and fire for each adult woman, although grandmother and mother shared their cooking, particularly with the grandchildren. The older unmarried son often cooked his fish for himself at the central fire, over which a rack held drying fish. Each morning the grandfather rowed out to the gill net close off shore, bringing in the day's fish. The married couple went moose hunting, leaving the children in camp with the other adults, or taking the kids with them for the day. Outside the camp, a moose hide was stretched on a large frame, for the women to scrape clean, an unpleasant task they would do off and on for a couple of hours. Most of our photographs document the processes by which Noah Custer created wooden objects and his wife made beautiful birchbark baskets, some of them now displayed as art in the Manitoba Museum of Man in Winnipeg.

Our personal interest in the camp, as ethnoarchaeology, revealed interesting intersections with archaeological interpretations we might have naively made. We saw that each adult woman had her own tent and fire, so that the number of tents and cooking fires (other than the large central fire with scaffolding above) equaled the number of adult women in the site, but not the number of couples with children. We could link "midden" scraps from food and

crafts to their sources, near or far from the tents, and note essen-
tial parts of the camp too far, or ephemeral, to be seen archaeo-
logically, such as the net placement offshore, the drying scaffold
over the central fire, and the hide-scraping frame. I observed
that the unmarried adult woman remained in her tent whenever
Tom was in the camp, the kind of distancing common in many
societies between single women and unrelated men. Were I not
part of our project, Tom would never have known that. When we
returned home, I looked into several published ethnographies of
similar Canadian forest communities, particularly one on another
group of Cree in the region. All by men alone, none mentioned
the seclusion of women from men strangers, and worse, I real-
ized that the male ethnographers hardly mentioned women at
all. A few years later I participated in an archaeological meeting
session that we titled "The Hidden Half."

Thirteen years after we mapped the Moose Mountain construc-
tion, Tom was asked to review a report on a boulder construc-
tion high in the Big Horn Mountains of southwest Montana. An
astronomer camping with his kids had noticed that stone lines in
the figure pointed to solstice sunrise and two bright stars. I was
washing up at home after supper when Tom came down from
the back room we used as a study, excited. "Come up, leave those
dishes!" He had laid out the map we made of Moose Mountain's
boulder construction. Its lines lay in the same pattern as those in
the Big Horn "medicine wheel" (northern plains sites with lines
of rocks in a circle with radiating lines). Except, Moose Mountain
had more lines. Tom sent in approval of the Big Horn report to
the journal and phoned the astronomer. Yes, he'd like to look at
our map. A couple weeks later, he phoned back: When could we
get together at the site? Could we be there at summer solstice?

Yes, we certainly could. We drove out, with the two younger
boys of our, by then, three, from Milwaukee where we had moved
in 1968, picked up Jack Eddy the astronomer at the Regina air-
port, and drove to Moose Mountain in the rainy evening. Jack
didn't want to stay in a tent or on the floor of our tent trailer, so

he asked us to let him off at the hotel at the rail depot. Um, we explained, it was really only a pub; Saskatchewan law required every place selling liquor to provide beds, and food, for drunken patrons. Okay, we would go in. Jack asked the woman at the bar for a room and some food. She was surprised then seemed upset. She reached into a space under the bar and pulled out a wrapped sandwich of baloney on white bread. That was the food required by law. Then she went to the foot of the stairs and yelled up, "Kids! Gotta get out of that room, we got to give it to a man here!" Scrambling noises. We went upstairs. Jack could sleep in the children's room, the bed rumpled from their quick exit. We left him there until morning.

For four days Jack worked with us on that gloriously beautiful hilltop, measuring the stone lines and calculating their directions in regard to sun and star risings and settings (fig. 12). Where the Big Horn "wheel" has three significant direction lines within its circle, Moose Mountain has six, more than any other known "medicine wheel." Jack recognized that the stone lines pointed to not only summer solstice sunrise but also to the bright stars at that time of year, Sirius and Aldebaran, if the site had been constructed around two thousand years ago. Later, other astronomers noted sightlines to stars Capella and Fomalhaut as well, and one calculated that 2,500 years ago, the sun would appear to rise over the middle of the central cairn. Sure enough, when we excavated the next year (fig. 13), right there is a large white rock that had been obscured by centuries of people walking by, putting small stones on the big cairn, as people do along trails. This site on the high prairie ridge was an American Stonehenge.

Did Moose Mountain make us famous? National Geographic asked Jack Eddy to write an article for its magazine, paying a Swiss aerial photographer to fly over to photograph it from the air, to show the pattern nearly invisible at ground level, in the tall grass. His story, mentioning our work, was in the January 1977 magazine. Then . . . nothing. Archaeo-astronomers in Britain and the United States ignored it. Finally, I challenged the leading Amer-

ican archaeo-astronomer, "How come you never mention Moose Mountain in any of your books?" He looked me straight in the eye and replied, "It's not one of my sites, or my students' sites." He was another would-be Big Frog in a little puddle.

That competitive attitude, flavored with machismo, is the reality of science. No matter how esoteric the particular subject—and what could be more esoteric then a 2,500-year-old astronomical observatory on a hilltop in the Saskatchewan prairies?—archaeologists, like other scientists, compete fiercely for money for projects, for academic jobs in the big universities, for students who will carry out the research grunt work cheaply and then acknowledge their mentor's greatness. For me and Tom, neither of us set up with graduate students, our work could be deliberately ignored. Like at Harvard.

# "Benign Neglect" at Harvard

Nineteen fifty-seven, I had a baby and I entered Harvard as an anthropology doctoral student (fig. 5). Those two things do not go together, although when I was there in 1957–58, there was indeed another young woman with a new baby enrolled with her husband in a Harvard graduate program, Mrs. Ruth Bader Ginsburg. As far as I know, we did not meet. Harvard students then were mostly men, and their wives earned their support as secretaries or, if they had babies, offering day care. Lamont Library on campus was closed to women—women students—so that the men studying there would not be distracted. Harvard did not enroll women, so I had to enroll in Radcliffe College, even though I was a graduate student. Two years later, Harvard bowed to the tidal wave and we "Radcliffe" grad students were swept in. If this had not happened, my PhD would have been a Radcliffe, not a more prestigious Harvard, degree.

It was mid-September, right after the museum in Browning closed for the winter, when we drove up to 20 Ware Street, Cambridge, to the apartment just vacated by a somewhat older anthro student I had met at the first American Anthropological Association (AAA) meeting I attended, in 1955. My colleagues Dena, Ann Stofer, and I had gone to the AAA meeting in Boston with a Columbia grad student who was driving. We stayed in West Concord with Dena's parents, entailing a long commute into Boston each day. With very few women at the meeting, and especially few

young women, we three were noticed, ogled, invited for drinks. One evening we went to a party in a room at the meeting hotel. Men were sprawled over the bed, the chairs, on the floor, drinking—in those days, hard liquor, not beer or wine. Loud laughter. We girls perched on the side of the bed, together. In one corner I noticed a man curled up, weeping. "Oh, is he all right?" "Yeah, it's just he's drunk." His name tag identified him as a prominent archaeologist in a major university. Gee, there was a lot of drinking going on, in the field and out.

Our apartment came furnished; we would be there only for the academic year, September to June. We had asked the few Harvard students we knew whether they could help us find a place, and one had suggested this one, where he and his flatmate David Kelley were both moving out. Kelley had already left for Peru where he would find some of the earliest corn there, and marry fellow Harvard grad student Jane Holden. In the pattern of the time, Jane followed her fiancé to his work, leaving her own dissertation research incomplete. Eight years later I would be teaching in the same anthropology department as David Kelley, and Jane would be writing up her dissertation, working part-time in the university museum, and managing her household and the kids. The Kelleys and us, our two families, became close friends for the rest of our lives.

Both husbands respected their wives' research and professional standing, yet it did not occur to either husband to compromise his time by sharing equally in household work, not even cooking. We were the shift generation between silent collaborator wife, and wife who had a professional career and split housework and child care with her husband. At least we were a generation beyond the frightful prewar one when some women anthropologists had tubal ligations to prevent pregnancies, feeling a child would close off any possibility of full-time work as an anthropologist. Margaret Mead had believed she could not conceive, and was well established when her third husband proved she could, and would, have a child. A woman colleague a generation younger than

Mead, and only ten years older than I, told me that she was one of four women in her cohort who chose to ensure by surgery that a child would not kill their opportunities to be anthropologists.

One drawback of our apartment was that the lease stipulated no pets. What to do with Dog Sam? No way were we leaving my co-wife back in Browning. A fellow student we knew asked one of the profs, J. O. Brew, whether he would keep our dog for us in his home in Cambridge. JO had always wanted a dog, he told us, and neither his mother nor his wife favored one. Sam would be temporary; we would bring over her cans of food and comb her every Sunday. As Sam enjoyed the Brews' garden and lots of petting, we became friends with JO, his wife, and their older son Alan, who would himself become an archaeologist. One Sunday morning we found JO sitting in his bathrobe in an easy chair, reading a stack of papers. A leather briefcase stuffed with more paper was beside the chair. JO looked up, waved his hand at the papers: "Never do this to a professor! This is two thousand pages supposed to be a dissertation. Years of mostly field surveys, thousands of artifacts analyzed. A dissertation is NOT a lifetime's work!" I took that to heart, and later turned in a draft of only 114 double-spaced pages.

Tom and I enrolled in the same courses, so that he could take notes for me while I was in hospital with the baby in October. People did look askance as I walked up, belly protruding, to sign up for classes. One professor told me that because I obviously would be dropping out, he would not permit me to join his seminar. Tom and Dena would be in the seminar. I politely argued with the prof, asking to be given the chance—there were enough seats in the class. Finally, his face still very doubting, he let me sign. From behind us, a woman said, "She'll never finish! I had to drop out for two years when I had my baby." It was the wife of a student just finishing his dissertation. Both her family and her husband's were wealthy and could have hired a nanny to free her to continue grad work. The professor hesitated, pen in hand. I begged for just the chance. Slowly he put pen to paper and signed me in.

Third week of October was my due date. About four a.m. I woke

feeling contractions. I shook Tom awake, got dressed, he drove me
to Massachusetts General Hospital in Boston. The cheapest hos-
pital, as I had chosen the least expensive obstetrician on the list
Harvard medical clinic provided; it hadn't occurred to Tom, when
we married, to enroll me in his government medical insurance,
so we had to pay cash. At the hospital I was put into a hospital
gown and told to lie on a bed. By noon the contractions lessened
and I was told to dress and return home. By the time I was up and
dressed, the contractions strengthened, so back to the gown and
bed. Those days were before evidence-based practice that lying
still on a bed was contrary to facilitating childbirth. Worse, the
hospital refused to give me any food, saying that I would need
anesthesia and couldn't eat before it would be administered. "I
don't want anesthesia," I told the nurses. "I want to experience
this birth." No! No was no, with them. The day passed, the night
passed, the next entire day passed with contractions strengthen-
ing each time I was up and lessening when I dutifully lay back
on the bed. NO FOOD. Hunger struggled with the contractions. I
begged to talk with my doctor, where was he? He was in surgery,
trying to save the lives of a mother injured in an accident, and
her baby. Oh god. . . . At long last, the second evening, the doc-
tor came. The contractions were now regular, not to be ignored.
"Please let me have something to eat," I pleaded. He looked sur-
prised, turned to the nurse, heard how I was denied, ordered that
I be given some soup at once, assured me that this labor was pro-
gressing and I should rest if I could. Next morning, still hungry,
I was wheeled to the delivery room and began pushing. At long,
long last, about two o'clock in the afternoon my boy was born. I
had passed out, weakened from hunger, before he emerged. When
I came awake, I was in a ward, it was dusk, and a nurse was plac-
ing a perfect baby in my arms. People in the room were gathered
at the window, exclaiming. Sputnik, the Russian satellite, had
been launched, its light passing through the heavens above Bos-
ton. My child was born into a new era.

A new era for my son who would earn his living doing com-

plex computer programming, but still the Eisenhower 1950s for me. Babies, like housecleaning and cooking and grocery shopping and laundry and typing, were women's work. Tom never shared in any of my woman's tasks, nor did I expect him to. No man I knew shared housework or child care. Nursing my baby was heaven for me; it gave me breaks in the work when I *had* to sit, cuddle the marvelous little person, and relax. If I read scholarly stuff while nursing, the milk stopped. Instead, I read Dr. Spock. Radical Dr. Spock, not yet famous for political protests against war, but radical for his advice to parents to take it easy, love the child. He challenged the "scientific" child management that had robbed my mother of the ineffable joy of nursing her babies. Had made her a clock-watcher, not daring to pick me up between the four-hour bottle feedings. Had discouraged her from hugging, from physical intimacy with her children. Spock knew, although he didn't write it in that treasured paperback, that the 1930s child-rearing advice was basically fascist, oriented toward strictly disciplined citizens obedient to dictates from government authorities. We weren't that perceptive yet, we only knew that when our six-month-old clambered over his crib rail and fell to the floor, his loud yelling meant he wasn't brain-damaged, *said Dr. Spock*. Bless Dr. Spock.

I would nurse the baby, then we would eat our meal. Often I kept him on my lap as I ate. One day, when he was nine months old and beginning to struggle to stand and walk, he pushed me away and reached for my glass of milk. It happened again, and again. He wanted to stand, to walk, and to drink like the big people around him—let me go, Mommy! He was weaning himself. What? Freud taught that weaning was a major trauma imposed upon innocent trusting babies, letting loose separation anxieties and repression. Here it was *I* who was upset, anxious and pressured by overfull breasts. It happened that one day I was wheeling my baby in the borrowed pram away from Peabody, Harvard's Anthropology Department building, when a senior professor walked by. This man had published a classic article on weaning trauma, based on his interviews with Navajo women. "Professor," I earnestly told

him, "my baby here is nine months old and he's pushing me away when I nurse him, he wants to drink from a cup, he wants to be weaned." The man leaned down, peered at the sweet baby, said to him, "Goo goo" (yes, really), and to me, "Well, obviously he's abnormal." Walked on. An epiphany for me: this professor was so damn wrong! What did he know . . . YES, *what did he know?*

Next day I reread his classic article. Now I could see that he failed to use our basic anthropological method of listening to the people we were studying, taking care not to push leading questions from academic theory. Instead, he had persisted, it seemed even bullied, those Navajo women to come up with some stories about trauma with weaning. They told the professor that weaning babies was not a problem. He wouldn't accept their word; he kept at them to describe trauma. They finally remembered abruptly weaning a child when its mother became very ill. They'd *heard* that women who wanted to cease nursing put chili pepper on their nipples to discourage their child. So now the professor had a paper he could publish about weaning trauma in a primitive society.

Soon after, summer of 1958, we returned to the Blackfeet Reservation for our summer work. Adjacent to our cottage, the museum had an upstairs workroom for the Blackfeet Crafts group. Most afternoons, half a dozen or so older Blackfeet ladies sat at the long table, sewing moccasins or beading. I liked to bring my baby, napping in a basket, watch the craftswomen, and listen to their chatting. They saw me as a young mother without her women kin, and kindly advised me. I asked them about weaning. Like the Navajo women, these Blackfeet grandmothers were puzzled: What's to talk about? Yes, when children begin to stand and try to walk, they want to eat and drink too, like big people. Isn't it obvious? When does it happen? Oh, around a year old, when they stand and try to walk.

My own grandmother told me the same: babies wean themselves as they grow toward independence. I looked at a couple books about Freud. He stayed aloof from his children, lest his

scientific reasoning be biased by personal feelings. His famous analysis of "Little Hans," a young boy, came entirely from Hans's father's account of the child, and when by chance Freud passed them on the street and the father attempted to introduce Dr. Freud to the child, Freud refused. *What did my professor know?* Nothing but Freud's pseudoscientific theory, elaborate speculation. Like Freud, he imposed leading questions upon his subjects instead of quietly observing, listening, to what was really going on.

Was that when I became skeptical of theories? Was it, perhaps, the trigger arousing sensitivity between what I was taught and what I observed? Surely it came from growing up Jewish in a dominant Christian society, learning at home that most of the people around us were brainwashed into believing a fantasy that grossly distorted what our own people knew. Surely it followed from knowing my father was so wrong in believing that women should not be educated. He had been so tragically wrong in bowing to local authority in little Skippy's death. Now I saw that a famous anthropologist, chairman of the Anthropology Department of Harvard University, was wrong in choosing academic theory over respectful participant observation with the Navajo people he went to study. I became primed to be critical of anything and everything "authoritative" I would read about Indian people, in recent times or through archaeological research.

### Harvard and Us

Harvard's treatment of women has been called "benign neglect." "Benign"? They didn't kick or beat us? It was hardly benign when women students received no research opportunities, no efforts to find positions for them, no mentoring or personal friendships. For Tom and me, we did have J. O. Brew's friendship, partly deriving from Dog Sam charming the family during our first academic year in Cambridge. JO sincerely meant to help both of us, so far as he could, but his inferior position vis-à-vis the wealthy, socially upper-class other professors gave him no research projects or job placements to bestow.

Throughout our three semesters at Harvard, Tom and I were very careful to establish distinct identities. We were partners in fieldwork on the reservation, while in Cambridge our seminar papers demonstrated our separate research and theoretical interests. Anyone who knew us knew we were complementary, not leader-follower. Anyone who knew us . . . yet because Tom was working-class and I a woman, neither of us with any money, few of the professors knew us at all. Only J. O. Brew, low man on their totem pole, neither rich nor Brahmin class, advisor to all the women and the lower-class men, knew us as persons. JO meant well when he insisted I should do a dissertation in cultural anthropology, not archaeology, so everyone would accept that I, though a woman, had worked independent of my archaeologist husband. Yes, Tom should continue excavating the deep series of bison corrals in southwest Saskatchewan near the town of Gull Lake. That was the kind of research men do, penetrating deep into awaiting sites. I should do what women should do, talk with people.

Next on the agenda for our doctorates after the minimum semesters in residence were our dissertation proposals. Tom was now provincial archaeologist for Saskatchewan, so our research would be in that province. We chose two sites: the deep bison drive in southwest Saskatchewan and a fur trade post four hundred miles northeast. Tom would excavate the bison pound to obtain a sequence of artifact types in the province's deep history, and I would excavate the trading post to discover artifacts, both native and European, marking the time of contact with European history. Overlap between our projects was virtually nil. When we sat down with Prof. Brew, he nodded approval to Tom's proposal, the Gull Lake bison drive (fig. 7). Toward me, he shook his head. "Alice, you can't do yours in archaeology. Everyone will say that Tom did it for you. You must choose a topic in ethnography."

Shock! "But I'm an archaeologist! There's no way Tom could do two dissertations at the same time! We deliberately chose two sites, two topics, far apart in topic and in actual distance." Our professor looked sad. "Nevertheless, people will say Tom did both. You can

do ethnography. Harvard prepares you to work in all four fields of anthropology. Go back and find some topic in ethnography."

Three years we'd carefully made it clear that we were two professional archaeologists, each skilled and with distinct, if overlapping, research interests. All for naught, I was only Tom's wife. To be recognized as a professional, I was required to reinvent myself. I could not be a woman archaeologist.

Four years later the U.S. Congress would pass the Civil Rights Act forbidding discrimination on the basis of sex. It was the same year that I received my PhD in anthropology, earned by an ethnographic dissertation. Nothing changed for me.

Meanwhile Tom's Gull Lake bison drive archaeology proposal had been accepted, and we returned to Cambridge for his Generals oral exam. At that time Harvard anthropology graduate students sat for two oral examinations, first the Generals with five faculty members representing the four fields of anthropology plus the candidate's major professor. Then, when the dissertation proposal was accepted, there would be a Specials exam, in effect a defense of dissertation proposal, with the major professor and two others in that field. My Generals was held in early May on a beautiful spring day, everyone feeling sunny—I made a stupid mistake answering Professor Howells's question from biological anthropology and he just grinned, corrected me, and said, "Well, we know you know that answer." Benign neglect.

Tom had no such luck. When he was a boy, if he sat reading, his parents told him to go outside, play, do his chores. Reading was not for their class of farmers and factory workers. The list of one hundred required big books for Generals was formidable for him. It didn't occur to me to teach him the art of skim-reading that I had learned in Barnard. He sat for his Generals in late fall. I waited outside the closed doors of the conference room. Suddenly I heard loud voices, banging on a table. Then the door burst open. Four professors stormed out. Tom and J. O. Brew followed, JO very distraught, Tom stern-faced. The professor representing cultural anthropology had asked Tom a question about a book,

*African Systems of Kinship and Marriage,* on the long list of required reading for graduate students. Tom had replied that he hadn't read that book, because he was already employed as an archaeologist in a Canadian prairie province. He was prepared to answer questions about kinship and marriage among North American Indians, especially the Blackfoot with whom he had done fieldwork. The professor coldly told Tom that he didn't care about his job, that each candidate was required to know every one of the books on the list. They could reconvene the Generals exam after Tom had read the book. Tom said, coldly polite, that he would not read a book with no relevance to his work. Prof. Brew pleaded with Tom. Tom was stubborn. The men rose and stalked out.

Back in our flat, Tom and I discussed our future. Was it worth the time and expense to go through the Generals again? To kowtow to an arrogant Harvard professor who cared nothing for the student he hadn't bothered to know? We decided we were done with Harvard. *Done.* It was November 1960.

Technically, not quite done. We knew I had to get a PhD, not merely to establish myself as a professional but to make it possible for me to obtain professional employment. Bluntly, Tom's earning power wasn't affected by not completing a PhD; he was already in his second full-time job in his chosen field. I had no such record, only the summer assistantships at the museum in Browning. If I were to contribute to the family income, to support myself and children if something happened to Tom, I needed that degree, that "union card." Returned to Saskatchewan in 1961, I looked for an ethnographic project while Tom, as provincial archaeologist, continued excavating the Gull Lake bison drive, where the previous summer I had been assistant field director *and* (foolishly) cooked for the crew, seventeen people including us.

Now I shelved my planned excavation in the fur trade post, to be pursued after I had my PhD. Instead, I had to find a topic for a dissertation in ethnography. Nothing seemed suitable in Regina, where we lived. I put my little boy in the station wagon and drove to Prince Albert, at the edge of the northern forest, to

talk with Mabel Richards, a woman who knew many Indian people through assisting them in marketing their craftwork at fair trade prices. Mabel was a committed Socialist in the province still governed by the Socialist Cooperative Commonwealth Federation (CCF) party (later morphing into the national NDP, New Democrat Party, Canada's third major political party). Mabel's husband was a geologist, and traveling with him as he did fieldwork, she saw the poverty and exploitation of most Indians in the province. Stopping at the shop where she sold Indian crafts, I asked Mabel if she had any ideas I could pursue for my dissertation. Specifically, did she know anything about a wooden bowl in the museum in Regina that came from Prince Albert, said to be a feast bowl, or of a shirt said to have been worn by a Ghost Dance participant? No, she didn't know about either, never heard of any Ghost Dance, but, hey, why don't you come for dinner to the house? Her husband was out in the field; it would be just her and her kids. How kind, I was delighted.

Come evening, I parked in Mabel's driveway, on a large plot at the edge of Prince Albert. A tipi stood in the middle of the yard, amid rows and rows of vegetable garden. Out of the tipi came a middle-aged Indian couple, whom Mabel introduced as Joe and Florence Douquette, explaining that they cared for her garden and watched the property when she and the kids were away with her husband. She asked them whether they had any knowledge of a shirt worn for a Ghost Dance ceremony; they demurred, "no." After a pleasant supper in the house, I left with my sleepy little boy about nine o'clock. As I was about to get into the car, the Douquettes came up and told me that they did, in fact, know about the Ghost Dance; that it was the religion of the neighboring Indian reserve that Florence belonged to; that it was kept secret but they had phoned her brother on the reserve and the family agreed it would be suitable to reciprocate Mabel's kindness to Joe and Florence, by divulging this information to Mabel's friend. If I would drive out with them to the reserve, the congregation's leader, Henry Two Bear, would tell me more.

Henry Two Bear—that was the name with the wooden feast bowl given to the Saskatchewan Museum. I was really excited. Florence sat in the backseat beside the sleeping child, Joe sat beside me, and I drove out, across the Saskatchewan River bridge, through jackpine forest on a dirt road, into a small village of log cabins. Buckboard wagons were parked alongside, like in the nineteenth-century early days of reservations. We went into one of the cabins.

Mr. Two Bear, a tall elderly man with braids, stood at a small table with a kerosene lantern—no electricity on the reserve. Florence's brother Robert Goodvoice sat at the table, ready to translate. The men welcomed me, graciously motioned me to sit at the table. Mr. Two Bear began to recite, in Dakota, what Robert explained was a short version of the gospel of the Ghost Dance religion. I wrote as fast as I could in my notebook, noticing as I did that Mr. Goodvoice was aptly named, his English was more than fluent, it had nuances and style. (The name was that of the family forebear listed in the first census of the Dakota band that settled in the locality.) It took two hours for the recitation and translation. When it was completed, I thanked Mr. Two Bear and Robert, drove the Douquettes back to Mabel's property, and then went on to the city campground where I camped. I had an exciting, significant dissertation topic. No one had known that the Ghost Dance religion had been carried into Saskatchewan and was still alive in 1961.

By the way, the Douquettes were, in effect, homeless that summer. Mabel connived to give them camping space and at the same time, preserve their dignity with the request to help her with the garden. Joe, like most Indian men at the time, worked summers as a day laborer on farms, camping with Florence near the farm. Following World War II, Saskatchewan farmers mechanized, eliminating the need for so many seasonal laborers. For the few jobs left, farmers (all white) hired young men, leaving older men like Joe without employment. Joe and Florence could have camped on her reserve, but although it was a short drive by car, they had no vehicle, could get to Prince Albert only by walking nine miles

or hitching a ride on a wagon if anyone was going. Or they could have gone to Joe's reserve, Mistawasis, a Cree reserve a distance northwest. But Joe was active in the Prince Albert Indian community, working with youths and endeavoring to assist other Indian people in need. Mabel, knowing this, made it possible for him and Florence to continue that good work. Years later, the alternate high school in Saskatoon, mainly serving Indian youth, was named Joe Duquette High School. A 1997 book about the school is titled *Making the Spirit Dance Within*.

Researching my Harvard dissertation involved driving to a variety of Indian reserves in Saskatchewan, camping in the station wagon with my three-year-old and the next year, a baby too, and introducing myself to local people. Everywhere, I was met with kindness. Some years later Robert Goodvoice told me that because I was a young mother in jeans, with my little kids, it was clear that I wasn't from an agency nor a government official. Other Indian people mentioned this too. Older people were pleased that I was interested in their beliefs, showed them respect, listened. They saw my visits as a teaching opportunity, to help this young woman, this young mother, understand core values. A memorable moment was Robert Goodvoice pointing out his window, "See those rhubarb plants? Every year they grow back, giving us food. *That* is the Almighty Power." So succinctly, and indelibly, he conveyed a Dakota understanding of the universe as fundamental vitality. So succinctly he imbued a gratitude for life. Today I treasure a rhubarb plant in the corner of my garden.

The question I posed in my dissertation (you couldn't just report what you found) was why only this one small community had preserved the Ghost Dance religion so long after its supposed demise in the Wounded Knee Massacre of December 1890. It hadn't spread throughout Saskatchewan, probably because the majority of Indian people in the province are Cree, a northern series of communities speaking dialects of an Algonkian language, and although they had been forced to accept Christian missions when they signed treaties in the late nineteenth and the twenti-

eth centuries, most retained their traditional religion. Saskatch-
ewan Dakota, including those in Sioux Wahpeton, Two Bear's
village, in contrast were refugees from the Minnesota Indian War
of 1862—displaced people. Years after they fled across the bor-
der, Canada reluctantly gave them small reserves but no welfare
services. Scattered among Cree, their young people intermarried
as had Florence Goodvoice to Joe Douquette, and their children
grew up with Cree. Some other Dakota communities in Canada
preserved their own heritage alongside mission Christianity, but
at Sioux Wahpeton, residents responded to the Ghost Dance gos-
pel message brought to them by an Assiniboin, Henry Robinson.
Robinson had been proselytized by Kicking Bear, a disciple of the
Ghost Dance prophet Wovoka. A photograph of Robinson hung
on the wall of Henry Two Bear's cabin. Wovoka's message, "Live
a clean, honest life," strive to live peaceably with everyone, took
root in that community.

To better understand the circumstances of the Sioux Wahpe-
ton community, for comparison I camped among Crees in west-
ern Saskatchewan, around Battleford. Poundmaker and Little Pine
Reserves were home to their spiritual leader, known by his Cree
name Piakwutch, and his daughter Winona Frank, equally well
known for her doctoring with medicinal plants. Mrs. Frank told
me she learned her medical practice from her grandmother; her
father did spiritual healing. Why, I wondered, did she not follow
her father into spiritual healing, or for that matter, why did he
not follow *his* mother into plant doctoring? She explained, "My
father apprenticed to a healer, living at his home. My father would
see that our family had wood and food, then be away for a cou-
ple weeks at a time. I could not leave my children like that. My
grandmother took me to gather plants for a few hours at a time,
in between family chores." To my feminist ears, that sounded sex-
ist, yet I saw that Mrs. Frank was deeply respected as a doctor, in
addition to her admired skills at tanning and sewing hides. She
and her father were more a complementary duo than superior
and inferior.

Piakwutch lived alone in a cabin set in a wide, lovely meadow beside the Battle River. His son and family lived nearby, caring for his needs. Every morning when we awoke, camping at the edge of the meadow, we saw Piakwutch standing in front of his cabin, facing the rising sun in the east. He would stand thus for a couple of hours, absorbing the warmth and, he told me, the waxing power of the Almighty streaming from the sun. During the night, he said, sorcerers might send evil toward him, against him personally to cripple his healing power, or against a patient he was working with. His soul fought these evil forces, ending the night exhausted; the sun replenished his strength. This man's deep quiet, his sparse simple life devoted to his people, strongly impressed me. A few years later I was in the area and drove over to say hello. To my surprise, ragged dirty children were running around the cabin. A disheveled, stick-thin woman came out. I entered the cabin and saw Piakwutch sitting on a chair, still. Worried and confused, I drove over to his son's home. They told me that the woman was an outcast, promiscuous and irresponsible. No one would take her in. No one but Piakwutch. "Great soul" came into my mind; yes, he was like Gandhi, a great soul so immensely compassionate.

Two summers visiting reserves, and winters in Regina researching in archives and talking with Indian people in the city, sufficed for my dissertation. I typed up and mailed a draft to Prof. Brew and to my new dissertation chairman who did ethnography in Guatemala with Maya Indian villagers. Very much to my surprise, the chairman replied that the manuscript was fine, no revisions needed, just get the five copies typed up, mailed in, and my degree would be granted. Fine? As it was? A mere 114 pages? Either I was a genius or, no question but this was more probable, benign neglect kicked in again. The three committee members could sign off on what I sent, and Harvard would be finished with me. Another woman, another lower-class person working in an unimportant research area (North American Indians) out of the way.

## Academia

Universities in 1964, when I received my PhD, were still on the surge of expansions triggered by the GI Bill influx of veterans like Tom who had never expected to go to college but, as Tom told me, figured sitting on a campus drinking beer and ogling girls was better than going to work. That wasn't true of Tom, and I suspect not of the majority of postwar students; it sounded smart to their working-class families and old buddies. Tom had good grades in high school and was put on the academic track of college preparation. His mother, by then divorced, needed to sign her agreement to this placement. She looked disapprovingly and told her son, "We're working class. We don't go to college. Tell them you'll study draftsmanship. That's a clean white-collar job." Tom's mother may have been more class-conscious because she was born in a Manchester slum in England, immigrating with her family as a child to Janesville, Wisconsin, a manufacturing town in the midst of farms. They lived an hour's drive from the great land-grant University of Wisconsin, famous for dedication to extending higher education to every Wisconsin resident; never mind, his mother's rare trips to Madison revealed to her a town of well-dressed middle-class professional and businesspeople, not her kind.

Tom should have graduated from high school in 1944, along with his best buddies in the Janesville Boy Scout troop that specialized in practicing American Indian crafts and powwow dancing. His first schooling had been in a one-room school in the

farm country outside Janesville, and when his father obtained a
factory job in the big Chevrolet plant in town and they moved
from the rented farm, the city school had him repeat first grade,
claiming the country school had been inadequate. He was small,
too. Quite possibly that repeated year in first grade saved his life,
because boys were being drafted into the armed forces right out
of high school during World War II, and he could have been sent
into battle in 1944. Instead, he was drafted in June 1945, a month
after Germany surrendered. He was sent there with the Occu-
pation and assigned to driving the mail jeep at the base. Mus-
tered out after a year and a half, he decided to go to college; on
the advice of a schoolteacher aunt, he enrolled in Beloit College,
in the town where his mother commuted to her clerical job in a
factory. Beloit, an excellent liberal arts college, offered an anthro-
pology major, unusual in the late 1940s. American Indians—like
his Boy Scout troop. Tom signed up, and with the caring faculty
of the small college, did well and went on to the graduate pro-
gram in anthropology at the University of Washington in Seattle,
paying with the five hundred dollars left him by his grandfather
and his savings from part-time jobs. Summers, he worked on the
archaeological crews of the Smithsonian's River Basin Surveys,
salvaging what could be excavated from precontact and early his-
toric First Nations villages along the Missouri River. When he had
completed course work for his MA at Washington, he applied for
the archaeological survey project on the Blackfeet Reservation,
housed in the Museum of the Plains Indian. For two years there,
he was mentored by the museum's director, taught how to work
with Indian elders to garner their knowledge, and guided through
preparing a master's thesis from reservation archaeology.

Put in charge of the museum when his mentor left for medical
treatment, Tom decided he could and should marry. This was still
the postwar Eisenhower era when young women were encour-
aged to marry at nineteen, and men in their midtwenties. Cohab-
itation without marriage was shameful. Tom had a job, was near
to completing an advanced degree, and in the reservation town

he was lonely. He devised the scheme of inviting applications for the summer museum position from women anthropology majors. The first year, the successful applicant arrived with her bridegroom. The second year, he chose me from the half-dozen applications; I was nice-looking, young, experienced in archaeology and museum work, and as it turned out, quickly came to love the mountains and High Plains, as he did. We were together all day every day; with nothing else to do on days off, he made clear his interest in me, and I, already about to turn twenty-two, warned by my sister that I would be an old maid, was ready to fall in love with this intelligent, healthy man in my chosen profession. Whether Tom fell in love with me, I shall never know. At the time, thirty-five years later, that we were divorcing, he declared to me that he had never loved me.

Love wasn't something we talked about. My parents never used that word with each other, in our hearing at least, nor embraced. Tom's parents divorced when he was thirteen, and through high school he lived with his mother who doted upon him. I didn't expect expressions of love outside the bedroom, or for that matter, inside it, who needs words to enjoy sex? Dog Sam was the one who expressed love freely and often. Our days were filled with work that was often interesting, and my off-work hours with cooking, housework, and within a year, baby care. In the summers, Tom managed an excavation of a bison drive corral near Browning, and I assisted. For two winters we were in Cambridge for graduate study. We had good friends there; Tom had classmates who had been with him at Beloit or the University of Washington, and I had Dena from Barnard. Our group had no family monies, no prep school sports, only determination to do well in our chosen profession in spite of lacking the funds and social ties that Harvard's preferred students called upon. We disliked Harvard's elitist attitude, but we and our friends could largely ignore it. We were challenged and happy.

Much as we loved the Rockies and plains, Glacier Park and the reservation, Tom and I did not see ourselves remaining there. The

museum director, a rather reclusive scholar, would be resuming his position. Tom applied for an advertised position as provincial archaeologist for Saskatchewan, the middle one of Canada's three Prairie Provinces. At the annual meeting of the Society for American Archaeology that year, 1959, he was at a urinal in the men's room when the man at the next one noticed his name tag and asked, "Are you the man who's applied for the Saskatchewan position?" Tom nodded, and there in the men's room the older man, the archaeologist at the National Museum of Canada, quizzed him on his experience and why he wanted to work in Saskatchewan. His questioner had been delegated to interview applicants and recommend the best to the provincial government. The men's room conversation went well, and Tom got the job.

We moved to Regina in October 1959. For the first month we lived in a tent in the park beside the Saskatchewan Museum, for housing was scarce. Then we got a ticky-tacky postwar little house on the edge of the city, the last street with city water supply. People from the next block came to ours to get water from a pump. A few months later the secretary to the Saskatchewan Museum director told Tom that her friend was moving away and we could rent a decent house close to the downtown museum if we went to the landlord with her friend when she gave notice of moving. We did, he agreed to rent to us, and though the house was old, with the only bathroom next to the kitchen, the sole input pipe serving both, it was ample for us. Tom studied the geography of the province, talked with avocational archaeologists, and devised a plan to conduct excavations in several regions, to build a base of archaeological data from the province's past. The Gull Lake bison drive site in the southwest of the province would be a major component of that plan. My ethnographic dissertation research, 1961–62, did not fit, but our discussion of the necessity of my getting a PhD in order to earn money in our field, made completing my degree a priority over participating in archaeological fieldwork. After a couple of years we were able to purchase a solid, handsome family home across the street from the

museum. Our second son was born in Regina. I became friends with two neighbors, a geologist's wife who herself had an MA in that field, and a Japanese Canadian woman, each with two children near my children's ages. Life looked good.

Then politics exploded. Saskatchewan was governed by the CCF, an agrarian Socialist party formed during the Great Depression. Its programs attracted many idealistic, dedicated leftist civil servants. With our own families' Socialist preferences (my grandparents were Social Democrats, Tom's maternal grandparents from Manchester leaned Socialist), Tom and I enjoyed socializing with the many CCFers in the museum and neighborhood. The province introduced universal automobile insurance: when you bought your annual car license, it included a few dollars that covered basic liability and collision insurance. A real saving, and so convenient. Then, following an election in which the major issue was creating a universal medical care plan for the province, passed by the voters, at the end of 1961 the CCF universal health plan was implemented. Doctors in the province determined to force it out. One day I picked up the telephone to hear Joyce, the museum geologist's wife who had befriended us when we moved to Regina, tell me that the pediatrician her family used, whom I took my boys to on her recommendation, had refused to give her kids their scheduled checkups and instead had tried to bully her to say she'd support retracting the CCF plan. Joyce warned, with tears in her voice, that I should not visit that doctor with my children.

In July 1962, doctors in Saskatchewan went on strike. Only hospital emergency rooms were staffed. Citizens were in a state of shock. We realized that backing the Saskatchewan strike was the American Medical Association, fighting against following European nations' provisions of health care to their residents. The American Medical Association (AMA) called upon the Liberal Party, the CCF's opposing, conservative party, to call a new election (Canada has a parliamentary system). Television, billboards, and pamphlets bombarded us with propaganda against the CCF and

universal health insurance. We all knew friends, neighbors, family members who had been denied medical care during that July, or even before the actual strike, as with our pediatrician. Stress lay upon us, and Tom seemed to become ill. He sat hunched into a chair, brooding, and there was a peculiar odor about him. In hindsight I think it was diabetes triggered by the stress of the volatile atmosphere all about us, all the arguments, anger, distrust. Late in the month, the CCF set up neighborhood clinics and brought in young medical graduates from Edinburgh University, the best medical school in the world. I tried to get Tom to go to the clinic at the end of our block, but he refused, irritably. I went myself to talk to the new Scottish doctor. He confirmed that the mood and odor could be signals of mental distress and urged that we try to pinpoint some triggers and avoid them—for example, the erratic commands of the director of the Saskatchewan Museum. I spoke with our friend, the director's secretary, and she began holding back some of the crazy memos. That really helped, and so did the end of the doctors' strike when the Liberals succeeded in demanding an election.

The 1964 provincial election defeated the CCF, although its provincial health-care plan continued by popular demand. Many civil servants and academics left Saskatchewan. Both Tom and I were hit by Liberal Party power. The provincial heritage program that had created the provincial archaeologist position was gutted, and Tom was ordered to stay the whole workweek in his museum office to identify whatever collectors might bring in. Fieldwork projects would not be funded. I was affected when my opportunity to teach in the University of Regina was rescinded: the historian who had headed its humanities and social sciences programs was a CCFer who had fled to Alberta, and his successor, a sociologist from Texas, told all us untenured faculty, "None of you will ever teach in this province again. You were all hired by that CCFer, and you're out." My expectation of building an anthropology program in Regina was dashed, after I had taught only one course, to an appreciative and interested dozen students. Until the elec-

tion, we were planting roots in Saskatchewan, in fieldwork (fig. 8) and in opportunities to learn both from the diversity of people in the province and on trips (fig. 9). Then suddenly in 1964 our future in Saskatchewan was bleak. We had to leave.

### Back into the United States

In the mid-1960s there were, briefly, more jobs for anthropologists than candidates with PhDs. Tom chose the position of director of the Nebraska State Historical Society Museum, Lincoln. Lincoln was also headquarters for the federal River Basin Surveys archaeological projects, with its staff, and of course the land-grant University of Nebraska. With two young boys, I hoped to teach part-time there. Hardly had we moved, when the Anthropology Department chairman telephoned, offering full-time teaching, three courses in a semester. When I demurred on account of the children, he assured me I could, if I wished, teach the three courses back-to-back to minimize time away from the home. After one semester part-time, I found Miss Daisy Goldberry, a retired seamstress looking for some supplement to her pension, to babysit my younger boy while I was teaching, and moved to full-time, three days per week—more pay for not much more work time, and one of the courses was with grad students (Nebraska gave an MA in anthropology at that time). Several of them were bright and eager to explore the discipline, making the course meetings lively fun. These students went on to good careers in anthropology and archaeology, continuing as friends and colleagues to the present, now retired themselves.

Teaching in the Anthropology Department at Nebraska, 1965–68, was a good introduction to the often brutal world of academia. The department chair acted macho, keeping his office door open and bursting out into the reception area whenever he saw his faculty members talking together. Glaring suspiciously, he muscled in between us, forcing us apart and usually causing us to go back to our offices or classroom. In his office he had piles of papers and offprints and books and journals on all surfaces, yet never seemed

to be working on anything, nor did he publish. He bicycled to work, a very long white silk aviator's scarf blowing behind him. A dedicated secretary managed the department, the common situation in those days when intelligent women could not rise above secretarial status. Recently some of his prewar archaeology has been published, and its excellence prompts me to suspect that this man, a veteran of the war, may have suffered PTSD effects. No such term existed in the 1960s; I only knew that he did nothing but harass faculty and students alike, leered at women, and for three years refused to give me a written contract for my teaching. Each year my paycheck showed less money than he had verbally promised. After three years Tom and I were fed up with the hot, humid climate, the conservative Christian-dominated politics of Nebraska (what a contrast to Socialist Saskatchewan), and both our bosses. Tom had to answer to the head of the Nebraska Historical Society, who sent him off on weekends to celebrate setting Pony Express monuments in small towns and had no interest in any archaeology that didn't Make Nebraska Great.

The break for Tom came in fall of 1967. He was so fed up, and so irritated by a janitor's sloppy work, that he punched the man. I was teaching and was called out of the classroom to take an emergency phone call: the historian at the Nebraska Historical Society Museum, who had become a good friend, told me Tom was about to be fired. On the phone our friend described the incident, so I would know the actual situation. That night we decided that we would leave Nebraska at the end of the academic year, spring 1968, and depend on my income for the remaining months. Tom would work at home on writing a full report on the Boarding School bison drive site near Browning that we had excavated and analyzed in 1957–59, summers during our graduate study at Harvard and while Tom ran the Museum of the Plains Indian. A professional journal, the *Plains Anthropologist*, would publish the report as a memoir. Since Tom would be at home, no need for a babysitter. I did pay a farm woman to clean once a week, bringing her little boy along to play with my second boy. By this time

we had a third child, born the previous July, whom I nursed at noon between classes on my three teaching days. On the two of my teaching days that Thelma didn't come in, I would find the toilet full of unflushed diapers; Tom would go so far as to change his third son's diaper, but only to drop it into the toilet for Mommy to flush and put into the diaper service pail.

In the spring of 1968 there was a social gathering of Lincoln archaeologists. Tom maybe got a little drunk—he didn't drink much then—and my department chairman more than a little. Tom backed him into a corner and demanded, "When are you going to give Alice a contract?" My boss replied, "Never! I will never put a woman on tenure track!" That did it: we would leave Lincoln, not regretfully but rejoicing to go. It so happened that, with jobs still available generally in anthropology, all five of the Anthropology Department's faculty other than the chairman, resigned that spring. University administration investigated and removed the chairman for incompetence.

Fortunately for Tom, who had been letting our friends know he was looking for a new job, a Beloit classmate who was also at Harvard with us telephoned to say that he was resigning his job at Milwaukee Public Museum, and if Tom was living in the city of Milwaukee when the position would be opened for applicants, the combination of city residence plus veterans' points, and Tom's solid experience, would likely guarantee him the job. Tom's dream job! At one of the finest anthropology museums in the world, in the beautiful city of Milwaukee on the Great Lake, so admired by everyone in Janesville. I was delighted too, knowing something of the city, its climate to my taste, its reputation of a clean, friendly, Socialist town. We would be close to Tom's family, our children would know their roots there, and I had his aunts, their daughters, and his father's second wife for my womenfolk.

The wife of our classmate who was leaving would be staying in Milwaukee. She was already my friend from not only seeing her in Cambridge but for two summers in Glacier Park where her husband worked as a seasonal ranger. We had picked berries

together, picnicked together with our menfolk, and since she her-
self was a Beloit college anthropology major, she was a real com-
panion to me. She advised us on moving to Milwaukee, where to
look for a house (her neighborhood adjacent to the lake), where to
shop, a dentist, a family doctor. Most critically, in our job search
when I found Marquette University in Milwaukee was hiring an
anthropologist and applied, she met me at the airport the morn-
ing I flew in from Nebraska for an interview. She kept the baby
outside while I sat in succession with the department chairman,
the liberal arts dean, and the graduate school dean. Of course I
was nervous about being a married woman with kids, applying to
a Jesuit university no less, but the graduate dean, a layman, put
that fear away when he asked how many children I had, and when
I answered, three, he laughed and said, "That's all? My wife has
thirteen!" I aced the interviews as nicely as I had my grad school
exams. Tom did not actually have any job when we moved to Mil-
waukee in August, so we needed the security of an income from
my new position.

Tom did get the Milwaukee Public Museum job as assistant
curator of archaeology. It gave him opportunity to supervise sev-
eral major new exhibits and to carry out fieldwork. After a few
years he was offered promotion but refused because it would put
him on the managerial level, no longer in the AFSCME union
(national union of federal, state, county, and municipal employ-
ees). Son of a factory worker, he feared losing that protection.
Refusing the promotion meant refusing a salary increase. This we
had to discuss. Tom told me that besides the union protection,
remaining at the lower level would keep him free of any admin-
istrative chores and let him spend his time on research. Research
is so much more important than mundane duties. Yes, I certainly
agreed on that. End of discussion.

Yes, I agreed that research is more important than mundane
duties—yet I continued doing all the mundane duties, keeping
house, teaching more than two hundred students each semester
in three courses, without any teaching assistant. We had agreed

that my salary would be our principal income, as I fulfilled all the tasks Marquette assigned me. In 1980 my department chairman had me promoted to full professor so that I could vote as a liberal voice in department and college deliberations. "Diversity" was beginning to be a slogan, and with me, the Jesuit university got in one person a woman, a mother, a Jew, a liberal, and an anthropologist. Rank of full professor did not bring much in the way of salary increase; when I retired, I calculated that I had been paid nearly 30 percent less than a man with my years in rank and a good publication record. Which translates to a smaller pension too.

Why did I not rebel? Why did I not demand fair compensation at work, fair sharing of household tasks at home? At Marquette the women faculty met several times each year, especially in the 1980s, to share experiences, consider remedies, and console each other. Most of the women were single, and if married, childless. Scholarly careers really mattered to them. We formed delegations to speak with administration about better recognition of women, offering women's studies courses and facilitating women's research. One dean of the liberal arts college listened to us. He was a Jesuit, yet he listened intently to us. To our surprise, he said he would sign for a program in women's studies if we brought one to him. We did, and he did. He also spoke up for Black students, whom he saw shunned on campus (except for the varsity basketball stars). A handful of politically liberal students organized a rally against racism, and this dean made sure that he, in Jesuit black with collar, could be seen with the leaders. What happened? The university trumped up a charge that someone had found a plagiarized paragraph in his dissertation and he must be dismissed. The charge was ridiculous; the dean was fired. Marquette settled back into its politically conservative patriarchal comfort zone.

That same time-honored, solidly structured patriarchy surrounded me off campus. Tom's self-centered insensitivity to the burdens I carried was normal for a man of our generation, as for my father's. For me, the difference between my father's harsh put-

down of women's and children's feelings and Tom's mere insensitivity was considerable. Tom did not deny me the time I found to work as an anthropologist. He accepted me as a field collaborator, he made no hindrance to recognition for my professional work. At conferences he stood with me as partner. That he benefitted enormously from my contributions to our income, our home, our research, and our family fit society's norms in our generation.

## Academia in Milwaukee

The thirty-one years I served at Marquette were a matter of making the best with what I could get. University of Wisconsin–Milwaukee's Anthropology Department never had any interest in me. Its campus is only a few blocks from my home and for that reason, plus the support one could get from a relatively large department offering the PhD in anthropology, made me wish I could teach there instead of five miles downtown. I did attend public lectures at UWM and social gatherings of anthropologists, initially friendly but as the market for academic jobs in anthropology dropped and dropped and the profession narrowed to niches in research instead of a broad anthropological perspective—my standpoint—I became less and less welcome. In 2016 at a small UWM conference on campus that had American Indians as its theme, when I tried to comment on a speaker's presentation, one of the UWM anthropologists ran to me, knocked the microphone out of my hand, and with her two hands on my shoulders, pushed me down into my seat, hissing "Shut up!" A misdemeanor assault, legally. A few of the anthropologists at UWM have been staunch friends, off campus, and I witness their frustrations.

Marquette had added anthropology to its Sociology Department a couple years before 1968, intending to build a program by hiring additional anthropologists until there were five, considered the minimum number needed for an anthropology undergraduate program. In 1968 the first anthropologist was dismissed when it was learned he was gay. That meant that two anthropologists would be hired in 1968. Then the archaeologist resigned to

take a better position in Chicago. He was an old friend of Tom's, from their teen years as Eagle Scouts helping at the state fair. He phoned me to tell me his position, as associate professor, would be vacant and I should insist on being hired at that rank, not the entry level. The job market still being favorable for anthropologists (it began dropping the following year), the university would accept that to keep me. Thus, I began Marquette as associate professor, came up for tenure in two years rather than six, and in a job market still favoring me, not the university, was granted tenure.

Two other anthropologists were hired that year with me. The three of us constituted Marquette's anthropology major faculty, all three of us new. The other two were men, one with a just-completed PhD from the University of Minnesota, the other ABD (All But Dissertation, no PhD yet) but had been teaching for seven years at UWM. That school let him go because seven years without completing his dissertation and earning the required degree meant automatic dismissal. Neither man had anything like my experience and publications, yet both lorded it over me, as men. Both told students that I was soft, not a real professional, just a wife of a professional. The sociologists who were the majority in our joint department shared that view of me. Eventually, the two men hired with me were induced to take early retirement, having done no research nor other professional activities. I replaced one with an excellent cultural anthropologist already a colleague, but he left after a few years because the administration sneered at his work. The second hire quickly saw who buttered his bread and brown-nosed the sociologists while advising students to avoid my courses.

To put it bluntly, neither at work nor at home was I shown respect by my peers. That was the experience of all the women my age in anthropology, and within the profession, of Margaret Mead too. Jane Goodall was touted in the media as the Girl Who Lives with Chimpanzees, sent to the jungle by the renowned (male) Louis Leakey. Leakey himself had a marriage like mine and Tom's; his (second) wife Mary collaborated in the fieldwork but, in her

case, had to tolerate his affairs with young women. Presumably, living in Africa, she had household help. As long as I lived with Tom, I, like Mary Leakey, had access to fieldwork. Our husbands got grants, and they didn't begrudge us publishing as coauthors. It would be futile to fight openly at Marquette against the men, or at home with Tom over housework, or at meetings against other archaeologists. No way to change the milieu I was born into.

If all you get at work are lemons, you can drink lemonade. My students at Marquette sweetened my lemonade. Most Marquette undergrads came from politically conservative Catholic families. Anthropology was outside the conservative package of courses; Marquette added it only to be competitive in the student market in the 1960s. Our Introductory Anthropology course drew a good number of students because it could fulfill a core curriculum requirement, and my section, offered conveniently in late morning, was largest. Students who went on to the other anthropology courses were mostly more liberal-thinking and often disgruntled by the narrow thinking of some faculty and many students. These "outliers" among the undergrads responded to my conviction that a very broad exposure to other cultures and an understanding of our biological nature and evolution are necessary for an intelligent human life. The Gender Cross-culturally course I taught for my last fifteen years at Marquette evoked exciting discussions, strengthening many young people endeavoring to break out of conventional straitjackets. Walking the path to deeper understanding with bright young people was truly a pleasure. A surprising number became archaeologists or anthropologists and have kept in touch; others make contact later in life, to tell me that my teaching influenced their life choices and inspired them to projects such as leading a fight to preserve and protect a wildlife habitat. With no grad students at Marquette, no funded program to bind them, my legacy is not a discrete line of research but inspiration to pursue anthropological principles toward greater understanding of humankind. This led one of my students, Alex Barker, to the highest position in American anthropology, the

presidency of the American Anthropological Association. After he was given the gavel, he stepped off the dais and hugged me in a bear hug. How sweet my lemonade!

The end to my teaching position came suddenly, like a mugging. A phone call in 1999 called me to the academic vice president's office. He was the sociologist who had been chairman of our joint department for several years. He was the one who got me promoted to full professor in order to get a token liberal, woman's, non-Catholic vote in committee hearings. Now he told me to resign. Was I hearing him right? Resign? It didn't make sense. My student evaluations were very good, I had three books out in less than two years (one an edited book delayed for several years). Yes, resign. At the conclusion of this semester in May. The department was going to be restructured to be a purely sociology department. Anthropology, social work, and criminology would go. I must resign.

Back in the office I shared with the social work director, we were both reeling. Now she understood why Marquette had refused to give her the temporary work-study student and printout money to prepare the dossier to recertify her bachelor in social work program. Carolyn, like me, was well published, like me she had a textbook that had gone into several editions, like me she had offices in professional organizations. Her strong commitment to humanitarian concerns inspired her students. How could it be that the university would, in effect, fire two of its top performers? Two of the only four women who were full professors in the entire university?

Besides us two women, the directive included the professor of criminology in our joint department. He was a man, and like Carolyn in his fifties, vigorous, leading a program he had originated and developed very successfully. Besides his masculinity, he had one advantage we women lacked: his criminology major had more students in it than any other major in the university. Hundreds. Most of them saw themselves as the hero of forensic crime dramas. Richard worked hard to disillusion them, advised

them to take pre-law or political science, without much effect. Richard determined to fight the directive, fight the guy from our joint department who was betraying all we had worked for. He finally succeeded, backed by the sheer numbers of his students. Carolyn used her training in conflict mediation to argue for continuation of social work, surely important in a Christian community? Bad line there, conservatives noticed that she didn't preach against abortion. She hated fighting; she gave in and resigned. And soon was offered a much better position as dean of a graduate program in social work at one of the Wisconsin state universities. If social work was being tossed out, could I possibly persuade the academic vice president to keep anthropology?

In the academic vice president's office again, I pointed out that I would be sixty-four the following academic year and was pondering retiring at sixty-five. Teaching one semester, taking the other semester off, for a couple years to ease the transition to my successor, was my plan. The VP shook his head. Retire now. My students? What would happen to our majors? Anthropology would become a program within a sociology bachelor's degree. Resign. My salary? Resign. I'm tenured! Resign. Several meetings like this, I realized that the university could legitimately fire tenured faculty if their program was being radically restructured. All I could do would be negotiate a salary. That brought me one year's pay and continuation of medical insurance. In June I turned in my resignation.

Now the story really twists. Happening to see the senior sociologist in the supermarket, I suffered his beaming face describing how the department was now all sociology. A couple weeks later, come July and the new fiscal year, the president of Marquette, a Jesuit, announced that after two years in the office, he had developed his own policy and would be relying on his own "team." The academic vice president position would become a provost and the incumbent VP would leave; he would not be considered for any administrative position. The president would not approve the changes in the joint Sociology, Anthropology, Social Work,

Criminology Department. Too late for me, I figured; I had a better deal with a year's salary until I turned sixty-five and started my pension with no obligations to Marquette. It did please me that my successor, a married woman archaeologist (Jane) with an archaeologist husband and, soon, children, would keep her job, at least until her tenure bid the next year. That year Jane led a delegation of junior department members, the others all sociologists, to the new liberal arts dean, to protest the rule of the two senior sociologists who had engineered the scheme to purge the department. Jane spoke for the group. When her dossier for tenure landed on the dean's desk, he approved it, noting how impressed he had been by her leadership. The deposed academic vice president, though apparently still on payroll, was seldom seen on campus.

The senior sociologists who had devised the coup were still heading my former department. Normally, a full professor such as I, with a strong list of research publications and offices in professional organizations, would upon retirement be named professor emeritus. Marquette required department chairpersons to prepare a brief dossier on retirees who deserved the honor, submitting it as a promotion proposal. The department did not do so. My friends in other departments began asking why I was not titled "emeritus," telling administrators that it was shameful to disregard me. Finally, the political science professor who had been one of the protestors was fishing on a Saturday with a high-placed Jesuit friend and convinced him that the neglect was an embarrassment to Marquette. After five years I was named professor emeritus.

Academic shenanigans. Eyes fixated on "power," tiny power plays by people who, like it or not, are way out on the fringe of real players in American society. To be thrown out was a relief. I had enough pension to live on and no longer had to interrupt my work to go teach. I had been divorced from Tom for seven years. My mother, in her nineties, was now sharing my house. In the next chapter, I go back to my life outside my job.

## Postscript

Kicked out of Marquette by the sociologists' purge, I was told, in writing, that I had no reason to be on campus, I no longer could use its postal mail, email, telephone, photocopying, or staff services. All right, I had another email account, home telephone, home mailbox. Then, only weeks after I was cut, my telephone rang: the National Endowment for the Humanities, NEH, had selected my application for a Summer Institute for Teachers, submitted earlier that year. Mark Thiel, archivist for Marquette Library's American Indian collections, and I had proposed a monthlong project for social studies teachers to enrich their knowledge of American Indians and assist them in preparing curricula to teach about Indians. I told the Smithsonian to address all mail about the project to Mark at the archives and phoned Marquette's Office of Research Support, whose staff had guided us in preparing the proposal. When I told the office head that the proposal had been successful, and that Mark would be the campus person they would work with, and why, he began laughing. Laughed and laughed. At last he managed to say, "So archives, not your former department, will be getting the overhead that comes with the funding! Seven thousand dollars! Your NEH grant is the largest that Marquette has ever received in the humanities."

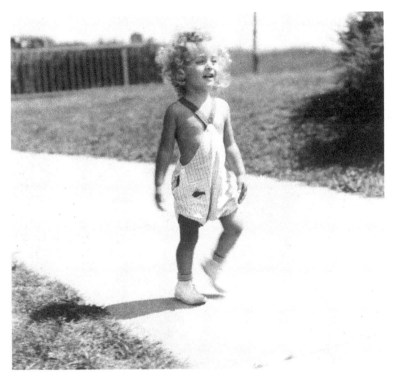

FIG. 1. Age 3, 1937.
Courtesy A. B. Kehoe.

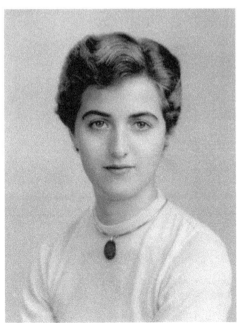

FIG. 2. High school
graduation, 1952.
Courtesy A. B. Kehoe.

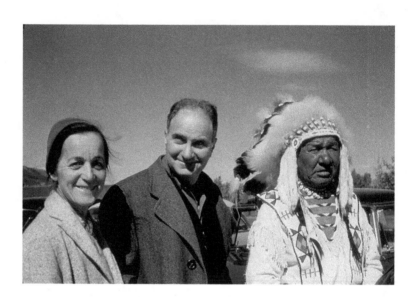

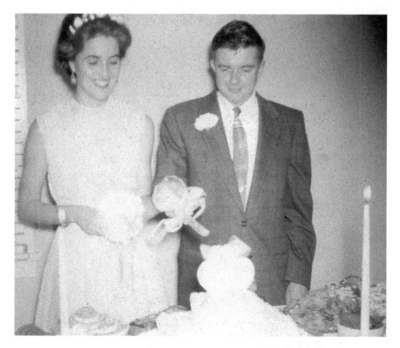

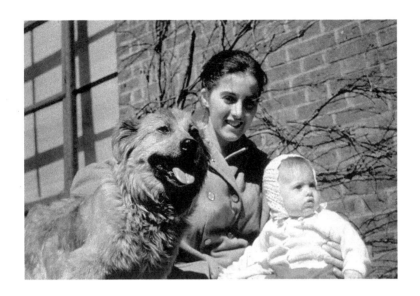

FIG. 3. (*opposite top*) Patty (Lena) and
Roman Beck, Alice's parents, with Blackfeet
man posing for photos, 1956, during week in
Montana for wedding. Courtesy A. B. Kehoe.

FIG. 4. (*opposite bottom*) Wedding, Alice
and Tom, 1956. Courtesy A. B. Kehoe.

FIG. 5. (*above*) With Dog Sam and first baby,
at Harvard, 1958. Courtesy T. F. Kehoe.

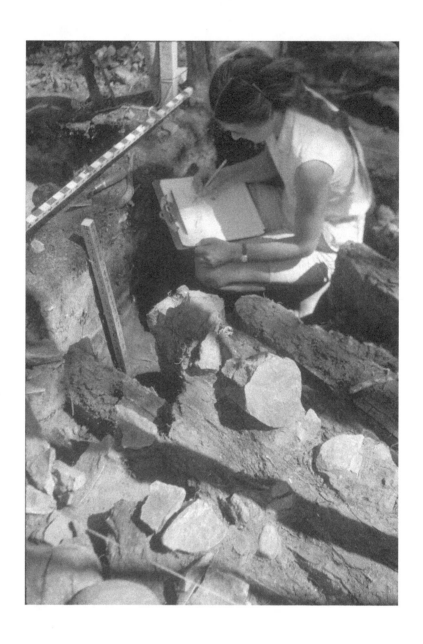

FIG. 6. Excavating François' House, Saskatchewan, 1963.
Courtesy T. F. Kehoe.

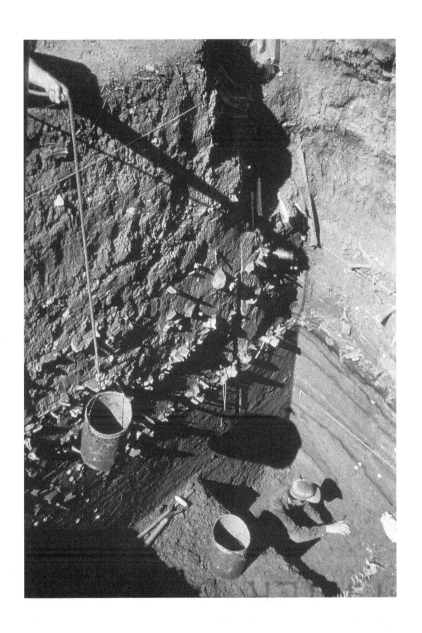

FIG. 7. Gull Lake bison drive excavation, Saskatchewan, 1963. Eugene Gryba working at bottom of deep trench. Courtesy T. F. Kehoe.

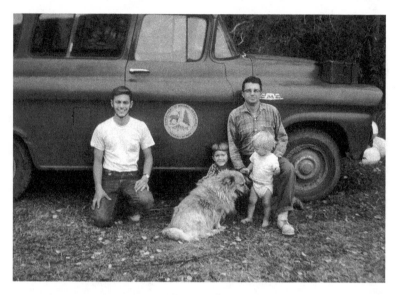

FIG. 8. Alice's brother Tom Beck, Dog Sam, Tom Kehoe, our two older sons in the field in Saskatchewan, 1963. Courtesy A. B. Kehoe.

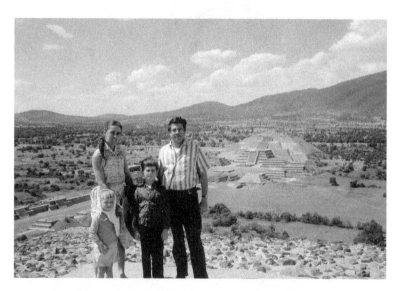

FIG. 9. With Tom and our two older sons, 1964, on top of Pyramid of the Sun, Teotihuacán, Mexico, during road trip through western and central Mexico to see sites. Courtesy A. B. Kehoe.

FIG. 10. At the Walter Felt site, Saskatchewan, 1965. This photo of me washing up dishes in camp was Tom's favorite photo of me. Courtesy T. F. Kehoe.

FIG. 11. With Tom and son (*behind Alice*) and Cree craftsman Noah Custer, whittling, and his son at the Custer family camp, Jan Lake, Saskatchewan, 1972. Courtesy D. M. Kehoe.

FIG. 12. Astronomer John Eddy, *left*, and Tom Kehoe measuring central cairn, Moose Mountain. Middle son is on top, holding tape taut, youngest son approaches, 1975. Courtesy A. B. Kehoe.

FIG. 13. Troweling at edge of central cairn, Moose Mountain, Saskatchewan, 1976. Courtesy T. F. Kehoe.

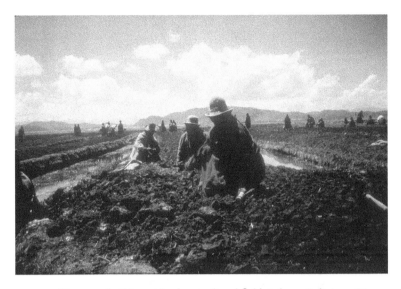

FIG. 14. Women rebuilding ridged agricultural field, Lakaya, Bolivia, 1988. Courtesy A. B. Kehoe.

FIG. 15. At Tamtok, ancient city in northeastern Mexico, 2012. Courtesy Enrique Garcia Fuentes.

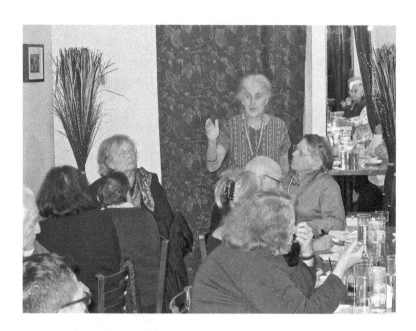

FIG. 16. (*opposite top*) Speaking at Senior Anthropologists'
luncheon, 2012. Jim Weil seated beside Alice. Courtesy
A. B. Kehoe.

FIG. 17. (*opposite bottom*) At Dayak festival in Borneo,
2018, with Dayak participant, during trip to Indonesia for
professional conference. Courtesy A. B. Kehoe.

FIG. 18. (*above*) Dena Ferran Dincauze. Courtesy
Elizabeth Chilton.

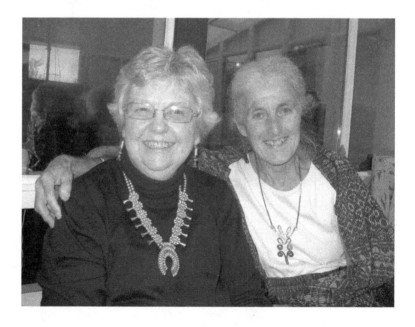

FIG. 19. (*opposite top*) During River Basin Surveys archaeological project, 1955: *from left*, Alfred Johnson, Dena Ferran (Dincauze), Ann Stofer (Johnson), Hannah Wheeler, Richard Wheeler (project director), May Stroup (cook), Valerie Wheeler. Courtesy Valerie Wheeler.

FIG. 20. (*opposite bottom*) With Jane Holden Kelley, Calgary, 2008. Courtesy A. B. Kehoe.

FIG. 21. (*above*) At 2019 American Anthropological Association annual meeting. Courtesy A. B. Kehoe.

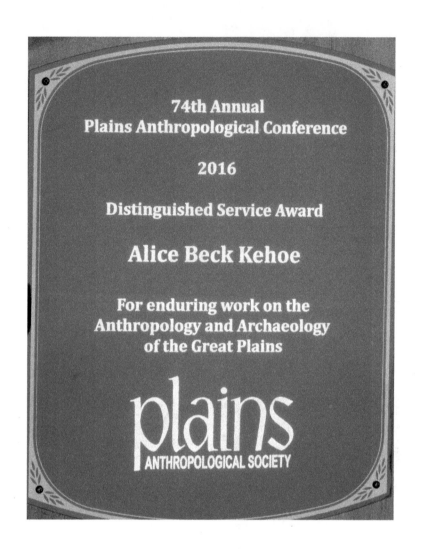

FIG. 22. Plains Anthropological Society Distinguished Service Award, 2016. Courtesy A. B. Kehoe.

# Trolls Appear

I thought I had a good marriage. Tom and I always agreed about money, about the kids, about archaeology and our colleagues. We hadn't hesitated over my continuing to complete my PhD after the Harvard professors refused to accommodate Tom—we both saw that as unjust snobbery, and while he was, as he told them, securely launched on his professional career, I as a woman would never get anything without the credential degree. True, Tom never did any housework or child care or cooking and precious little yardwork, but that was the norm for professional husbands of our generation. They were commended for focusing on their career research while the silent wife served them.

Then Tom went to Germany for a year, on a Fulbright professional grant. The stipend was barely enough for his expenses, but that was no problem; we had agreed several years earlier that my income would be the breadwinner, so that Tom could refuse administrative duties that would come with promotion at work. He would be able to devote his time to research and his museum obligations. My time went to . . . teaching, committee duties, cooking, grocery shopping, cleaning, laundry, yardwork, the PTA, and the Cub Scouts pack my friend Helen and I ran for our sons. Our summer collaborative fieldwork was my research time. It was 1979, but we were still in a 1950s marriage.

I was eager to join Tom in Tübingen, the lovely university town in Germany where the Archaeology Department was housed in

the castle on the hill. As soon as the semester ended in May, I flew to Germany with our youngest, age eleven. Our cheapo flight plus train trip was grueling. Tom met us at the Stuttgart station. It was already dark. Under the glaring lights of the station, Tom looked at me and said, "You look terrible." Not with sympathy for the sleepless, crowded ordeal, no, he said it as a statement of fact. His wife was terrible-looking.

Three months with Tom in Tübingen were horrible. He clearly disliked me intensely. Nor did he take much interest in our sons, our youngest and the middle son who had taken a semester off from college to be with Dad in Germany. Tom drove the vw he had bought in Germany to the castle to work, ate lunch at the least expensive student cafeteria, returned at end of day to sit at his desk trying to memorize five hundred irregular German verbs. He wouldn't go to shops or speak German, as I tried to do. He had put on a bit of weight, looked flabby. He would get up at night and pace for an hour, telling me in the wee hours how he hated Milwaukee and the museum and didn't want to ever go back.

Our youngest and I returned home in August. Tom stayed on into fall, joining a Tübingen archaeological project. Once home, in our house and also at Milwaukee Public Museum, he was scowling and moody. He did as little as he could at the museum. He did indulge, as he always had, in the two daily coffee-with-pastry breaks in the cafeteria and ate a full lunch there. Coffee breaks gave him time to talk with the carpenters and other men outside the scientific staff. They advised him that he was suffering his midlife crisis, what he needed to do was get a girlfriend who would be fun. Not like his always-working, no-fun wife. No one suspected that Tom was suffering from unregulated diabetes.

Tom didn't go to bars. Where would he find a girlfriend?

The Marquette women faculty! He'd seen them so often in our house when the women met for potluck and discussion. He knew, from me, who was single. He invited Carolyn, the pretty social work professor, to meet him at a wine bar. He propositioned her. She was outraged. I think he next propositioned the French pro-

fessor we sometimes bicycled with, because suddenly she refused to ride with us or come to our house. How about Mary Anne, the psychology professor? She said yes.

For five years Tom and Mary Anne were friends with benefits. They traveled together in Europe in the summer. He had dinner at her apartment, increasingly often, arriving home about midnight. A few times she invited me to join them there for dinner. She came, at Tom's invitation, to our house every Saturday evening for my homemade pizza. After they ate, she and Tom went to the sunroom, sitting close together on the couch to watch TV, while I did the washing-up. Our son, high school age, would take his slice of pizza up to his room; he hated to see his father intrude the girlfriend into our home. Still, she professed to be *my* friend. She did no research, claiming that as a teacher of clinical psychology she wasn't required to; echoing the conservative Marquette faculty, she told Tom that I was no scholar and that my research was faulty because anthropology, she said, isn't scientific. A professed friend, claiming to be a feminist, she hit every sensitive button I had.

Tom's unrecognized diabetes worsened until he felt so sick he went to the doctor. He was on the verge of a diabetic coma. The doctor hospitalized him immediately and called me in. "Untreated diabetes causes depression and mild paranoia," he told me. So THAT was what had happened in Tübingen, his poor diet and lack of exercise had brought on diabetes, the condition that had led to the early death of a first cousin. From then on I cooked carefully according to guidelines for diabetics, which angered Tom when some favorites never appeared and his portion was limited. He poured a glass of wine at dinner, as his doctor had permitted, then a second glass "for the doctor," he said, and often during the evening he'd finish the bottle. Before Tübingen he seldom drank. I'll put up with this, I said to myself, until our youngest finishes high school. I won't break up our child's home until he leaves for college.

The day arrived, 1991. Tom had taken early retirement from the museum, spending much of his time with Mary Anne. Our son was

in Madison at the university; the three years I had endured in order to let his relationship with his father continue had ended. Sitting at the dining-room table, I told Tom he must decide between us. He didn't hesitate: I should file for divorce. Why had he not? He wouldn't explain, only reiterated that I should file. He bought a condo with the money in our joint account, in Mary Anne's apartment development. I cried tears of relief.

It seemed like a story. Overnight my (1950s-style) decent husband had disappeared. A mean ugly troll took his place.

The troll refused a reasonable divorce settlement. He insisted I should pay him seven hundred dollars each month for maintenance (aka alimony). No judge in Milwaukee would award maintenance to an able-bodied man who had chosen to retire at age sixty-three. Tom's stubbornness meant we each spent thousands of dollars on lawyers as a consequence of rescheduled divorce hearings. At last, November 1993, my lawyer and I met Tom and his lawyer outside the courtroom where a hearing on my petition for divorce was scheduled. Tom reluctantly agreed to drop the maintenance demand. Our assets would be divided as community property; thus, I would buy his share of the house to keep my home. That he had taken $70,000 out of our joint savings and bank account to buy his condo wasn't figured into the settlement; somehow it wasn't community property. To equalize our pensions, my annuity in addition to my pension with TIAA-CREF would be turned over to him (TIAA-CREF does not permit such transfers in divorce). At my request Tom would write a will specifying that upon his death, all his assets would be divided equally among his sons, none to Mary Anne. When he did die, in 2008, Mary Anne showed up with a lawyer to claim all his assets so long as she lives, as her community property. My sons were shocked, knowing that she, with no dependents ever, had far more assets and money than I or any of them. She even refused to give any of them their father's car, letting it rust away in a parking lot.

## The Lovely Mock-Orange Bush

Against the gray stucco wall of our neighbors' garage, smack on our back lot line, grew a mature mock orange bush. Come June, it transformed that gray wall with its wonderfully fragrant flowers. As I hung up the laundry on the clothesline (my passive solar dryer), I felt bathed in ethereal beauty.

Through the 1980s the beautiful bush had slowly died. Its farther branches first, then death crept toward its main stem. I sawed off branches of the maple tree that might be shading it, and I gave it fertilizer. Slowly it died. I asked Tom whether he had any idea what was killing the bush. "Maybe it's the kerosene and paint thinner and stuff I've been pouring into that strip it's rooted in, since the city banned pouring that stuff down the sewer," he answered, with the hostile stare that had become his usual visage. Paint thinner? Kerosene? It had been years since he'd painted anything; for what would he have been using kerosene? Was he deliberately killing the sweet being I loved, to hurt me?

Death versus life. That changeling, that troll facing me was negativity, death. He'd killed our family activities, he'd killed our fieldwork, he'd killed our social friendships at professional meetings. Diabetes sapped any sexual action, even if he might still want it with me. Nothing was left between us.

He moved out. Every day I saw the ugly gray stucco wall of the neighbors' big garage.

A couple years later, as I was pulling weeds from the edge of the driveway along the house foundation, I stopped to look closely at one that had grown an unfamiliar stalk about my height. Live and let live has always been my motto. The stalk survived our winter, and in late spring a few white flowers appeared. OMG! It's a mock orange! Surely a seed from the murdered plant.

Those few years with the changeling troll were the nadir of my life. Now the sapling's fragrant flowers seemed like icons of a sweet new life for me. Not entirely sweet, for my mother came to live with me after first my father, then a year later my younger

brother, died. Alone as she turned ninety, not even cousins nearby anymore, Mother was still healthy but Dad had excluded her from handling their finances, leaving her inexperienced in managing bills and accounts. He had gone so far as to cover up the signature page of their joint income tax return, so that as she signed, she could not see their income. Sue, my sister, and I engaged a real estate agent to sell the house, and when that was accomplished, I flew out in May, right after the academic year ended, to bring her to my house. She had chosen mine over my sister's in California because there were no sidewalks or park in Sue's neighborhood, while mine, a century old, has safe walking and a great park. Mother had not packed a single thing when I got to her house on a Friday afternoon, leaving me to frantically organize for the movers coming Monday morning. They systematically, rapidly, packed everything into their van, and the next day I drove us away in Mother's car, with her house plants (some from *her* mother), a couple suitcases of clothes, and some financial records and necessary papers grabbed out of desk drawers and attic boxes—Mother explained that of course my father had not filed things like a secretary would; instead, he left papers to a secretary to file. Left unsaid was that he kept her ignorant of their financial situation.

It had been less than a year since Tom moved out. Mother lived with me for nine years, very gradually aging further. If the 1980s with a hostile sick husband were difficult, the 1990s with Mother were distressing. Her doctor had never checked her for thyroid hormone level, which the doctor I took her to in Milwaukee discovered to be seriously low. Low thyroid, like low blood sugar, adversely affects a person's mood. Mother was angry that we had insisted on her giving up her house, the house where she was mistress, forcing her into a house with another woman in the kitchen. She watched me go to work, heard me talk with women friends who were professors or a doctor or a lawyer. Too often she thought over her life of obedience to first her parents then her husband, never openly questioning, devoting herself to cleaning house, laundry, grocery shopping, and preparing meals.

She told Sue and me that our father didn't like sex. (Sue thinks she was frigid. She hated being touched, never hugged us, not even as babies.) When Sue and I went through her things after her death, we found her notebooks with poetry she had written. Some of the poems, we think, are quite good. We saw that she stopped writing poems the year she married. She gave herself totally to the role of housewife.

Low thyroid made Mother vulnerable to bitterness and frustration. The second month she was with me, she sat me down opposite her to listen to her viciously tell me that I'm a monster, my children all hate me, no wonder my husband left me. After the first exam with the doctor here, she began taking thyroid pills and would be less prone to anger until she required a higher dosage that the doctor would prescribe at every half-year visit. That I am a monster, she hung on to all through those nine years with me. A couple times she berated me with such fury that the cat rushed up, to stand with arched back in front of me, hissing at her with bared teeth.

In this toxic atmosphere, the little mock orange was a bit of simple bliss. Just when I was wondering whether it could continue to grow so close to the house, on the north side yet with little sunlight, it became necessary to resurface the driveway. I talked with the arborist who came a few times in the spring to spray the yew hedge and flowering trees. When the old driveway was jackhammered up, the men agreed to avoid the sapling, and that evening the arborist came over, dug it up, and planted it in the middle of the backyard garden. It took root and flourished. Every June it seems to fill the garden, its fragrance floating over me. Against lethal odds, we survived.

Mother, at ninety-eight, developed a cough that turned out to be caused by a tumor in the back of her lung. At this point she went to my sister's lovely sunny California home for the winter, for the second time. Sue took her to radiation to shrink the tumor, and cared for her. Come April, she wanted to move back to Milwaukee. Sue and I both found she was becoming forgetful about eating and easily angered when we would politely remind her to have some lunch or come to supper. She bruised easily

and bled, distressingly. I visited several of the nice assisted-living facilities in Milwaukee and chose the one a friend's mother had been happy in. When I picked Mother up at the airport, I took her to dinner at her favorite restaurant and then to Laurel Oaks. Up the elevator to the pretty two-room apartment, with balcony overlooking trees, that I had rented for her. She saw her beloved furniture in the rooms, sunset light coming in from the balcony. She was delighted! When I returned the next day, she happily told me she loved the apartment and the people and the dining room that, I noticed, uncannily resembled her favorite restaurant in Mount Vernon, back in the 1950s. After that I visited her two or three times each week, until at the end of May she told the staff nurse at the evening checkup that she wasn't feeling well. Her blood pressure, he told me, was "off the chart" and he had her hospitalized. They phoned me when they had her stabilized. "Come in the morning, she's sleeping now," the nurse advised on the phone. At about two a.m. the phone rang. Mother had died in her sleep. The evening nurse had recognized serious signs (oddly, his first name was Roman, same as my father's). Just what Mother had hoped for, quick, no pain, and still walking unassisted every day. As I was clearing out her apartment, the physical therapist stopped to tell me, "Your mom had an appointment with me for this morning. I was going to show her how to use the little walker she asked you to buy her a week ago. She had been carrying it on her arm like a handbag." "Yes," I replied, "she asked me to buy her a walker because she was the only woman here without one."

The mock orange hosts a congress of birds. Chickadees and sparrows flit through its branches, the pair of cardinals who always live in my yard alight, a northern flicker may sit calmly near its high top. All the birds of the air delight in its reborn, fruitful beauty. My home is tranquil now. The series of student roomers in her room since Mother died are grateful and respectful. The cat, sometimes two, who shares my bed sits contentedly on the patio. Storms no longer loom over me.

# SEVEN

## Life on My Own

Life on my own launched in 1993. I bought my own car. A Saturn station wagon. For driving to the Rockies and camping. Tested it by lying in the back, could I sleep in it? Car salesman discombobulated by middle-aged woman lying in car.

That car fitted me perfectly: well engineered, as green as they came in 1993, light plastic shell, good mileage, easy to drive. Just enough room, with half the backseat down, to stretch my sleeping bag. Dry and safe, I could camp anywhere I could park. For several summers I drove around the West, seeing archaeological sites and historic sites and wonderful scenery. Then I settled into an annual drive to the Blackfeet Reservation and Glacier Park, with a few days in northern Banff Park and visits with my friends and colleagues in Calgary. Five thousand miles each summer, a three-day 1,500-mile drive from Milwaukee to Browning on the Blackfeet Reservation. Touching First Nations reality on the reservation, blissing out camping and hiking in the parks. I did it every summer until the 2020 pandemic.

Life on my own meant taking other paths, walking with other people. Blackfeet people welcomed my annual visits to their reservation in Montana. So did rangers in Glacier Park, the western strip of the original Blackfeet Reservation. On beautiful days I camped in the park's Two Medicine Valley, closest to Browning, the reservation town. When it rained I visited Blackfeet friends and colleagues in their homes and offices. When climate change

resulted in massive wildfires in the mountains, the last few years, I found refuge in the cottage of two ranger friends, a married couple, in East Glacier village. Seeing the faces of these many friends light up when I appeared each summer has been as beautiful as the mountains we all love. Like them, these welcomes overshadow petty annoyances in what I feel as the outside world.

Mountains are not dead hunks in the Blackfoot world. They live very long, very slow lives. From time to time they move— obviously. In 1992 Chief Mountain, where Thunder lives during the warm months, became fed up with the rock climbers and New Age spiritual visitors disrespecting it. With a thunderous roar, it let fall a section of its rock. No one was hurt; it was speaking its warning. Blackfeet heard and understood, the tribal government setting boundaries and rules to protect the leader of its mountains. Walking on Glacier's trails, and seeing the Front Range of the Rockies from the reservation, I feel the eons-long lives of the mountains. First sight of them after the three-day drive from Milwaukee is always truly awesome. It moves me into the reality of Blackfoot tradition, where we respect not only mountains and forces of nature but also the other nations on our earth, the bison people, elk people, birds and small animals, each with its songs and dances tied to Indians peoples' medicine bundles. There's nothing mystical about this; it's so very obvious when one casts off the shackles of Western culture.

Happening to start my professional life, right out of college, on the Blackfeet Reservation was extraordinary good luck. I came to know several remarkable people who became national figures: Earl Old Person, politician; Darrel Robes Kipp, language revival leader; and Elouise Pepion Cobell, who fought against the U.S. government for fourteen years, finally settling, on behalf of all U.S. Indians, with the largest monetary award ever made in a U.S. court. Along with these outstanding leaders are others less well known outside the reservation, people such as John Murray, the THPO (Tribal Historic Preservation Officer); his wife Carol Tatsey Murray, leader of Blackfeet Community College; and the late

Stewart Miller, my collaborator on the history of the Amskapi Pikuni, the southern Blackfoot on the Montana reservation. It's a temptation to go on listing my friends who are Pikuni, but I'll stay with these leaders whose frustrations and achievements illuminate what it means to be American Indian. Experiences on the rez pushed me firmly into postcolonialism, the understanding that much of what is asserted about colonized nations is propaganda trying to legitimate oppression and exploitation.

Earl Old Person is a couple years older than I. Tom and I knew him when he worked for some weeks cleaning and numbering what we excavated from the Boarding School bison drive site, when Tom still worked for the museum in Browning. Earl entered national American Indian politics, becoming executive director of the National Congress of American Indians. Then he returned to the Blackfeet Reservation, running for Tribal Council. He won his district and the chairmanship of the Tribal Council. For forty years Earl Old Person headed the Blackfeet Nation government, reclining in the big leather chair at the head of the conference table. At the annual North American Indian Days tribal powwow, like a huge family reunion for the Amskapi Pikuni, Earl was the master of ceremonies, speaking often in fluent Blackfoot. Eventually, as elders before him passed away, he fulfilled the role of elder, knowledgeable about rituals, the language, and their history. Nearing his eighties, he undertook to record all the songs and prayers and teach them in the school system. Was he a good chief? Who can judge? No way can we know what would have happened during his forty years in the chief's chair if someone else had been in it. I do know that Earl Old Person is very shrewd and politically sophisticated, that he did devote himself to managing the tribe's affairs as best he could under the Bureau of Indian Affairs's heavy paternalism and economic marginalization. He now fulfills the role of elder as a Pikuni leader should, working to inspire his people with love and respect for their heritage and way of community. Dropping in to visit with him over these many years, I could observe how intractable the problems of a reserva-

tion could be. Mutual respect and appreciation of hard roads to travel gave us a bond I have been very fortunate to hold.

Darrell Robes Kipp was big, like so many Blackfoot, descendants of hundreds of generations of people who ate plenty of meat, the bison. Like so many Indian people, he had spent a lot of time as a child in his grandparents' home. They spoke Blackfoot to each other, but English with the children, to strengthen their ability to cope with school. That was the strategy of my family too, and thousands of other immigrant families. I heard my mother tell my grandmother, in our home, "Don't speak Yiddish here!" and my grandmother accepted. For Darrell Kipp's generation, born in the 1930s and '40s, they heard Blackfoot on the street in Browning and in grandparents' homes but did not speak it. Reaching middle age, Darrell and a number of his friends on the reservation realized that the language was disappearing, along with traditional rituals and arts. Most women did beadwork, for dance regalia and to sell to tourists; otherwise, as an anthropologist remarked, what you saw were "Montanans on a reservation." Kipp determined the Blackfoot world, expressed in its language, should not go extinct. He had earned a master in education degree from Harvard University. With the sophistication he had gained through Ivy League study, Darrell solicited funds from philanthropic foundations and local people to build a Blackfoot-language immersion school in Browning. An architect married into a Blackfeet family designed a modest, yet attractive and comfortable, building. An Alberta Blackfoot woman fluent in the language and certified to teach became the lead teacher. Small children were the first students, some remaining in the school until ready for high school. There were fewer than forty students, with about four teachers and a few elders to work with the students on language. Visiting Hawai'i's pioneer language revitalization school, Kipp brought its method to his school. His unceasing solicitations of funds for the school brought him to national attention, aided by his interest in making films portraying Blackfeet country and its people. During the 1980s Darrell's generation of Blackfeet leaders cre-

ated Blackfeet Community College to prepare their young people for jobs and to instill familiarity with their language and history. The same group revived the Okaan, a variation of the Plains Sun Dance that emphasizes peaceful relationships rather than the bloody self-sacrifice that climaxes in Sioux Sun Dances. Gradually, over thirty years, enthusiasm for learning Blackfoot spread, the Browning public schools slowly adding the language to their curricula. Darrell Kipp died of cancer in 2013, aged sixty-three. He had coaxed embers of his culture into flames. Visiting with Darrell and his school year after year, long conversations about the challenges he worked with, the hope that knowledge and pride in the Blackfeet world would combat the despair from racism and economic hardship, was one of the highlights of my life on my own. He gave me an insight that fundamentally shifted my anthropological perspective when he declared, at the annual Blackfeet history symposium he sponsored at the immersion school, "I no longer speak about Blackfoot 'culture.' I say, Blackfoot reality."

Most extraordinary of my Blackfeet friends was Elouise Pepion Cobell. The Pepions are a well-respected family on the reservation, Elouise's brother Ernie perhaps the best known, for his paintings. There were nine children in Ernie and Elouise's family, crammed into a small cabin on their allotment from the turn-of-the-century breakup of tribal land into little farms. Out there on the High Plains, the federal-mandated allotments were too meager to support families, so it was decreed that they should be leased to white ranchers, to make up large ranches that could be profitable. Indians were not asked to consent, and few ever saw lease payments. Without money, Elouise managed to attend a business college to work as a bookkeeper. She followed many other Blackfeet to employment in Seattle and other Pacific Coast cities, marrying a fellow Blackfeet there. One day her father called from Montana, crying, "We're going to lose our land!" Elouise could not understand how this could happen. "They say I didn't pay property tax, but how could I? I never get any money to pay a tax." "Don't you get a check every year from the lease?" "No, hardly ever." Elouise

returned to the reservation. She went to the local bank, asking for financial statements on her father's account. The bank didn't prepare any statements for Indians. She talked with the Bureau of Indian Affairs agent for the reservation; he said that he forwarded lease and mineral royalty payments to Washington. She went to Washington, asking to see the records of those forwarded payments. There were no records. The commissioner of Indian Affairs was too busy to see her. Finally, she tracked her people's money to the U.S. Treasury's General Fund, where it disappeared into the big pot that any program in the country could draw upon.

Elouise ran for treasurer of the Blackfeet Tribal Business Council, the tribe's governing body. She persuaded the council to support a bank for its people—the local bank owned by outsiders had closed. Blackfeet National Bank, the first bank on a reservation owned by a tribe, quickly succeeded. She created the Native American Bancorporation to assist other tribes to build their own banks. She branched out further with the Native American Community Development Corporation, providing both capital and management assistance for enterprises such as local motels and building materials businesses. Under all these successes—mostly in desperately poor, marginalized reservations—nagged the disappearance of those lease moneys. In 1996 Elouise Cobell filed a class-action lawsuit on behalf of the hundreds of thousands of federally recognized American Indians betrayed by the U.S. government of the money that same government had forced them to sign for. The lawsuit is *Cobell v. Salazar*, Salazar being the secretary of interior. Earl Old Person is one of the named lead plaintiffs in the lawsuit.

*Cobell v. U.S. Department of Interior* (Salazar and his predecessors as secretary from 1996) was heard in federal court in Washington DC. Judge Royce Lambeth found for the plaintiffs, expressing disgust for the blatant racism displayed against those the government, by treaties, was legally obliged to aid and protect. By 2006 the Court of Appeals removed Judge Lambeth from the case, alleging he displayed bias against the defendant, government. By

2009 Barack Obama was president and eager to reach a settlement of the case. Cobell, saying that the lawsuit had dragged on long enough, was criticized by many Indians for giving up at that point. She and the lawyers for the plaintiffs negotiated a settlement of $3.4 billion, of which $1.4 billion was to be paid to the many thousands of Indians owed their lease money or royalties, $60 million was for a scholarship fund for Indians, and most of the remainder, after paying lawyers' fees, could be used to buy up allotments and alienated land to expand tribal trust lands, reversing two centuries of dispossessing America's First Nations of their lands.

Elouise Cobell died of cancer, at age sixty-five, in 2011. She had received many honors, from a 1997 MacArthur Foundation "Genius Grant" (she used the money for the lawsuit) to, posthumously in 2016, the Presidential Medal of Freedom from President Obama. Her people call her *inawa'sioskitsipaki*, "leader-hearted woman." What I remember is dropping in, summer after summer, at her plain office in Browning, above the GED office. She would be at her desk, eating a brown-bag lunch, she'd look up and greet me with that warm smile and sparkle in her eyes. We'd talk for a while, How are you? as well as about the history of the Amskapi Pikuni (Blackfeet) I was writing collaboratively with the tribe and the college. Elouise Cobell was one of the kindest, most thoughtful women I've known. And I think she was the most practical, brilliant person I've ever known. It both humbles me and strengthens me to remember her.

### Traveling

Alberta, Andes Mountains, Angkor, Arizona, Bolivia, Cambodia, Crete, Cuba, Czech Republic, Denmark, England, Finland, France, Greece, Hawai'i, India, Indiana, Indonesia, Ireland, Italy, Japan, Jerusalem, Jordan, Malaysia, Mexico, Minnesota, Montana, Nebraska, Ohio, Peru, Saskatchewan, Scotland, Sitka, Sweden, Tiwanaku and Titicaca, Tübingen, Virginia, Wales, Wisconsin, Zagreb. This Girl Archaeologist got to go to all these places.

It's cool that for an archaeologist, every place has sites. Add
that I'm an anthropologist too, making every human, every com-
munity of scientific interest to me. Wherever I go, it's the daily
life of the people there that attracts me, their usual foods and
activities. Walking is the way to experience a place. Working on
a project, or participating in a locally hosted conference, opens
doors. Being only a woman, not tall, smiling at people, gives me
(for once) an advantage.

What stands out? Experiences of place were facilitated by Tom
for years, then they were mine alone, as my first excursions had
been. Most of my trips take advantage of professional confer-
ences, simplifying arrangements and, importantly, introducing
me to foreign colleagues. Everything human interests an anthro-
pologist, every place has its relevance to history, and everywhere
I have entered into friendships. Looking back, I see a treasure
chest sparkling with gems of memories.

There was our summer in France, 1969. Tom wanted to check
out the famous Paleolithic site of Solutré, in eastern France. Dra-
matically, a sharp white cliff dominates a valley lush with vine-
yards. For a century archaeologists excavated at the base of the
precipice, exposing butchered bones of reindeer and wild horses,
stone knives mixed in and around the slaughter. The site gave its
name to the Solutrean culture, lasting several millennia around
17,000 BCE. Supposedly, a herd of horses had been driven off the
cliff to their deaths below, food for the people. Was this really
the earliest known animal drive? Was it like the bison corrals we
had excavated?

We left our little boys with my parents, taking our eldest, eleven,
with us, the three of us volunteering on that summer's dig at the
Rock of Solutré. We took a room in a decayed country manor
house, the toilet a hole in a chimney-like structure running up
the side of the house. Sort of a multistory latrine. Breakfast, on
our way to the site, was at a roadside café serving strong coffee
and yesterday's baguettes, toasted. At the site we joined a crew
mostly of volunteers, from several European countries, and a

few French graduate students. The field director came from an old family in the region; I thought, *a very, very old family*, for he looked rather Neanderthal and the region had a number of Neanderthal sites. Smarting from not being a Sorbonne graduate, he was very touchy about his authority—no way did I dare remark to him about his stocky Neanderthal build and long head. When I tried to speak French (which I've never studied), he bristled and snapped, "Madame Ke-ho-e, please do not speak French. You hurt my ears!" Yes, sir, and whew! what a break for me.

While Tom and I troweled the soil around the butchered bones, in the later layers of reindeer, our son helped a local teenager wash and sort the bones. The boy never said much, and the only French our boy picked up was "Manger!" (Eat!)—run to the snack pile to get the chocolate before the others do. After dig hours we climbed up the rock to look for signs of a drive. We found the back side of the rock was a gentle sloping pasture. Humans approaching a herd grazing there could spook the animals upslope, not to the sharp precipice but to a cleft in the side cliff. Just like in American Plains bison drives, the herd leader would see an escape from the hunters, galloping down the narrow cleft, too late seeing a wooden corral at the bottom. Panicked and dazed, the herd stumbled around the enclosure, easy pickings for the spearmen surrounding it. Then everyone set upon the carcasses, stripping the meat, leaving a layer of butchered bones inside the corral. Sure enough, we saw that the horse bones at Solutré were packed into a circle of bones, not a scatter. There had been a corral. There had been a horse drive like the bison drives of America, but thousands of years earlier, 17,000 BCE.

Another famous Paleolithic site in Europe is Dolní Vestonice, in the Czech Republic near Brno. I worked there in 1988, with the Czech archaeologist who at a conference had discussed with Tom and me how to recognize animal drives. Dolní Vestonice wasn't a drive site; it had been a village of wigwams beside a marsh. Its people ate mammoths and covered their homes with mammoth hides. Butchered mammoth bones were tossed into

the marsh. The site, on a hillside terrace overlooking the beautiful Dyje River, had been excavated soon after World War II by an archaeologist now retired to a home and vineyard near it. My host and I stayed in an old inn in the village, a pleasant walk from the site, and the older man often greeted us as we passed by his vineyard. Ours would be the last excavation of this great Paleolithic site, because the Czech central government, still Communist in 1988, decreed it would be quarried for soil to build a dam to make a recreational lake for the village. Never mind the villagers didn't want the lake, certainly not when their famous site might otherwise become a UNESCO World Heritage Site. As my host, his little crew of teenagers, and I excavated the butchered mammoth bones along one edge of the terrace, lorry after lorry carried the soil down to the dam. I could see in the hillside exposed by the quarrying that the site was more complicated than the retired excavator had described; there were a series of black charcoal-mixed settlement layers. They could be separately examined and radiocarbon-dated, if only the Communist authorities cared. They didn't. Paleolithic Dolní Vestonice is gone.

Dolní Vestonice is well known for a small carved female figurine, labeled a "Venus" and supposed, by all the men archaeologists, to be a fertility goddess. Men archaeologists seem to be fixated on the idea of worshipping female fertility. Vestonice and her sister figurine, the Venus of Willendorf, in Austria above the Great Bend of the Danube, are very curvy, plump, naked women. Vestonice, like Willendorf, was on a high terrace overlooking a major river, in this case the Dyje. The daily walk we took to the site passed a local power plant with an oversized, very curvy, nearly-naked woman statue in front, overlooking the river. "What does that statue signify?" I asked my host. "She's the Spirit of the Dyje," he replied. "She's like the Venus figurine that was just above on the hill terrace," I remarked. "Might the Paleolithic Venus actually represent the flowing, curvy Dyje?" My host squirmed, "All the authorities say it's a fertility goddess."

Famous also from Dolní Vestonice are a set of tiny mammoth-

ivory carvings said to represent women's breasts, with a neck projecting from between them—that's all. "Mammiform pendants," they're labeled. More fertility goddesses, minimalized to only their breasts. After three weeks at the edge of the site, we ended the excavation, and my host arranged for me to examine the Paleolithic artifacts in the museum in Brno and to stay in an old mill in a charming village a lovely local bus ride from the city. I wanted to see whether bone and antler rods from the Paleolithic sites might show polish from having been used to make baskets or other fiber manufactures—the artifacts I selected resembled such tools used by American Indians. Some did, but I couldn't take photos of the polish because the artifacts had all been shellacked for preservation, so all that photos showed was reflections from the shiny shellac.

While sorting through the Paleolithic items, I saw a replica of the famous "mammiform pendants." Picking it up, I was astonished to see in back a projecting part of the carving, with a hole through it for suspending the pendant. That was never shown in photos of the "breasts." Put a string through the hole, hold it out so the pendant hung from it. OMG! the "neck" was horizontal, the "breasts" were a pair of balls just below and in back of it—the pendant was absolutely, no possible doubt, male genitals. It would not hang any other way. In fact, the Paleolithic pendant looks exactly like the little metal pendants of male genitalia that Roman soldiers liked to hang in camp. "Look!" I pushed the hanging replica in front of my host. "Not mammiform!" His face turned stern, "The museum director says they are mammiform." End of story. Indeed, I was told not to dare publish my discovery; its challenge might bring the director to forbid any Americans researching in Czech Moravia. All I could do was publish a small note in a British archaeological journal. A woman, a married woman like me, might think she was seeing a carving of a penis and testicles, but men know breasts.

A celebration brought me to India for a week in February 1986. Christmas Eve before that, the telephone rang as I was cooking a

special supper for Tom and the boys. It was Mickie (Mary LeCron) Foster, a linguistic anthropologist married to the chairman of the Anthropology Department at the University of California–Berkeley. "Could you go to India with us for a week in February?" my colleague asked. "Uh, yeah, I suppose, uh, Mickie, I have to watch the cooking, can I get back to you later?" "Of course." Stirring the cooking, it hit me—Go to India? For a week? What?

Mickie's husband had a former student at the Indian Institute of Technology in Kanpur, India. That university was celebrating its twenty-fifth anniversary, and George Foster's student, a professor in its Humanities and Social Sciences division, planned an international conference on peace studies to be part of the celebration. The Fosters were invited and were asked to bring other Americans to the conference. Proud of the success of his student, George was determined to go and shine; problem was he had no interest in peace studies, it was his wife Mickie who was working hard to make peace studies an accepted part of anthropology. Sharing that concern brought me and a few others regularly together with her at anthropology conferences. George considered peace studies a woman's thing, soft, beneath him.

There was another hitch: the IIT-Kanpur professor had no funds to bring people to his conference. Once on campus, we would be housed and fed, but travel would be at our own expense. Peace studies not being an established research line in anthropology, our universities were unlikely to pay for our travel; I knew for sure that the Jesuits at Marquette would not buy me a ticket to India. IIT-Kanpur's invitational list of great names in peace studies evaporated quickly when the great names learned they had to pay their own way. Foster's student wrote him in despair; only scholars in India seemed likely to come. The student would be humiliated. Anthropology would be despised. George decided that he would pay for Americans who agreed to participate (both the Fosters came from moneyed families). Even that was small help, only I and a young man, a postdoc (who had recently completed his PhD), promised to go if our travel was covered.

We flew to Delhi, had a day of sightseeing, then the next morning joined the Fosters in the Delhi airport to fly to Kanpur. All day, hour after hour, we sat in the airport, waiting for the Kanpur flight to be announced. At last it was dark. "Kanpur airport has no landing lights, the Kanpur flight today is canceled." George Foster and a bevy of Indian businessmen rose and marched to the manager's office. Overwhelmed, he arranged for a plane to Lucknow, the nearest airport with lights. From Lucknow the Fosters hired a car to drive us to Kanpur. Along the way we stopped at a roadside vendor for honey-ball sweets. George insisted we eat them; they had been cooked so they would not poison us. My practice, taught me by my medical-student boyfriend in Mexico when I was nineteen, is to not eat anything from any street vendor in an Asian or Latin country. Reluctantly, I bowed to George's demand. That was the only time, in all my travels, that I got "tourista," upset stomach from contaminated food.

Kanpur, on the Ganges River, is a crowded industrial city, reeking poverty. IIT-Kanpur outside the city is an island of green beauty, secluded, peaceful. We ate bountiful meals of delicious Indian dishes, laid out on terraces overlooking gardens. We were given rooms in the institute's guesthouse, the rooms cinderblock and simply furnished, each with a doorless bathroom. The first night I heard scratching behind my head, in the wall. Rats. The next two nights, continued scratching. The last night the rat broke through and walked to the bathroom, leaving turds. I said nothing about it. Sipping the tea brought to me each morning by a servant, I dressed and went out to meet the professors, one of whom was a woman with a PhD in philosophy from Oxford. She was magnificent in colorful silk sari and shawl, gold jewelry; her daughter, just returned from college in England, waiting for her parents to arrange a marriage, similarly shone in silks and gold.

Among the Indian notables in the small conference was a grandson of Mahatma Gandhi. He was a philosophy professor, with an English PhD. His presentation at the conference politely denounced First World aid projects to India, most of them designed

without input from affected local people, the same as under the British Raj. Professor Gandhi urged attention to grassroots concerns, to work as his grandfather had with common people, peasants, humbly. Excellent, thought I, yes. NO, came from George Foster. He stood up, how dare Professor Gandhi insult Americans! He stalked out of the room; Mickie somewhat slowly followed him, and so did the postdoc. I did not.

At tea break on the terrace, I talked with Professor Gandhi. A young woman with short hair, wearing a plain shirt and slacks, no jewelry, approached. She taught mathematics in the institute, and she wanted to follow the Mahatma's way. No silk sari, no gold ornaments. She asked Professor Gandhi whether her plain clothes were in the spirit of his grandfather. He looked her over and said yes, her modest utilitarian cotton clothes were indeed what the Mahatma would approve. Her face lit with joy.

As soon as we broke for the day, George Foster denounced me. How could I betray America by talking with that Gandhi! What, did I fall for his good looks? We should return to America at once, only we did have plane tickets for a day later, and it would be trouble to change them. We would not speak with the Indians anymore. Mickie did not argue with her husband. Standing before this big, handsome, wealthy, successful man, I could only be silent. So this Ugly American didn't get it—colonialism, the deliberate destruction of the Indian economy to privilege British manufactures, the taxation to support Britain's army in power. The perpetuation of impoverishing the people while global finance profited from building dams and railroads and factories paying poverty wages. On top of such arrogant blindness to suffering, George Foster was charging I had fallen for Professor Gandhi's good looks! Back home in America, Mickie and I, and the postdoc and I, resumed our collegial friendship focused on pushing for peace studies. If George had advocated for peace studies, it might have been accepted as a valid subfield, but he frowned at any man showing interest in it and paid no attention to women. I admired Mickie's persistent fruitless efforts to establish peace

studies; we felt affection for each other for she was a lovely person in every way. George's arrogant disparagement of her work pained me.

Two years later I experienced poverty in a very different part of the world, the Andes. One of my former students led a large project excavating the ancient capital city of Tiwanaku, near Lake Titicaca high on the mountain plateau. Along the lake are sets of ridges, clearly once made by villagers. Their purpose was a mystery. My former student, interested in how Tiwanakuans lived a thousand years ago, not only in their monumental architecture, figured that the ridges might have been raised beds for agriculture. Testing with excavation, that proved likely. How might that practice have worked? He got a small grant of money, recruited villagers to clean off and rebuild a set of ridges and ditches, gave the people shovels and picks and seed potatoes, and at harvesttime got an answer to the mystery: the ditches provided water to the plants on the ridges, then when an early frost threatened the harvest, being raised protected the plants from the frost. His villagers reaped a bounty of potatoes from the ridges, while frost-hit potatoes in conventional fields rotted. Second year, repeat the experiment—only, the villagers said, "We work ONLY with wages." "You got a great harvest last year, and I'll get you the seed potatoes, and shovels and picks free, again." "No, Doctor Alan, no wages, no work."

Visiting me when he came to see his parents in Milwaukee, my student was upset. What could have been so wrong? Why were they stiffing him for wages, when he had shown them how to get crops from the marshy lakeside, sturdy crops! Free tools and seed potatoes! I asked him who was staying in the villages, to hear what the people were saying among themselves. No one, he said; his university graduate students only wanted to excavate big things in the ruins of the capital. "I'm going to be on sabbatical leave this year, I could live in one of the villages to find out what was happening," I suggested. "This seems like so worthwhile a project, and I love mountains." "It'll be pretty primitive, adobe houses, no conveniences." "Just my style."

I flew to Bolivia in August, rested a few days in the capital, La Paz, to acclimate to the altitude, talked with some Aymara scholars (Aymara are the Indian peoples of the region), then went by pickup along the gravel highway to Tiwanaku. A large town now, its ancestors' capital was an impressive city a thousand and more years ago. Its river was channeled around it like a moat, and a long canal had brought shipping from Lake Titicaca. My student and his team were excavating one section of finely dressed stone temples and large courtyards; a Mexican archaeologist worked on an adjacent section and shared the project's quarters and cook. Local Aymara men did the actual labor. For three weeks I assisted in the archaeology, until arrangements were made for me in a village called Lakaya. That would be my home for nearly three months.

First I was given a house along the plaza in the center of the village. Bonifacia, a young woman who wanted to work on the raised fields, was my hostess. I took my suitcase to the upper room. Bonifacia and her mother, a widow, came up carrying a plate of dinner. "Oh, don't you eat downstairs? I'll join you." We sat on stools in the lower room. In my bowl was potato soup topped with pieces of chicken. In their bowls was potato soup. "This is so much food, please take some of this chicken," I offered the women. They looked confused. An uncomfortable silence as we ate. At last Bonifacia told me, "We never eat with the visitors." "Well, I have family at home and I don't like eating alone, please." Ice broken, I was welcome.

A week later the owner of the house returned, so I moved across the plaza to another unused house. Sacks of potatoes were stored on its lower floor. The upper floor was pleasant: I had a cot for my sleeping bag, a basin to wash in, a bucket for water, an empty backyard for a toilet. Next door lived the village headman Don Placido and his wife, a dignified elderly couple who didn't speak Spanish. They cared for their grandson, a delightful child about eight years old. One week he played he was a procession around his backyard, first day the drummer, next day the flagbearers, next the dancers, each day singing happily. I observed people coming to

his grandparents to consult on problems. Even though I couldn't understand Aymara, I could observe the deference and respect shown to Don Placido. "Doctor Alan" spoke with the leader of the village work crew, in Spanish, not knowing Don Placido was the person he should negotiate with. Talking with younger villagers who spoke Spanish, I learned the people were desperate for money. They couldn't afford even candles; they used rag wicks in junked cans with a little kerosene to make lamps for night. The cans were salvaged from the roadside and dumps outside larger towns. Bonifacia's cousin, a girl, walked a couple miles to high school, took a rigorous academic course, studied at night by that weak light of the single can in the family's one room. Yes, they were poor, there was no employment for them in the countryside. They did indeed need wages. Eventually, I was able to explain why Doctor Alan did not have money to pay, the raised fields project was not part of the Tiwanaku excavation project, he found a small donor to help them, and he was not rich, his own family in America were working-class people. When it was nearly too late to prepare the fields, the village agreed to work for, basically, what they might harvest from their labor. It had been worth trying to get money, but okay, getting more potatoes was, after all, better than going hungry.

Potatoes. For breakfast we had rolls and coffee; dinner was at noon, carried into the fields, by the women who cooked, in their home-woven, all-purpose, beautiful carrying cloths. Potatoes and little fishes from the lake were the dinner. In the morning fishermen came to the houses to sell the catch. Housewives boiled the fishes, not too long because kerosene for the burner was expensive. When they poured the fishes out onto the carrying cloth, some were still wriggling. There wasn't much meat on the bony little things; adults were expert at picking out the bits but small children and I spent the whole dinner hour working on one fish. I noticed the children who no longer nursed (older than three) but hadn't yet mastered eating the fish, seemed lethargic, while the older children, eating some protein, were lively. For supper we

had potato soup; that is, the water the dinner potatoes had boiled in. Dogs and cats, all skinny, lapped up the potato soup served to them. The only time I've ever dreamed of food was during those months of potatoes.

Usually I was with the women. Bonifacia had organized a team of women without men to rebuild one raised field (fig. 14). Alan had designated a couple of ridges for the men he negotiated with. Their wives and daughters worked with them. Some women in the village, widows and not-yet-married younger women like Bonifacia, had no access to those fields. She hesitantly asked Doctor Alan whether the women might take on a field. His enthusiasm surprised her; she decided to call her group El Centro de Madres because the only women's place she knew of was the government's clinics for mothers. Every afternoon after work, the women sat on the raised field to discuss their project. Led by Bonifacia, they voted by show of hands over questions. Bonifacia's high-school-educated cousin, who could get only housemaid work in La Paz because she was Indian, kept the books of who worked, to distribute the harvest accordingly. In the evenings some of the women joined me in my room, cheerful with the light of the candle I could afford to buy—I bought the village store's one box of a dozen candles, and then there were no more to buy in the village. Last thing in the evening, all the women trooped out to the edge of the village to use the roadside for a toilet. Staying together, they would not be molested.

Living in Lakaya was fun. Washing my clothes in the river, where a small dam made a pool for a washtub, hanging the clothes to dry on the bushes planted for that purpose by the pool. Filling my water bucket at the spring farthest from the farmyard where a donkey grazed next to the spring there, as my village friends wondered why I walked farther to get water. Enjoying the mighty Andes ringing the horizon, the sparkling lake beyond the marshy shore, that Big Sky feeling I treasured on the American prairie and Rockies. The camaraderie with the intelligent, hardworking women of Bonifacia's work-group. Chopping up clods of dirt

with the older women, our part of the project where young people dug and shoveled up the dirt to make the ditches and ridges between, with us breaking up the clods to make planting soil. Taking breaks with my co-workers, at first standing awhile, until my friends called to me, "Sit down, ma'am! Rest yourself!" In the late afternoon, sharing coca leaves with these ladies, just like having tea; in fact, chewing the dried leaves was much like chewing tea leaves, a pleasant relaxing buzz.

Living in Lakaya had an undercurrent of serious concern. Aymara women and men of my generation had been forced to work, unpaid, two or three days a week for the local hacienda owner. His mansion in a neighboring village was going to ruin now, after the 1952 Bolivian Revolution gave the peasants ownership of their farms. My friends told me of being whipped as they labored in the rich family's fields. Whipped! It shocked me, people I was living with, my age, whipped like slaves! Their present dire poverty, the blatant racism against Indians, was the good life contrasted with that slavery. Evo Morales's election as president of Bolivia in 2005 consolidated their slow road to relief, for Morales is Aymara and proud of it.

Postscript to my life in Lakaya, in 1991 the Smithsonian Folklife Festival, on the Mall in Washington, brought some of the villagers to participate. Doctor Alan was the agent linking them to the festival's focus that year on Andes Indians. Bonifacia and her cousin came, with their heavy colorful wool skirts and little bowler hats (copied from Western fashion a century ago). In the oppressive humid heat of Washington in July, twelve thousand feet lower than their highlands village, they danced in full costume for the crowds of American families. Beside them was a miniature raised-field. After the performances all the Andean Indians were bused to a big hotel across the Potomac in densely built Arlington, Virginia. There they ate and slept. On an off day they were all bused to a shopping mall to buy what they wanted with the fees paid them by the Smithsonian. It was the elite upscale mall favored by wealthy Washingtonians. Our friends couldn't afford

anything there. Alan and I were appalled; he was paid twice what
the Indians were given. He tried to reverse that, but the fees were
set. All we could do was ourselves buy as much as we could for
our friends. A Gap store near the friend's house where I was stay-
ing was, thank goodness, running its final clearance sale. Gap's
sturdy cottons were ideal. I bought a couple big duffle bags and
filled them with clearance-price clothes; for Bonifacia, her mother
back home, and her cousin with her, I added nice blouses. When
I lugged the duffle bags to their place on the Mall, their faces lit
up: now they had gifts for their families and friends. For Alan and
me, the festival's taking all the Andean poor farmers to the glitz-
iest, most overpriced mall stunk of American arrogance. If only
our friends had been taken to a Target or K-Mart, along streets of
working-class homes, to show them the real America, our America.

A new project slowly developed back at home, in ethnohistory.
Needing to check something about the 1934 Indian New Deal, I
looked into a book of contributions from the people involved in
it, telling an anniversary meeting about their work. The chapter
for Felix Cohen, the lawyer who had drafted the legislation and
later components, was by his widow, Lucy Kramer Cohen, and the
little biography blurb in italics at the head of the chapter men-
tioned she had studied with Franz Boas. When I'd read the book
previously, I hadn't noticed that. It startled me because none of
the histories of the Indian New Deal had given her name nor any
connection between Cohen and Boas; in his autobiography, the
head of the Bureau of Indian Affairs at the time had explicitly
stated that Boas had no connection with the Indian New Deal. As
I worked on other projects following my retirement from teach-
ing, the discrepancy bothered me.

In 2007 a biography of Felix Cohen, titled *Architect of Justice*,
was published by a legal scholar, Dalia Tsuk Mitchell. Here I
found a treasury of overlooked facts that completely reversed the
accepted picture of the revolutionary reversal of United States
policy toward its First Nations. John Collier, the commissioner
of Indian Affairs who took full credit for it, was the front man for

the work, speaking publicly for it, a wealthy and well-connected WASP. Felix Cohen, a Jew, wrote all the significant legislation, did fieldwork with Indian communities, and from boyhood was a family friend of Franz Boas. Lucy Kramer, his wife, was a Barnard anthropology major, ABD as a graduate student with Boas—she dropped out when she moved with Felix to Washington—and *for three years, worked full-time as research assistant on the Indian New Deal project.* Here was a gross example of facts hidden by misogyny and anti-Semitism.

Now, in 2008, the truth about the Indian New Deal was shouting to be heard. I spoke about it at an Association of Senior Anthropologists session, prompting one of our members to suggest I contact the Cohens' daughters, and giving me the email for one of them. She, her sister, and her cousin quickly offered to assist my research; the cousin, Nancy Bickel, was making a documentary about Lucy Kramer titled *Twentieth Century Woman*. Dalia Tsuk also wanted to help, and we became friends. Indeed, it was a sisterhood of the Cohen women, Tsuk, and me. Reading up on the Indian New Deal and U.S. Indian policies in the Marquette University archives (Indian policies were the principal research interest of Marquette's noted historian F. P. Prucha, always helpful to me), and corresponding with the sisterhood, climaxed in 2010 with a month fellowship to work in the Beinecke Library at Yale University, expenses paid. Both Felix's and Lucy's personal papers were deposited in the Beinecke.

That month at Yale was a dream come true. A pleasant apartment near the university, welcomes from the History and Archaeology Departments where I already had colleagues, and unsuspected revelations in the papers in the Cohens' folders made a paradise, heightened by opportunities to visit with East Coast cousins and my close friend Dena Dincauze. Most significant personally was the picture of 1930s anti-Semitism, far more stringent and pervasive than I had been aware of, and in complement, the secular Judaism based on social ethics that the Cohens followed. Theirs was a world parallel to WASPs, Social Democrat in poli-

tics, with an upper class of intellectuals and legal scholars that included Supreme Court justices Brandeis and Frankfurter. Felix and Lucy hiked and canoed the Adirondacks with their friends and convened annual mindfests where they camped together to discuss practical implications of philosophy, energized by their parents' generation of Boas, Frankfurter, Brandeis, civil rights lawyer Louis Marshall, and Felix's father, the philosopher Morris Raphael Cohen. Immersed in this circle's work, I awakened to the deep guidance of our Jewish heritage, what their favorite philosopher Baruch Spinoza had taught in the seventeenth century: the life worth living is concerned with justice and goodness toward our fellow humans. As John Collier acknowledged in his eulogy for Felix, dead of cancer at age forty-six, the Cohens had "a passion for the true and the just." Coming to know them, I felt humbled and at the same time inspired.

Living on my own, without Tom, without the now-grown kids, has been rich beyond my dreams. Beautiful places, yes—the Rockies, the Andes, the lovely Czech countryside—and heartwarming. The welcomes of local people, creating friendships as woman to woman. Living with people on different continents, working beside them or listening and seeing their privations, the national and global economic politics rigged against them, reverberated with my upbringing as a Depression baby in an anti-Semitic America. I was just lucky to reach adulthood when America blossomed with economic growth, with revolutionary opportunities for working- and middle-class young people, and the Civil Rights Act. The perspective I developed outside the average American's way of life gave me perseverance against the biases exhibited by those in power at home.

My childhood roaming alone, unsupervised, gave me confidence and drive to explore. For twenty-five years, until the diabetes hit him, I shared travels with Tom. It was his initiative to go to Solutré and then to the memorable 1969 tour of French Paleolithic sites with a husband-and-wife pair of leading French archaeologists. He proposed we attend an international archaeological congress

in Lima, Peru, in 1970, following it with seeing Cuzco, Puno, an exciting Paleo-American rock shelter excavation near Ayacucho, and Machu Picchu, surely one of the most romantic and extraordinary places on the planet. We traveled there with our close friend Bea Medicine, a Lakota Indian anthropologist, and her son. Bea suffered appalling racist intolerance from anthropologists as she persevered in her chosen profession, which infuriated Tom as well as me. Through the years of our deep friendship, I looked at Bea and could not feel sorry for myself, in every respect I had it easier than she. Whether with Tom, who was no different than multitudes of men in the 1950s, or later, freed from the housework burden of our marriage, I wasn't beaten down by racists, I wasn't even belittled as Mickie Foster had been. Tom's eventual hostility and my mother's came from sick minds. I had never been in a home where affection was openly offered. Living on my own felt good. It was in a world where everywhere I went, I was met with friendship from a remarkable number of very fine human beings.

## My Friends Out on the Tundra with Me

Life on my own, no longer partnered with Tom, opened up horizons and drew rewarding friends into my life. A turning point was my sabbatical leave in 1989, when Tom was still in the house, able to cat-sit. A project had become increasingly interesting to me over the years as I tried to make sense of the politics of academia and American archaeology. I read a lot of history and philosophy of science, I found a British group of researchers doing sociology of science, and I studied the history of archaeology. Papers I submitted to our leading journals were rejected, in that heyday of National Science Foundation–funded Cold War scientism. At a small conference in 1987 titled "History of Archaeology," a group coalesced. Some of this group's work got published in books we put together, with little notice outside our tiny subfield. This was more than an academic tiffle: We didn't get jobs in the big universities that support research. Men as well as us few women had their archival work dismissed as unimportant and uninteresting to archaeologists. Meeting together in 1987 revealed it was, to the contrary, highly significant for understanding the practices and power structure in archaeology. My sabbatical would be devoted to work on this.

It was the book *Natural Order* that sparked my plan. Although termed "sociology of science," the essays in the book are very anthropological, describing the culture within which the scientist subjects worked. Contrary to standard science teaching, out-

standing research doesn't proceed cookbook-style, and productive
ideas often happen when disparate thoughts catch together in
someone's mind. How did contemporary archaeology become a
science? To start, I looked for the time and place that the con-
cept of past history discoverable by disciplined fieldwork first
was formulated: for English speakers it was in Scotland around
1850. Coincidently, *Natural Order* was prepared by scholars at, or
associated with, Edinburgh University. To find out about the cir-
cumstances of development of a science of prehistory, I figured I
should go to Edinburgh to examine archived documents. At Edin-
burgh I might be able to talk with the *Natural Order* editors, be
advised on my procedures and interpretations. Although my appli-
cations for an NEH (National Endowment for the Humanities)
grant to pay expenses had been turned down, on the grounds that
only PhD historians should do history, I've always been able to
live frugally. My partial salary for sabbatical leave would suffice.

Arriving in Edinburgh in February, I moved into a flat in one
of the old crescents, sharing with a very young man just gradu-
ated from Edinburgh University. He liked the flat clean and neat,
we got along well, and through him, I learned a lot about Scot-
land, its contested sovereignty, social classes, and local history.
The university's Institute for Advanced Studies in the Humanities
accepted me as a visiting fellow, providing an office in a pictur-
esque building beside the Meadows park, with tea breaks in the
lounge, and most agreeably, fellowship with half a dozen other
scholars and the institute's director and his lively, enterprising
wife. Heaven on earth. Unalloyed companionship with a variety
of fine scholars, beautiful surroundings, no housework burdens,
fascinating reading of 1840s material in the National Library,
even the food was excellent (oh, those lunch sandwiches of dou-
ble Gloucester cheese on whole-grain bread). I bought a used
bicycle and on weekends went touring the countryside, seeing
archaeological sites. Through friendships with two women pro-
fessors at the School of Scottish Studies, not far from the insti-
tute, I joined students for a week excavating in a crannog (small

island) on North Uist in the Western Isles. Topping it all was Arthur's Seat, the magical extinct volcano cone in the middle of Edinburgh, with a nature preserve to roam in, a view of Firth of Forth waves from the top, and the reminder that a rock along the hillside path was the conclusive key to earth history demonstrated by geologist James Hutton in the 1780s.

A block from my office by the Meadows was the Sociology Department where the *Natural Order* writers worked on their "Strong Programme in the Sociology of Knowledge." With trepidation I approached the senior editor of the book, explaining that prehistoric archaeology seemed to me to embed many of the practices he and his colleagues had illuminated, but no one was working on archaeology. He responded with enthusiasm, yes, a new field to use their approach upon. We and two of his associates had many discussions over the months, culminating in weekend visits to their suburban homes—a rare extension of friendship from European professors. From the controversial "Strong Programme" sociologists of knowledge and the rich material in the National Library, grounded by seeing the actual landscape and artifacts of the first person to use the word "prehistory," Daniel Wilson of Edinburgh, I was able to write of the emergence of a scientific method for archaeology in that decade of revolutions, the 1840s, in my book *The Land of Prehistory: A Critical History of American Archaeology.*

### Feminism

A conference in 1989 legitimated feminist research in archaeology. Jane Kelley (fig. 20), my fellow mother and archaeologist back in Nebraska, was behind it, and of course I attended. Jane and her husband David had been hired to teach archaeology at the University of Calgary, Alberta, in 1968, when Dave was one of us five who deserted the University of Nebraska's Anthropology Department en masse. Archaeology was a new program at the University of Calgary. To strengthen it, the Kelleys worked with their students to host an annual archaeological conference that

they called Chacmool, after the Maya statues. That year, 1989, the students chose the theme "Archaeology of Gender." To everyone's surprise, that Chacmool drew its largest number of participants, and its published papers had to be reprinted to meet continuing demand. Most of the participants were women, making a new experience for most of us: archaeology discussions dominated by women speaking.

"Archaeology of Gender" could be about recognizing traces of typically women's activities, such as making household pots, or it could try to assess women's status through association of expensive objects in women's graves (not reliable, a favored concubine could be buried with lavish gifts). It opened up assumptions too routinely made, such as that only men were priests or went into battle. For some of us, it had called for much more experience in non-Western societies, embedding ourselves in communities to see daily life. We saw that women's and men's activities could be clearly different, without men dominating women. We saw that roles could be clearly different but not iron-clad, that in hunting societies widows and independent-minded women might hunt, and men knew how to cook and sew. For me, that cautioned against uncritical "cookbook" interpretations, putting me out on the fringe again. Double jeopardy: conventional men archaeologists ignoring me because I am a woman, and ambitious women ignoring me if I complained that their interpretations fail to take into account what we know from ethnographies and ethnohistories. Not much use speaking truth to the power-hungry, even when the power they lust for is in as inconsequential a field as archaeology.

At a later Chacmool, 2011, the theme "Climates of Change" mixtaped, as it were, presentations on archaeological evidence of the planet's climate changes, and discussions on the "chilly climate" for women in archaeology. A 2002 book described Canada's academic climate as a "tundra" for women, cold and barren. "Gender studies" opened some space for women, since it's assumed that only women care to look for evidence of women in archae-

ological material. The majority of archaeologists, up to 2017 the majority of them men, continue to excavate remains of ancient communities without thinking beyond potsherds as markers of time and cultural groups, and stone tools as "projectile points." As the number of women archaeologists increased to half of all practitioners, research as well as discussions into women's roles became acceptable. A landmark book in 1993 was *Hidden Scholars*, chronicling the lives and labor of women who had carried out archaeological work in the American Southwest. Climate change was happening on the metaphorical tundra as well as (unhappily) on the actual land. It was warming up for women, for studies of women in the past, and for broader historical studies of the cultural patterns that affect, and had affected, women.

### Listening

In 2008 I was sitting on a bench on the green campus of Dublin University, eating the bag lunch provided by the World Archaeological Congress (WAC), the conference I was participating in. A large, gray-bearded professor walked up to me and politely asked, "May I join you?" "Of course," said I, thinking, *It's a public bench, doofus*.

The graybeard sat down. His name tag said he was Peter and affiliated with the University of Florida, one of the prestigious research universities. I continued munching my sandwich. Peter asked me whether I would be willing to join a session he was organizing for the Society for Historical Archaeology, a group even more colonialist and conservative than the Society for American Archaeology. The session was to be called "Death of Prehistory." It would argue that every community has its history, deep-time history, and that there is no such thing as "prehistory" to be researched.

YES, though I hardly ever attended the Historical Archaeology meetings. Who was this Peter who knew my work? He did archaeology in Africa, particularly in Tanzania, that was why I didn't know him at all. We were at the World Archaeological Congress,

that year in Dublin. WAC, wacky archaeologists. Archaeologists aware and concerned about political and economic conditions in the countries we work in. Aware and concerned about our profession's history of elitism, of disregarding and disrespecting local people at our sites. Because Peter was at this WAC meeting, he must be different from most American archaeologists.

I had been at WAC's founding in 1986 in Southampton, England. Peter Ucko, chairman of archaeology at Southampton University, had arranged to host the International Union for Prehistoric and Protohistoric Sciences (IUPPS), a venerable gathering of venerable professors. The city of Southampton promised some funding for the congress, provided no one holding a South African passport would participate—the city had joined the pressure on the Union of South Africa to end apartheid. Ucko had arranged support for three African archaeologists, Black natives of Namibia and Botswana, to enable them to attend. Their countries were still colonies of the Union of South Africa, so they had to use its passport. Ucko was told to reject the Africans; he refused. The city of Southampton withdrew its support. IUPPS considered the congress canceled. All this happened at the last minute, with many archaeologists already gathered in Southampton. A call went out, who supports Ucko? Come to the alt-congress! A crowd flocked to a pub with a generous open lawn. In the bright sun, the World Archaeological Congress was born, for all wacky archaeologists with liberal political views. Sprawled over the pub's picnic tables, we introduced ourselves, saluting the new organization with raised beer glasses. So I am a charter member of WAC, been there, done that with comrades who recognize the colonialist conventions that limit and distort so much American archaeology.

WAC congresses are held every four years, in different countries. I haven't been to all of them; memorable ones I did attend were in 2012, appropriately for archaeologists at the Dead Sea in Jordan; 2016 in Kyoto, Japan; and that Irish meeting in 2008. There are always young people earnestly giving papers telling us that archaeology can bring peace and save the world. Among more

seasoned scientists, presentations by practitioners from all conti-
nents are full of interesting interpretations and mind-awakening
data. People are open-minded. Many collegial relationships are
forged. Thus, I was only momentarily surprised by Peter's invita-
tion to join his postcolonial mission. I could present spectacular
photos of our bison drive site, Gull Lake, twenty-six feet of suc-
cessive corrals beginning two thousand years ago, overlapping the
historic entry of Europeans at 1690, to the last drive in 1876. Lit-
erally, deep-time history of Blackfoot people (fig. 7).

Our session at the Society for Historical Archaeology meeting
in 2010 was packed. Peter invited us presenters to stay over the
weekend in Gainesville, home of the University of Florida, not too
long a drive from Jacksonville where the conference was held. We
spent a day discussing our approaches to rejecting the cutting of
history into precolonial and paper-documented, the actual con-
cepts behind "prehistory" and "history." Peter told us of his years
following suggestions from Tanzanians about where to dig, dis-
covering the unexpected antiquity of their ironworking. Another
presenter described how Nipmuc Indians in New England showed
him evidence that Colonial settlers had not destroyed their towns,
but instead had claimed "civilizing" them by claiming their towns
to be new-created by the missionaries. The group decided to pub-
lish our materials in a book to be edited by Peter and the New
England archaeologist. It came out in 2013, *Death of Prehistory*.
Typical of academic books, it got good reviews in archaeologi-
cal journals, a few copies were sold to libraries and a handful of
other archaeologists, and there it is. Preaching to a small choir.

Peter is an entrepreneur in archaeology. Later I learned that he
founded or advised on several new archaeology programs in Afri-
can universities; he and his wife are frequently in Africa. After
*Death of Prehistory* was published, he proposed a new mission, to
persuade archaeologists to respect local people and descendants
of those who had created the sites we work on. This time Peter
asked me to collaborate with him in organizing a session on this
topic for a Society of American Archaeology meeting, then to

coedit with him another academic book, of the presentations in that session. I won't say I was flattered, I've certainly proved my capabilities; I'll admit I was suspicious that Peter, like so many men, would put his name on the project while I did most of the work. No, as it turned out, Peter performed a full share. My ideas and opinions carried weight. In addition to a book, our group published a short version in Society for American Archaeology's magazine that goes to every member and prints color photos. The academic book is published with Peter and me as coeditors, titled *Archaeologies of Listening*. On the book jacket is a photo of a young me taking notes as I listen, outdoors, to my Cree instructor Joe Douquette.

While Peter and I were pursuing, with our little group of comrades, *Death of Prehistory* and then *Archaeologies of Listening*, another archaeologist sought me out as a senior colleague. This was not at a meeting, but via emails stimulated by Nancy Lurie, an anthropologist ten years older than I, a native of Milwaukee who had remained here. Nancy was highly respected in spite of her insistence on writing in popular style instead of fancy academese. Her years as curator of anthropology at Milwaukee Public Museum (where she was Tom's supervisor) are marked by her bringing into the museum, representatives of the Indian nations of Wisconsin as an advisory committee and memorably in the form of life-size figures modeled directly on them, dressed in finest dance regalia, set on a turntable representing the Grand Entry to a Wisconsin powwow. It greets visitors entering the halls devoted to American Indians.

Nancy's father took her to Milwaukee Public Museum as a child, on Saturdays. He volunteered there, and knew its director, an anthropologist. Over the years the director befriended the girl, advising her to study anthropology in college and on her dissertation research with Ho-Chunk people in Wisconsin. PhD in hand, Nancy applied for a curator position in her beloved museum. In the director's office, he stared at her, shocked. "But, Nancy, you're a woman! We can't have a woman curator!" Many

years later, the same man, retired, produced ethnographic films on American Indians. He advertised for a director of one proposed on Plains Indians. Tom applied, and we came together to be interviewed. Tom introduced me as collaborator, that by hiring Tom, the project would get two anthropologists, a team. The director's face turned stern. "I don't permit my staff to bring wives into the field." Period. Nancy, in time, did obtain the Milwaukee Public Museum curator of anthropology position; was elected president of the American Anthropological Association; was awarded its highest honor, the Franz Boas Medal; and was ceremoniously wrapped in a fine gift blanket by the Ho-Chunk community who called her Lurie-ga, "The Lurie." She was a professional and a woman of heart, highly intelligent and always kind. A colleague and friend I could deeply admire.

The man who emailed me, at Nancy's suggestion, has, with his wife, a small archaeological consulting company in eastern Washington State. For years the couple have worked with the Wanapum and Yakama Indian Nations of the middle Columbia River Valley. A prairie fire on Wanapum homeland had been followed by heavy machinery reseeding grasses, which may have disrupted Wanapum sites. An archaeologist working for another company had investigated and reported that sites were not damaged. His report stated that the only value of the sites was for archaeologists, because he had obtained radiocarbon dates filling in a gap in the list of the region's dated sites. Wanapum were disturbed and angry. The valley was the heart of their homeland, below the holy mountain ridge where the Creator had fashioned life. Little campsites lay along the major trail inland from the Columbia River to their hunting and plant collection grounds. As they walked, they were in the shadow of the holy ridge.

Nancy's friend asked me to read the archaeological report and comment on whether it was adequate. If he had objected to it, it would be seen as a business rival's ploy; I was an outsider archaeologist. When I agreed to do the evaluation, he sent me a digital overview of the homeland he had prepared with the Wanapum

themselves. OMG, this is beautiful, I responded. Satellite and landscape photos lay across the pages, bringing into focus the land as the Wanapum lived it, the great river, the ranges of ridges and hills, the undulating earth. Holy places were unobtrusively labeled. Accompanying the photos was the history of the people as they knew it, their village beside Priest Rapids where salmon leaped into their nets, their routes to cultivation plots of camas and other plant foods, to pronghorn and deer. For them, it was a rich land bestowed by their Creator. To me, there was no question that the area merited federal designation as a Traditional Cultural Property (TCP), according to the 1992 amendment to the National Historic Property Act. Therefore, it—the area along the trail, not just the little campsites—belongs on the National Register of Historic Places, to be protected.

Along with thanks for my work, Nancy's friend enclosed a generous check, the consulting fee. Here was very tangible proof that my opinions are worth something. "I didn't expect a check, it was enough to help, if I could, to show up the other archaeologist's failure to report the project qualifies as a TCP," I wrote back, "and I hope it helps the Wanapum people. Wish I could visit their beautiful land." His email flashed back, "Not now in August, it's 106 degrees in the shade. How about coming in the fall?" October rolled round; my friend suggested a four-day visit, he'd send the air ticket and I would be a guest in his home. What an unanticipated reward for work that, for me as a Jew, was a mitzvah, an obligation in right living.

Out in eastern Washington State, the dry sagebrush desert stretched away from the little Wanapum village relocated when the U.S. Army Corps of Engineers inundated their rich fishery and riverside community. If I hadn't read the report written with Wanapum eyes, I wouldn't have seen the holy mountain ridge and valley alongside as imbued with historic aura. I did see, and I saw also hellish landscape of the Hanford Military Reserve. Chosen for nuclear research and testing, plus missile testing, on account of its "remoteness," far from cities or main transportation routes,

the Hanford Reserve sits upon the Wanapum homeland. Their treaties give them the right to gather plants, hunt, and fish on their homeland, rights that are useless because nuclear operations, missile ranges, and highly radioactive ground lie atop their land. To get in, they must pass several military checkpoints. Their land rights are as inaccessible as their fishing rights at Priest Rapids, now deep underwater.

For my visit, my friend arranged that I accompany him and his employees surveying the area of the contested campsites and then meeting with the Wanapum-elected chief and the elder teaching Wanapum culture to their children. Field-walking with fellow archaeologists was fun, noticing artifacts, noting their exact placement and relation to other features. No question, the valley below the low ridge was a much-used trail inland. Not fun was turning from the holy ridge toward the Hanford landscape spouting nuclear towers, transmission grids, big warning signs. Literally, a sickening sight. One of the archaeological crew was a young Wanapum woman. How could she bear such desecration?

My last morning, my friend and I met with the Wanapum leaders in the consulting company's modest office. Both the Indian men were obviously well educated. With so little uncontaminated land and no businesses in this "remote" area, most Wanapum must live outside their remnant homeland. Against this hard fact, the community is dedicated to teaching their children traditional knowledge and beliefs, skills in hunting, fishing, cultivation of native foods, the art of weaving fine baskets and twining sturdy bags. Other Indians buy these handsome bags from the Wanapum and neighboring peoples, to hold holy paraphernalia for rituals, or prized dance regalia. These Columbia River peoples are descended from the famous Kennewick Man, one of the oldest human skeletons in the Americas, discovered in 1996 eroding out of the bank of the Columbia a few miles from the Wanapum village. Nine thousand years these communities lived along the great river. In 1943 they were thrown out, to make room to build the bombs that blasted Hiroshima and Nagasaki. The

contamination does not dissipate. Wanapum people will not let it destroy them. I returned home depressed, impressed, powerfully strengthened in determination to continue speaking truth to power, however silly I looked to the powerful. Nevertheless, they persist, these Columbia River small nations.

### Racism Rampant

Anthropologists can be as racist as other Americans. When Joe Medicine Chief returned from battling Nazis, counting coup as a Crow warrior on those enemies, he went to resume graduate study in anthropology. He was told that despite earning an anthropology MA degree at the University of Southern California in 1939, he would not be capable of PhD work. No, he wouldn't be given the opportunity to try. Go back to the reservation. Living to 102, Medicine Crow served his people there, publishing several books. Very belatedly, in his nineties he was honored at an American Anthropological Association meeting. Not by the association itself, but by its Association of Indigenous Anthropologists section.

I was there, in a small meeting room of the big conference hotel. A grandson helped Mr. Medicine Crow to the lectern. Standing tall, he introduced himself in Crow, then formally recounted the coups he had performed during the war, taking a gun from an enemy, hitting an enemy with a coup stick, leading an attack, stealing enemy horses (yes, he rode off with horses from a German army stable). This day's ceremony would add to the honors of this true Apsáalooke leader. Left unmentioned was the repugnant racism that had denied Medicine Crow an earned PhD in our profession.

Ten years younger than Mr. Medicine Crow, Bea Medicine—no relation, she was Lakota Sioux, not Crow—had met the same rejection from academics. One, a prominent woman sociologist, was an exception, standing with her at conferences, introducing her, urging anthropology departments to accept her as a doctoral candidate. A moment I shall never forget was at a conference titled

"The Modern Sioux," at the University of Chicago. We all ate lunch
in the conference center's dining room. Bea and her mentor were
at a table a few tables away from where I was sitting. Next table
to me, one of the conference organizers, a middle-aged blond
woman, noticed Bea across the room and remarked, in a carry-
ing voice, "There's that Indian woman with her sponsor. Doesn't
she [the sponsor] know that an Indian woman can't do a PhD?"
Tensely, I held back from slapping that blond woman, what good
would it do? I would only be labeled stupid, like Bea's mentor.

Bea, as it happened, was in Tom's graduate anthropology class at
the University of Washington. Tom and the others in that cohort
recognized her intelligence, abilities, and strength of character.
Through Tom, I had become Bea's friend. I knew that acceptance
into a doctoral program was only one of the blatant racist blows
Bea suffered. She had been wooed by an older graduate student
enamored of the Wild West and Indians. Tom and the other stu-
dents cautioned her that he saw her as a squaw. Against their warn-
ing, she did marry the man. He insisted she should wear buckskin
dresses even to class, and when their baby was born, carry him
in a cradleboard everywhere. Finally, she filed for divorce. He
demanded custody of their child, cruelly telling her that "no judge
in America would ever give custody to an Indian when a child
has a white father!" He was wrong, and Tom and other grad stu-
dents were ready to testify for Bea, when the judge ruled to keep
the boy with his mother. At the conference in Chicago, before the
judgment was handed down, I went with Bea to her hotel room
and held her in my arms while she sobbed, so torn with fear of
losing her child, me trying to console her with assurance that her
fellow students would be able to sway the judge.

Bea became a single mother, struggling to finish a PhD at the
University of Wisconsin, which did accept her as a student, then
moving from one temporary faculty appointment to another until
in late middle age she found a teaching home in one of the Cal-
ifornia state universities. All along, she and her son summered
on their home reservation, Standing Rock, speaking Lakota, par-

ticipating in its everyday life and its celebrations. *Learning to Be an Anthropologist and Remaining Native* is how she titled a collection of her notable articles, published a few years after she was awarded the highest honors of both the American Anthropological Association and the Society for Applied Anthropology. A success story? Not really. Could those honors make up for the decades of searing struggle?

Standing Rock is the reservation of another Lakota woman anthropologist, close to my age. Indian people in our generation encountered less outright racism. Indeed, in the 1980s they were sought after to fill new positions specifically for Indian PhDs, to do outreach to Indian students and tribes whose artifacts are in museum collections, and to teach in Native American studies programs. This friend, JoAllyn, came to Milwaukee in that time, soon after completing her PhD in political anthropology from the University of California–Berkeley. With her, she brought her mother who was in a coma; my friend sat with her, talked to her, stroked her for hours, hoping she would wake up. Understandably, my friend did not socialize after hours with the other anthropologists, nor did any of them reach out to her. She, like Bea, was Indian. A subject for anthropologists, not one of us. To me, she was a lively, intelligent colleague, a professional with whom I could discuss issues in one of my research areas, North American Indians. I'd go over to her house, a ten-minute walk from mine, and sit talking with her at her comatose mother's bedside. After about a year, the mother died. Racism became blatant in that even when she was then present so much more in the Anthropology Department, no one saw her as a colleague. No surprise, then, that she took advantage of the new positions for Indians to apply for one in the Smithsonian's Anthropology Department, doing outreach to Indians. Her last night in Milwaukee, she stayed with us, Tom showing her how to manage the U-Haul truck she and some local Indian friends had loaded with her belongings for the move.

At the Smithsonian, the same story, the anthropologists said she wasn't hired as a curator (true), so she shouldn't be part of the

department meetings. Surprisingly, a senior man in the department took her side, insisting that she was as much an anthropologist as any of them, that her work and participation were valuable. Literally, he stood beside her. Some years later she reciprocated by inviting him to join her camp at a Lakota Sun Dance led by a priest who is also a well-known artist. My friend provided part of the feast before the ceremony, in memory of her parents, both deceased less than two years before, and in memory of her defender's tragically deceased son. Experienced though he was in decades of fieldwork, it had always been in the Southeast or South America, never in the plains. We had to mentor him there, how to deal with the feast's big chunks of beef on the bone, what to expect in the ceremony. A bit awkward, but he did feel at home when, in the honoring dances before the feast, the caller sang out, "All of you women who earned doctors' degrees, come dance!" and five of us did, JoAllyn and I among them. (This was not your ordinary reservation Sun Dance, it was held in a tranquil forest clearing, invitation only, many EdD leaders in tribal colleges participating.)

Gaining confidence in Washington, my friend worked to organize her colleagues who are American Indian anthropologists into a section of the American Anthropological Association, the Association of Indigenous Anthropologists. She became an elder advising the next generation, women and men whose role as PhD professional anthropologists was not contended, although still drawing some glances askance. The "Indigenous Anthros" throw a little business meeting and reception each year at the big AAA meeting, an opportunity for networking, sharing goals, and reinforcing respect. As a close friend of Bea Medicine and my friend the group's founder, I've known some of the younger anthros since they were interns in my friend's Smithsonian program; I drop in to the meetings and thrive in their warm embraces.

Outside the American Anthropological Association's section, I find colleagues who are American Indian in the American Society for Ethnohistory and among archaeologists. Ethnohistory is a happy group of historians and anthropologists who equally fall

outside the mainstream of their professions. It began with women anthropologists overlooked or hired for second-rate jobs who were willing to research for the plaintiffs in Indian Claims Commission cases beginning in the 1950s. Nancy Lurie was one of these women. Feminism got a jolt in the 1970s with ethnohistorians focusing on the "country wives" of fur traders, Indian and half-Indian women living in the trading posts, married "à la façon du pays," in the custom of the country. Archaeology played a part in bringing to light the presence of country wives, their tools and ornaments uncovered, as I did in excavating François' House. One of my colleagues who had been ignored in Harvard's graduate program published a seminal study of women's roles in the Canadian fur trade, which with a woman historian's book coincidentally published the same year, went beyond scholarly studies to call attention to Canada's "half-breed" population, now known as Métis. Métis had been denied benefits given to Indians, not accepted as whites, forced to live in dire poverty on the outskirts of towns. A century earlier Métis sons and daughters of European traders and their Indian wives, women often left behind when the traders returned East to legal wives there, traveled in big carts to hunt bison and trap furs. Extinction of bison herds left them dependent on farms they created, land on the frontier that expanding Anglo Canada coveted. Ethnohistory revealed a century of gross injustices, emboldening Métis to assert their rights as citizens. Ethnohistory conferences warmly welcome my kind of person, women and American Indian scholars and men appreciating our work, so many presentations are given on facts and contexts outside the boxes of orthodox history.

NAGPRA, Native American Graves Protection and Repatriation Act, the 1990 act of Congress recognizing Indians' rights to their ancestors' remains and artifacts, upset the applecart of white supremacy in American archaeology. Two years after NAGPRA, the federal government matched State Historic Preservation Offices (SHPOs) with Tribal Historic Preservation Offices (THPOs), giving them jurisdiction over heritage management on

reservations. Instead of refusing professional education to Indians, universities and fieldwork programs now look to encourage Indian enrollment. At Society for American Archaeology meetings the year I am writing this, Indian students can look up to the president of the society, Joe Watkins, a Choctaw. Not the first American Indian to be president; ironically the society's very first president, in 1935, was Arthur Parker, a Seneca Iroquois anthropologist museum director. Back in 2000 Joe Watkins and I were amused that the publisher of his book *Indigenous Archaeology* sent me his manuscript to evaluate, same time that my publisher sent him the manuscript of my *America Before the European Invasions*. We each honestly recommended the other's book. When it was announced that Joe had won the election for Society for American Archaeology president, our embrace was especially warm.

### Senior Anthros

That I, as a Jew whose people, like America's First Nations, had been persecuted since 1492, and as someone who loves the outdoors, should find good friends and respect among American Indians, isn't surprising. That I should find a group of soul mates within the American Anthropological Association was less expected. It happened when Mike, a still-lively retired anthropologist from one of the smaller Illinois state universities, gently pressured me to join the Association of Senior Anthropologists. "You've retired," he'd remind me at Central States Anthropology meetings. "Only from teaching," I'd shoot back. "That's right, that's why you should join us." Okay, Mike was such an all-around good guy, enlivening Central States evenings with his masterful Chicago stride piano as well as meeting days with solid presentations on Central American local politics where he did fieldwork. I joined.

A year later Mike phoned. "Can I put you down as a candidate for president of the Senior Anthros? I'm on the nominations committee." "Jeez, Mike, I retired to be free. Not tied up in organization work." "Well, I need to put names down. Can I just put you on the list?" "Will you have at least one other candidate

for president? Someone the Seniors already know?" "Oh, yeah, of course." "Well, on condition that you have at least one other person as candidate, okay." Months went by, and I heard nothing further. Good.

Comes the next AAA national meeting. The first morning, as I walk toward the convention center, my friend Paul comes up. Paul was one of the small group with Mickie Foster trying to promote peace studies. "Can we have lunch today?" he asks. "Uh, sure." Paul must want to talk about peace studies. Lunchtime, we sit over sandwiches. "Now that you're president of the Senior Anthros—" "WHAT! What do you mean? I wasn't elected president!" "Well, it's by default. Did you know about Mike's fall?" "When he fell down steps at a London small hotel? Yes, he was badly injured, but they say he's recovering." "Mike was supposed to come up with a list of candidates for Senior Anthro officers, but when we finally were able to talk with him, he hadn't been able to work on that. You were the only candidate on the list he had. So, it's you. I'm the secretary-treasurer, I'll be helping you."

Reeling, feeling I'd been reeled in, I looked at Paul, thought, *Paul is one of the finest human beings I know. He really lives his Quaker faith. Working with Paul will be a good thing.* It proved to be so. Together, we organized a series of sessions at AAA meetings where the oldest of the Seniors described how they had initiated projects for which they were renowned professionally, and then we prepared the papers for a book, *Expanding American Anthropology, 1945–1980*—the postwar period. Through Paul's membership in the Society for Applied Anthropology, I met some extraordinary elders. Mary Elmendorf was one. She, trained in anthropology, was living in Mexico as homemaker for her husband stationed there, when she was asked to help the charity CARE adapt its funds to postwar needs. She persuaded CARE to expand beyond food relief to basic economic assistance, her project of digging wells for safe water in Mexican villages. Overseeing the project in her "spare time," this anthropologist wife and mother sparked a turn in international charities toward building local economies

instead of simply distributing relief. Another Senior was Will Sib-
ley whom I knew from Central States: teaching in Cleveland, he
involved himself in the work to clean up fouled Lake Erie, bring-
ing the human costs and problems into formal discussions of
engineers and politicians. Walter Goldschmidt was a star of our
profession, a very handsome, confident, well-spoken man who
had not only written textbooks but had created public programs
including a fascinating series of radio dramas vividly illustrating
how "exotic" peoples dealt with human problems in different but
reasonable, understandable, ways. Goldschmidt's dissertation in
the early 1930s dealt with agribusinesses invading California's
Central Valley, forcing family farms to give up. It was a new per-
spective, paid little attention at the time, then found forty years
later and hailed by economists as a landmark study. I was in awe
of Professor Goldschmidt until he greeted me one late afternoon
at an AAA meeting and began a conversation. Although he grew
up in a small Texas town, this eminent intellectual was keenly
aware of labor issues, speaking out against economic inequality
and injustice. I can still see him, in his nineties, hobbling with
his cane up a hill to a protest against hotels' exploitation of their
employees. His voice helped persuade the American Anthropo-
logical Association to consider union membership and employee
policies when selecting localities for its annual meetings.

Senior Anthros turned out to be both convivial and stimu-
lating. Convivial was enhanced by a bright idea of mine, that
we have our business meeting during a luncheon for members
(fig. 16), providing a good three-course meal at a nice restaurant
near the meeting. It's free for members, paid for out of the mod-
est dues that each year add up to cover the cost of the luncheon
for the forty or so attending the AAA meeting; the 140 or so who
don't, or can't, come to the AAA meeting have underwritten it.
Before and after the luncheon are our formal presentations at
sessions we organize. Most discuss early fieldwork, illustrating
with slides, reflecting from late maturity on younger selves and
the conventions of anthropology at the time, and comparing with

current standards and fads. Anthropologists active in the Society for Applied Anthropology, engaged in practical projects such as Mary Elmendorf's and Will Sibley's, make up the majority of Senior Anthros. Because I never attended the Applied meetings, I knew few of them before joining the Seniors. Now I revel in new friendships. Mike had been right, like Central States anthropologists, these are my kind of people, born anthropologists with no use for orthodox censoring, no ambitions to be kings of their domains, and instead energized by fascination with the varieties and the commonalities of human beings.

On balance, the climate outside the orthodox boxes isn't so chilly. It's inside the boxes that it's frigid.

## Issues with Limits

When I was a girl, so long as I was a good girl in the house and in school, no one imposed limits on my explorations. Grown up, still imbued with Kroeber's encyclopedic view of anthropology's unbounded field of study, I followed up interesting leads and also concerns as a citizen and parent. These could carry me far outside the "proper" domain of American archaeologists.

Men of my generation focused on their careers. When we were in our fifties, I became accustomed to these men coming up during professional meetings with their baby and young wife, former graduate student, to tell me how happy they were with this infant. They would say, "I never knew my kids with my first wife. Of course I was doing my research, for my career." My stony face, at this line, wasn't noticed: how despicable to ignore your children! Tom had done well in his career without sacrificing fatherhood; one of the reasons I stayed with our marriage was his then-exceptional commitment to being with his boys. As for me, I felt millions of years of natural selection impelling me to make my children first and close.

My children's lives pulled me into working for better social studies teaching in our schools, for preventing religious dogma to interfere with good science teaching, and to pay attention to what was going on among "the great unwashed," as one archaeologist my age termed the general public. These activities were, I eventually realized, a mitzvah, a moral obligation, voiced by Rabbi

Hillel two thousand years ago: "If I am only for myself, then what am I? And if not now, when?" My parents seldom talked about Jewish ethics, yet this ethic came through when my father told us that his National Labor Relations Board mediations had contributed to destroying Hitler, or recounted how adroitly he had brought the warring Irishmen tugboat owners and the union to agree on a contract. A little dog loved by his girl children could not move him as the lives of men had; in time I could admire his unflagging efforts toward social justice, even as I never forget the lesson that blind obedience to authority can kill.

There was a moment, in my early thirties, that crystallized my adult approach to life. We were in Nebraska when one of my two close friends in Regina, the geologist's wife, telephoned to tell me that our other friend, Nora, was dead. Dead!? How could that be? Nora was our age, her kids were in grade school. Nora was the first person among friends in my generation to die. A brain aneurysm had felled her instantly, in her kitchen. Nora haunted me for days, so intelligent, so giving of her time and talents to everyone she knew, so spirited and effective in creating opportunities for art and music and dance for every family in our provincial city. Finally, out of my sorrow came the realization from Nora's life: every day, every decision, should depend upon the question, If I should die tomorrow, what would be the better thing I can do today?

Any day, every day, my answer to that question has never been to give priority to a career. Perhaps it's sour grapes, considering the total lack of success of my occasional efforts to get hired at a better university where my researches could be supported. More likely it's the years of childhood and graduate experience when a career in archaeology simply wasn't offered. The MRS. was the ticket to fieldwork, though loaded with a burden of chores. The PhD has been a door to an awesome variety of experiences, a door that many open only a crack, seeing so many threats to their careers swarming outside. In this chapter I want to bring in some of those outsiders whom a careerist would never enter-

tain. If I were to die tomorrow, I'd rest in peace in the universe I've walked in.

## Pseudo-American Histories

In 1999 I attended an archaeological conference on rock art research at Ripon College in Wisconsin. It was spring, and eastern Wisconsin was lovely. I drove up from Milwaukee with an English colleague, Chris, who had stayed overnight with me after landing in our airport the previous day. Taking the scenic old highway, we drove through the village of Fredonia. Flag Day was near; its one main street was lined with little American flags fluttering. Chris peered out the car window. "Do they have a statue of their president ahead?" "I don't know, why would they in this little village?" "Little village! This is Freedonia! That sign said so!" "Huh?" "Freedonia! Groucho Marx is its president! *Duck Soup*—didn't you see it?" Took an Englishman to recognize our Freedonia—and shame on me, my father's stepbrother was cousin to the Marx brothers.

When we got to Ripon and were registering for the conference, an African American man from Milwaukee, Paul, was by the table. Paul had come north from a sharecroppers' cabin in the South; without formal education, he worked laborer jobs until his back gave out. Highly intelligent, Paul sat in on courses at the University of Wisconsin–Milwaukee and read in its library. He always carried a tote bag, looking like a homeless man, but his bag was filled with notebooks and books. Paul attended all our archaeology public lectures, and several professors showed him the respect he deserved. At the Ripon table, Paul told me that one of the Milwaukee archaeologists had given him a ride to Ripon, and he would take the bus back a day later because he didn't have money to pay for more than one night's room. Before I could say anything, Chris cut in. "Paul, don't do that. The dorm rooms all have two beds. You take the other bed in my room. My university is paying for it." For the three days of the meeting, Paul was there, the only Black person. Each meal was a feast for him. In

the evenings he would go with Chris, laughing at the English-
man's wit. Ride home? He went with the friend who had brought
him. Back to America's most segregated city. Back from a schol-
arly conference that, like all scholarly conferences a generation
ago, was all white people. Including a white supremacist Nazi,
Frank Joseph Collin.

As in a parallel universe, near Ripon was the headquarters of
a magazine called *Ancient American*, published by a Mormon to
promote Mormon and other versions of American deep history.
Nonprofessionals are invited to submit articles, particularly claims
about pre-Columbian voyages to America. Because that has been
one of my research interests since my seminar in grad school,
*Ancient American*'s publisher had been sending me issues, asking
me for comment. My replies, honest comments, were so negative
that he told me he would stop sending the magazine to me; he
did not appreciate my opinions. That would be reasonable. Dis-
turbingly, *Ancient American* promoted an outrageous scam by its
editor, "Frank Joseph," whose surname was Collin.

Supposedly, in 1982 a man, Russ Burrows, was walking along
the Embarras River in southern Illinois (this is a real river there).
He either fell into a pit that was the opening of a long cave with
many chambers, or he was using a metal detector that feverishly
pinged at a spot, where of course he pushed away the brush to
discover what was buried. According to his publicity, the cave
was the tomb of ancient Asian kings who had fled to America
two thousand or so years ago. Hundreds of thin black stone tab-
lets had carved pictures of more-or-less western Asian–looking
heads and inscriptions in a slew of Eastern Mediterranean scripts
including incongruous cuneiform-like (cuneiform was impressed
with a stylus in damp clay, not carved). Along with the tablets, he
brought out gleaming gold coins and small ornaments. All these
relics were offered for sale at an annual auction in Peoria, Illinois.

Behind Russ Burrows's scam to sell fraudulent artifacts to gull-
ible collectors was a rather scrawny, small man who called him-
self Frank Joseph. His full name was Frank Joseph Collin: he

was the neo-Nazi who in 1977 organized a Nazi parade through Chicago's Jewish suburb of Skokie. Two years later, a year after he did lead his Nazis in a brief parade in downtown Chicago, Collin was arrested for child molestation. Though protesting it was a frame-up because of his political views, Collin was imprisoned in Pontiac Correctional Center in southern Illinois, 1979–80. Russ Burrows was a guard at that prison, 1979–80. The men must have met. After his release, Collin—minus his surname—worked in Wisconsin for the Mormon publisher of *Ancient American*. Frank Joseph also wrote several books on claims for exotic people in pre-Columbian North America. His work was appreciated by white supremacy groups.

At the rock art conference at Ripon College in 1999, I was in the lunch line at the cafeteria, next to Paul and Chris, when a man walked up, extending his hand to shake mine. To my horror, his name tag said "Frank Joseph." Collin was attending the conference. I froze. No way would I shake that Nazi's hand. The lunch line was moving slowly along. It took Collin a minute or two to understand I was rejecting him and move away.

Should I, like most American archaeologists, avoid naive collectors of American Indian artifacts, and collectors only wanting to make a buck selling them, and people fascinated by conspiracy claims, and Mormons, and schoolteachers innocently passing on misinformation? Frank Joseph Collin was the antipathetic extreme of "the great unwashed." Most of the "unwashed" deserve answers to their queries and encouragement to ask more, and no more derogatory slurs such as "the great unwashed." We can call our public hoi polloi, "the many."

### Indiana Jones Types

Russ Burrows himself telephoned me one day. A deep, manly voice, "Alice, this is Russ Burrows." What, *the* Russ Burrows is talking to me? That real Indiana Jones, Russ Burrows who penetrated the dark, dangerous underground of our own Midwest! Russ invites me to accompany him to see the fabled cave. Me—

after my seriously interested colleagues, even Scott Wolter, the geologist–turned–TV hero, have been rebuffed. Of course I accept Russ's invitation. We have a long phone conversation, he sounds so solid a Midwest guy, hardworking and honest. But one after another, the dates we agree on for my trip need to be postponed. Then I never hear from Russ again.

Another deep, manly voice phoned me, in 1998, a few years before Burrows. Colonel John Blashford-Snell, calling from England. Inviting me to join his expedition to prove that reed ships could have sailed from Tiwanaku in Bolivia to Africa. Reed ships made by Aymara on Lake Titicaca, sailing down its outlet, the Desaguadero River, to Lake Poopo, then over the Andes' eastern rim into the Amazon, and out to the Atlantic and Africa. The first year of the project would go only to Poopo. Would I join them? Well, when? What were the arrangements? April; a contribution of five thousand dollars would cover my expenses. "Oh, I'm sorry, but I have to teach in April."

Colonel BS, as I can call him, was a retired British army officer sold on the idea that Americans had sailed to Africa before 1492. Reading about Thor Heyerdahl's Pacific Ocean experiments with ancient ships, the colonel determined to be the Heyerdahl of the Atlantic. I'm not sure whether he believed, as a few fanatics do, that Tiwanaku was Plato's fabled Atlantis, the city on the plain surrounded by mountains. Tiwanku is that, indeed, only it is twelve thousand feet up in the Andes and many miles from an ocean. Minor details you could overlook if you were excited by Plato's story of the destruction of a city earlier than Egypt's, a city beyond the Pillars of Hercules (Gibralter).

What Colonel BS, who maybe didn't speak Spanish, failed to understand was that Desaguadero means "Without Water." It's a river only during the snowmelt flood season; otherwise it's just a series of small pools in a deep rocky channel. I wasn't there in person, but I've seen some BBC footage of the expedition, their two reed boats stuck in the mud, pulled out by tractors borrowed from local farmers. Eventually they carried the boats on jeeps

to Poopo. The BBC film shows the colonel, a big man in muddy khaki fatigues, celebrating with his crew, popping firecrackers and toasting their success.

That BBC film with the colonel is spliced with a different film, never completed, about Heyerdahl's ideas of Indians sailing from Peru. I am in that other film, standing on a beach beside the little one-person reed boats local fishermen use, saying that, yes, big reed ships, such as Heyerdahl successfully sailed, could have been oceangoing. In the film splicing, my name was edited out. Also out was the rest of what I said and other footage where I climb to the top of one of the bizarre adobe-brick steep pyramids at the site of Tucumé, near the sea. BBC paid my expenses and arranged my trip for the week in April we had off for Easter. An American woman anthropologist filmed the aborted documentary for BBC. Like the English television producer who made the film *In Search of Atlantis* and its spin-off, *Mystery of the Cocaine Mummies*, two years previously, Harriet relished having another woman on the project. Filming in remote regions in the 1990s was still a guy thing. Both film projects were fun holidays for me, in areas I had not visited—the Olmec region in southern Mexico for the 1996 film, the north coast of Peru for the 1998 one—and both filmmakers generously gave me a day trip, plus car and driver, to visit a famous site after the filming was finished, San Lorenzo in Mexico and Sipán in Peru. The films have appeared on the Discovery Channel, and in each I'm on a beach to say that Asians, Polynesians, and Europeans had ships and sailing knowledge quite capable of crossing the oceans long before Columbus.

A third big macho guy in my professional life began our acquaintance as a respected scientist, co-owner of a petrographic laboratory in St. Paul, Minnesota. Scott Wolter was approached in 2000 by Dr. Richard Nielsen, PhD in materials science, and Barry Hanson, a research chemist. The two Scandinavian Americans teamed to bring the latest scientific technology to determine whether the Kensington Runestone inscription might be an authentic record of Norse exploring North America in 1362. They wanted an elec-

tron scanning microscope to image the surface of the stone, magnifying the carving. Wolter's American Petrographic Services, Inc., in St. Paul was the reputable laboratory nearest the Runestone Museum that might do the job.

➤ Wolter had never heard of the Runestone inscription, in spite of being a native Minnesotan, but was willing to do it pro bono, without asking his lab's normal business price. Following much dickering with the good people in Alexandria, Minnesota, loath to let their Runestone Museum treasure travel, Nielsen and Hanson brought the stone to Wolter's lab. A hitch: his scanning microscope required coating the object with a chemical. No way; its surface must not be comprised. Wolter advised that the lab at Iowa State University had a machine that didn't require coating, and he volunteered to drive the stone there and work with his colleague in that lab to scan the stone. Agreed. Wolter carried out the job, reporting that the scanning microscope slides showed considerable deterioration from weathering along the inscription incisions, indicating they could not have been carved less than several centuries ago—long before any European settlers in the area. Olof Ohman, the farmer who found the stone in 1898, definitely could not have carved it, nor anyone in the state in the nineteenth century.

Nielsen, who had become obsessed with proving the Runestone inscription authentic, continued to discuss with Wolter the standard notion that it was a hoax from 1898. Wolter gave a presentation on it, with the microscope slides, to a Minneapolis geologists' society meeting. That went somewhat off-track when he insisted on estimating a deterioration rate for biotite, a mineral in the stone, and this was criticized by his fellow geologists. (A red herring. I happened to be close friends with a geochemist at Brown University, husband of one of my closest friends. I asked Bruno his opinion of this biotite controversy. He told me that none of the Minnesota geologists correctly understood biotite; his lab at Brown had discovered that all the standard information was flawed, and the Brown group had not yet published their final, definitive results.)

While continuing to argue with his geologist colleagues, Wolter began spending his lunch hours at the Minnesota Historical Society archives, near his lab. There, he uncovered many documents, never published, that clearly authenticate Ohman's account of finding the stone and by implication, the authenticity of its inscription. There appeared to be a conspiracy among historians to suppress this evidence. Columbus as the first white man to discover America was more precious to these Minnesotans than claiming a history contrary to the myth of America, the Anglo Manifest Destiny.

What especially impressed Wolter was the report of Minnesota's first state geologist, Newton Winchell, commissioned in 1909 by the Minnesota Historical Society to investigate the claims for the Runestone. Winchell, one of the most eminent geologists of his time, whose name is inscribed above the entrance to the University of Minnesota's geology building, spent three weeks around the village of Kensington. He walked the fields, determining that the stone was a glacial erratic transported by the glacier from an eastern Minnesota outcrop. He closely examined the carving, noting the weathering in a very hard metamorphic rock. He interviewed Ohman and the villagers, taking legal affidavits from them about seeing the stone unearthed and testimonies to the honesty of Olof Ohman. He consulted with two of his peers, the state geologist of Wisconsin and the leading glacial geologist of their time. With all these data, he submitted to the Historical Society a report, signed also by his two consultants, that the evidence indicates the Runestone found near Kensington, Minnesota, had indeed been carved centuries ago by someone literate in the Norse language and its rune alphabet. Presumably, what the inscription said about a party of Norse exploring west of Vinland in 1362 was true.

Winchell's report was rejected by the Minnesota Historical Society. They preferred the opinion of a professor of languages at the university, that there were mistakes in the inscription, indicating authorship by an unlearned Swedish immigrant—farmer Ohman. Scott Wolter, as a geologist who had been taught that Winchell

was a founding scientist of his profession, reacted angrily to this. How dare the local historians disrespect a hero of Minnesota geology! Wolter and Nielsen decided to coauthor a book bringing together Winchell's report, all the records Wolter had found in the Historical Society archives, Wolter's scanning microscope report on the stone, and Nielsen's analysis of the language of the runes, that according to a linguist he had consulted at Copenhagen University, is a dialect of Swedish spoken in the 1300s in Bohüslan, on Sweden's Atlantic coast. The book was published, unfortunately prompting a break between Nielsen and Wolter over the cost of publishing it.

Where did I come in? Right at the beginning. I'd met Dick Nielsen in the mid-1980s at a conference in California called to bring together all the "fringe" researchers claiming pre-Columbian overseas visits to America. Center stage featured a verbal boxing match between Barry Fell, Australian-born marine biologist, and Gloria Farley, from the Oklahoma panhandle, a lady dressed in a pink suit. Both had for years been finding inscriptions of Old World alphabets on American rocks. Fell, retired from the staff of the Harvard marine biology project that brought him to America, argued that the Polynesian deity Maui had sailed the globe and left his name on many rocks; Mrs. Farley saw the sign of the Phoenician goddess Tanit everywhere on rocks, an inverted triangle. An eternal battle between male and female, never to be resolved . . . not by amateur linguists carried away with seeing signs on rocks.

Watching this battle of titans was Dick Nielsen. He described to me his investigations into the rune language, the identification of the inscription as Bohüslan dialect, and asked whether he could discuss archaeological angles with me. Yes, of course; over the years I saw how scholarly Dick was. By the time Wolter scanned the Runestone, I had been following Nielsen's searches in Sweden for fourteenth-century examples of the alleged "mistakes" in the Kensington inscription and had read up on my own about the Runestone. I suggested that, since the annual meeting

of the Plains and Midwest Archaeological Conferences would be in St. Paul in October 2000, we present Nielsen's and Wolter's work in a session at the conference.

Right away I got hit. One of the conference organizers, the Minnesota state archaeologist (wouldn't you know), wrote me that he would not permit that fantasy stuff, no busloads of fanatics would be allowed in that conference. Busloads? My assurance that no one but the four speakers, and I, would be there made no difference. Oh well . . . I called up the co-organizer, not a Minnesotan. He laughed and promised me our session would be on the program. There, at the front of the room stood the Runestone itself, as tall as I, the weathering along the edges of the rune incisions quite visible. Wolter had not yet returned it to the Runestone Museum and set it up. Did the unmistakable evidence of weathering before our eyes persuade the audience, mostly Minnesotans? Nope. They had been taught it was a hoax. All the authorities in Minnesota said so. They scoffed at my gullibility.

What came out of this confrontation of evidence before self-described scientists, the mainstream archaeologists? Nielsen went on searching for medieval documents in Bohüslan and endeavoring to persuade Swedish rune specialists to accept the Kensington inscription. I took the opportunity of retiring from teaching to pursue the Kensington question, publishing a book in 2005 that lays out all the evidence, historical, linguistic, geological, and from forestry (Could an uprooted tree lift that stone? Are two channels across the back evidence of tap roots against it?). Minnesotans had rejected Newton Winchell's scientific conclusions and not only Nielsen's opinion but also the opinion of a Cornell professor of linguistics, that the language of the runes conforms to a medieval dialect *that could not be known to Olof Ohman or anyone of his time.* Add to that the smoking gun I found in the history of Scandinavia around 1360: the Black Death had killed off nearly half the population a few years before, leaving surviving nobles without the tenant farmers providing their income; German troops hired by the Hanseatic League of Baltic area merchants

had invaded and taken over Bergen, Scandinavia's principal port; the league seized the lucrative fur trade through Russia to Constantinople, cutting out the Scandinavians. I could well imagine some experienced fur traders, bereft of tenants' rents and fur trade profits, deciding to procure luxury furs west of Vinland, knowing that for two centuries, a ship had annually brought in such furs sold by the Norse settlers in Greenland. Those furs came from the American mainland.

Did the Norse fur traders succeed in 1362, in spite of losing ten of their men to an Indian attack in Minnesota? We don't know. Did they come back to America? Not likely: if they had managed to return home, in 1363 they would have been called up to the army amassed by the three kingdoms in Scandinavia to drive the Hanseatic usurpers out. Which they did in 1368, restoring the Russian fur trade to its longtime Scandinavian entrepreneurs.

Did my book, published by a reputable textbook company, persuade archaeologists, or Minnesotans, that the big stone that farmer Ohman pulled up entangled with a stump is a record of a real effort by northern European fur traders to tap the American forests? No. Fifty million Minnesotans taught that it's a hoax won't admit wrong.

And Scott Wolter? He started lecturing to local audiences, vigorously asserting that he proved the authenticity of the famous "Viking" stone. (Vikings are the pre-Christian Norse, before the peninsula became Christian in the 1000s. The Kensington inscription, ending in "Ave Maria," was written by a Christian from a region by then Christian for two centuries.) Wolter is a tall, fit, good-looking man. Television's History Channel 2 built a series around him journeying to sites supposedly evidencing Old World émigrés unknown to history, or pre-Columbian Mexicans or Mayans in the United States. Advocates for Templar Knights carrying the Holy Grail to hide it in the New World became his buddies. A mysterious hook at the end of Christopher Columbus's signature is a secret sign. Masonic Order ritualists laid out the streets of Minneapolis to form a Masonic sign. They stamp their sign

on Oreo cookies. Just look. Nabisco Baking Company denies it, which proves it's a secret sign. All this Wolter published in a book, along with his television revelations. His wife published a book about the Goddess signs in America—if only Gloria Farley had lived to read it.

Launched into the excitement, the glamour, the groupies of fantasy television, Scott Wolter telephoned me one day to say that he would no longer speak with me. No phone, no email, no postal mail. All I did, he said, was criticize. He'd had enough of that. Me too. I had already given up on persuading this epitome of machismo to pay attention to facts.

Then, a dozen years after my book was published, the Swedish American actor Peter Stormare heard about the Runestone in America, got my book, and was intrigued by its lack of impact. He decided to make a documentary about the controversy, filming an interview with me. The producer offered it to Swedish television channel ViaPlay, which liked it so much it ordered it extended to a six-episode quest film, starring Stormare and a Minnesota guy but frequently cutting to me presenting facts. ViaPlay ordered a second six-episode series, and I was interviewed again at length. Will the big Swede convince America that twenty-two of his forebears journeyed to Minnesota to trade for furs, before Columbus was born?

### Chariots of the Gods

One evening at dinner, my husband remarked he had had an odd phone call in his Milwaukee Public Museum office. "Hello, Dr. Kehoe? I'm a reporter for the *National Enquirer*, I'm phoning from our West Palm Beach office. What is your opinion on Erich von Däniken's statement that the Moose Mountain medicine wheel that you worked on is a landing pad for ancient astronauts?" Tom was puzzled. "Of course he's wrong, that's nonsense, it's a structure for observing star and sun movements to determine the solstices" (see chapter 3). "But Mr. von Däniken says he is sure it was built by ancient astronauts." "Well, my wife and I and an astron-

omer were there, we measured everything and it was definitely
built by Indians to observe time of year by the stars."

"Mr. von Däniken saw it too. He is sure it's for astronauts."
"He saw it? When? It's not open to visitors." "His spirit visited it.
His spirit examined it for fifteen minutes and then reported to
him." At that point Tom slammed down the phone. Turning to
the others in the department, he told them, "I just got the cra-
ziest phone call from a reporter in Florida, says he works for a
newspaper called *National Enquirer*. Ever hear of it?" Half a dozen
people burst into laughter. Poor Tom, he left all the grocery buy-
ing to me. Never in a supermarket checkout line, he had never
seen the *National Enquirer*.

*Chariots of the Gods* was Erich von Däniken's bestseller. Three
times convicted of theft, embezzlement, fraud, and forgery, he
zoomed from prison to fame and riches with his books assert-
ing that extraterrestrial astronauts taught civilization to ancient
Egyptians, Peruvians, Britons, everywhere famous ancient mon-
uments are visited. We figured out that von Däniken's spirit had
transported to Saskatchewan, to Moose Mountain, while its mas-
ter was imprisoned for fraud. Poor Erich, he couldn't otherwise
get out to Saskatchewan.

### Goddesses

Once upon a time, when I was a grad student at Harvard, a seri-
ous woman archaeologist from Lithuania worked in a room in the
Peabody Museum anthropology building. Several times I paused
at the open door, curious, but she didn't look up. We understood
that she had emigrated to America to escape the Nazis and had
been given workspace in Peabody. A couple years after I finished
at Harvard, Dr. Gimbutas obtained a position in UCLA's archae-
ology program. She was at the time respected for her profes-
sional excavations and analyses of Eastern European Neolithic
and Bronze Age sites, and her researches into the folklore, songs,
and oral traditions of Lithuania.

Ten years after she moved to Los Angeles, Gimbutas published

a well-illustrated book, *Gods and Goddesses of Old Europe*. It presented carvings and pottery decoration that she interpreted to represent ideas of fertility, a female Earth impregnated by masculine rain from Above. Los Angeles bubbled with New Age devotees of the Goddess and Female Power. Her book was snapped up and reissued with a reversal in the title, to *Goddesses and Gods of Old Europe*. The reversal reflected her conviction that before the Indo-European invasions from the Asian steppes, in the Bronze Age, Neolithic southern Europe societies were peaceful, organized around respect for women and their powers. That sold in California. Bevies of California women in ancient-Greek white robes, garlands in their hair, converged on the professor. At one American Anthropological Association meeting in Los Angeles, I saw a harried Dr. Gimbutas followed by a train of these belles. One of them told me, "She is our Goddess! Oh, we adore her!"

Really, it was sad. Gimbutas had a husband and three daughters; she wasn't a lonely soul. Her archaeological work and studies of Lithuanian traditions are solid. She had met rejection of her linking "kurgan" burial mounds of Bronze Age warriors in the steppes to the Indo-European invasions; otherwise her professional publications were accepted. After her death in 1994, genetic data proved she was correct about invasions of kurgan-culture steppe horse riders bringing the Indo-European takeover of Europe. She isn't always cited for presenting that interpretation before genetics proved it. What, unhappily, endures with her name is the adoration by New Age Goddess believers.

Marija Gimbutas couldn't control high-handed men professors' rejection of her Indo-European invasion interpretation, nor could she resist Californians seeing her as their oracle. Caught between a rock and a hard place, her career shows how difficult it was for a woman just a generation older than I, to be taken seriously as an archaeologist.

More broadly, Gimbutas's story illustrates that hoi polloi can pull serious scientific archaeological work into the realm of popular yearnings. The Kensington Runestone has been a victim of Anglo

Manifest Destiny, the foundation of American history taught in schools. Nothing seems able to dislodge it from its knee-jerk dismissal as hoax. Archaeology is grounded in more ways than digging in dirt. For most of my lifetime, being a woman colored my archaeology, made it easy for men to overlook it. Being a mother, never questioning that my children are my priority, broadened my agenda and, in handicapping any career I might aspire to, let me follow out in such a variety of experiences the breadth of anthropology that had captured me when I was sixteen.

## Applause and Reward

When my father looked up from his newspaper at his daughters playing dress-up princesses and told us, "If you were in the Middle Ages, you'd both be scullery maids," he wasn't correcting our knowledge of medieval life. We were Jewish girls, and Jewish girls weren't hired as scullery maids. He was telling us our ordained place in the world was down on the floor scrubbing to make a proper home for the man we belonged to. A man's world.

My father, like my mother's father, believed it was wrong to educate girls. Education turned girls into sluts, whores—abominations against nature. We were destined by nature to carry men's children, raise them, make homes for men and their children. That would and should fill and fulfill our lives.

Nevertheless, I persisted. The glorious freedom to be intellectual that Barnard gave me, the satisfaction of working *with*, not just for, my husband, talking, reading, analyzing science and history and human life everywhere, all this rich pleasure I grabbed against my father's will. Eventually, when I had raised bright and healthy grandsons for him, when I was a full professor with published books, he accepted the fait accompli. We still didn't discuss anything.

The world my sons live in is not the man's world of their grandfather. No one today would openly call a young woman professional a "girl archaeologist." They are "women." They're not pressured to marry at nineteen or twenty, to have several children, to be efficient housekeepers and cook straight from a Betty Crocker cook-

book. They're encouraged, even pushed, to work out in gyms, to run, to rock climb. Young women don't hesitate to go out to bars with their buddies, to chat up guys (then at meetings we hear over and over in discussions on sexual harassment, "I got drunk and this guy was on top of me. . . ."). Women's empowerment is not a gift but a still-precarious position.

Sexual dominance is only one facet of the lust for power fostered in academia. Physically big men are admired, literally looked up to; they can passively dominate. Some women in archaeology exude confidence, forcefully presenting their professional experience, while more usual now is younger women's expectation that they will be listened to as are the younger men. We older women are more aware of persistent inequalities, in number of papers by women published in leading journals, in number of National Science Foundation grants to women for field projects. Women generally have less institutional support than do men faculty for writing academic papers, and for revising papers and grant proposals. Yes, there are more women PhDs in American archaeology, with many of them still in my circumstances, overburdened with tasks and under-supported professionally.

In 2016, approximately the tipping point for number of women to match or exceed number of men in American archaeology, I opened my email to read a message that astounded me: the Plains Anthropological Conference had nominated me to receive its 2016 Distinguished Service Award. My reaction was disbelief, is this a sick joke? Plains Conferences had been full of guys with a cowboy air and boots, drinking and carousing. We few women who attended could easily fit into a small hotel meeting room. In 1977 we did, presenting a set of papers on "The Hidden Half," meaning us but ostensibly on recognizing the presence and work of women in archaeological and ethnographic studies. Bea Medicine was a co-organizer. Several publishers rejected our edited volume, then one agreed to publish if we would guarantee selling five hundred copies. We did, and the book sold well in the 1980s, encouraging more studies on women's activities in past societ-

ies. I attended Plains Conferences only occasionally, preferring
the Chacmool conferences in Calgary where I could be with my
closest colleagues in prairie archaeology, or Ethnohistory with
scholars brave enough to work between academic boundaries.
Tom had received the Plains Distinguished Service Award years
before, but he attended regularly and had been local organizer
for a couple of their conferences.

I read the email again. It came from the conference's secretary,
a man who overlooked citing my work but was friendly in con-
versations. I googled the officers of the Plains Anthropological
Society and saw they were, most of them, women, and the three
men on their board were close colleagues of mine, each working
with a broad perspective as I did. This award could be true: the
times, they had been a-changing.

For years young women had been coming up to me at confer-
ences to tell me I am their role model. That made me flinch. My
persistence through thickets of disrespect to women was not a
path I wanted to see others struggle in. But it would not do to
discourage these young women; I would thank them and tell
them to stay in touch . . . the cohort of women can be critical in
strengthening one's will to remain a professional. Now, in 2016,
women filled not a small meeting room but the ballroom of the
hotel where the Plains Conference was meeting. When I stepped
up to receive my plaque, all these women rose to applaud, and
the men among them too. They stood applauding so long that I
had to motion to them to please be seated, as if I were the Queen
of England on her dais.

Of course I eagerly told my sons of my award, and sent them a
photo of the plaque (fig. 22): "For enduring work on the Anthro-
pology and Archaeology of the Great Plains." My youngest quipped,
"For you enduring the work?"

## Archaeology, Too, Was Changing

When I started in archaeology, mid-1950s, the job was to find evi-
dence of different stages of ancient history. Digging down through

ruins or into the ground of vanished villages revealed layers of floors or campgrounds, the most recent on top and the oldest, lowest. Unless you were working in the Southwest where dry timbers let you date by their tree rings, you could only estimate dates by how deep a floor or artifacts were. Then came radiocarbon dating. Suddenly the big challenge of dating was manageable: you send some charcoal from a cooking hearth or some bone to a lab, back comes its date and, by association, the date of the human activities that produced the charcoal or butchered bone. Other questions could now be addressed in archaeological work.

Tom and I had excavated to follow a real-time history for a real nation, the Blackfoot. We lived year-round in their territory in the first years of our marriage, within one of their communities. They, not ivory-tower theorists, were the people we addressed in our work. We had learned careful, observant fieldwork from our professors and field directors. Technically, we worked inductively, drawing inferences on what had happened in our sites from the data we uncovered, in their context of landscape and local knowledge. While I worked beside Tom, in addition I read about the history, philosophy, and sociology of science. There it was abundantly clear that we were following the methods of historical sciences, contrasted with the physics model of scientific research popular in American archaeology in the 1970s to 1990s. As CRM (cultural resources management, or heritage management) came to dominate archaeological employment by the 1990s, and NAG-PRA (Native American Graves Protection and Repatriation Act) passed in 1990, our approach to American archaeology, coming from engagement with living First Nations and their histories, was accepted in the practice of most archaeologists. An entitled few in the major research universities indulged in bandying about theories with French or Greek terms. The 2016 Plains Conference crowd was applauding my commitment to real people.

I had been not only a girl archaeologist in a man's world, enabled to do field research not by my PhD but by my MRS.; I had been also the muted voice endeavoring to bring an anthropological

perspective, a sensitivity to the people of the past and of today, to archaeological practice that from the 1970s through the 1990s had been dominated by a false version of science, ignoring human qualities. That ballyhooed "hard science" unsurprisingly was promoted by big, competitive, white men. They told me I was naive to listen to Indian people. It wasn't only because I was a woman that these self-promoting "hard scientists" ignored me; it was my message too. My *Archaeologies of Listening* collaborator, Peter, met the same contempt when he advocated paying heed to African villagers. Cultural resources management forced archaeologists out of their trenches and labs to speak with citizens. Most of the Plains Conference members who applauded me in 2016 work for CRM programs.

A nice little note is that in 2016 the Plains Conference met in Lincoln, Nebraska. Close by was the anthropology building where in 1967 the department chairman told us that he would never put a woman on tenure track. He was long gone; the department chairperson was a woman. She had been a Marquette student who found her life's work in my classes. Seeing her applauding with the crowd at the conference personalized my "enduring work." I was recognized as an archaeologist. All it took was persistence.

## The Larger Picture

Describing the greatest memoir in the English language, *The Education of Henry Adams*, a writer in the *New Yorker* noted that Adams had realized "the bankruptcy of the very distinction between winning and losing . . . situating a single human imagination inside . . . historical time" (Dan Chiasson, "Inside Story," *New Yorker*, December 7, 2020, p. 71). This perspective persuaded me to work on a memoir focused on a single human's passage through nearly a century of social change.

Opportunities for women in archaeology, and recognition of women's activities in the detritus excavated by archaeologists, are components of a sea change in the scholarly world. Paralleling acknowledgment that women are half the human population, vis-

ible, if you look, practically everywhere, is acknowledgment that billions of people labeled "primitive" are as fully human as we who read books (fig. 17). Following the post–World War II sloughing off of colonies by empires that found it cheaper to exploit them without the expense of administering them, citizens of the former colonies asserted their capabilities to play on the world stage. First Nations encapsulated like colonies within states, and descendants of enslaved people joined in decrying the suppression and wrongs suffered by those labeled "primitive." "Postcolonial" is the label for this radical reversal of standpoint.

The historical time in which I've lived as an adult is postcolonial, like it or not. Most of my age group liked it not. Many American archaeologists, afraid to confront orthodoxy, cling to the colonial racist formulations created at the height of imperialism in the late nineteenth century, taught to them throughout their schooling. Was I courageous that I stood out against that? Honestly, no. Kowtowing to the mainstream wasn't going to bring me career success. I saw clearly that successful men had in many cases benefited from mentoring professors, or in Tom's case just by using a urinal next to a job-giver. The dice were weighted against women until a generation born after 1964, the Civil Rights Act, had matured (*Fortune* magazine highlighted this in its October 2018 issue). Admiration has come late to those of us persisting in solidly empirical archaeology challenging the essentially colonialist models not yet uprooted.

Postcolonialism is more than a standpoint. For many of us, it's a moral imperative. Colonizing conquerors massacred, raped, stole, impoverished, enslaved to impose their rule. Awareness of this history, realizing that my own ancestors were colonized and persecuted, permeates my work. It's a mitzvah, as I saw when, researching the Indian New Deal, I was reading Felix Cohen's brilliant arguments for social justice. Though I can't overturn colonialism as he did in the *Handbook of Federal Indian Law* and the Indian Claims Commission, I've tried to counteract the naïveté or obstinate orthodoxy that supports colonial premises. The his-

tory I live in encompasses all communities of humans, all of them having equal claims to full humanity.

At last, a lifetime—my lifetime—after the New Deal broke the colonial stranglehold with its Indian New Deal and NAGPRA recognized sovereignties, younger American archaeologists are struggling to ground their work in postcolonial understanding. The Black Lives Matter protests in 2020 galvanized the Society for American Archaeology to reconsider its gatekeeping structure. That may have been easier given that the majority of its journals' editors are women. Effective social change is incremental and generates backlash. I've lived long enough to witness that. Roll with the punches and keep on truckin' carried me to 2020 and some tipping points (fig. 21). History continues.

# EPILOGUE

*Where Was I When Kennedy Was Shot?*

In 2016, as I held the plaque praising me for "enduring work," I shuddered at the enduring memory of an earlier generation of archaeologists putting me down for trying to work.

It was November 22, 1963. I was sitting beside Tom at an archaeology session of the American Anthropological Association annual meeting. On my other side, a senior professor had chosen to sit next to me. In the darkened room, as the professor apparently was looking at the slides on the screen up front, his hand was sliding under my skirt, along my thigh, higher and higher each time I pushed it away. Desperate, I leaned hard against my husband attending to the talk, who only ignored my pressure. The senior professor's hard, outstretched finger was at my crotch. Dare I stand up, in the middle of the session, push past the other men to get out of the room? Be forever scorned as a silly, rude woman? Suddenly, the room door was thrown open and the lights switched on: "The president has been shot!" Everyone jumped up, rushing out into the lobby. My rapist was foiled!

Remembering vividly those horrible minutes, I now realize that older professor was more than indulging his lust. He knew I had published in our leading archaeological journal and that with my husband—impotent that morning to protect me—I was working as a professional archaeologist. With his hard thrusting finger, he was impressing upon me that, regardless, I was no more

than a sex object. The tsunami of fear, desperation, and anger at that moment will never leave me.

For years later that man was a fixture at the reception for women hosted by the Committee on the Status of Women at the Society for American Archaeology's annual meetings. He stood near the door, grinning, staring lecherously at us. We were careful not to go near him as we moved in or out the door. We suspected he would goose us. Could we have banned him from our event? His peers, like university administrators, would have dismissed us women daring to impugn a respected professional man.

I remembered also an earlier experience, witnessing a man indulging with impunity in digital sex. It was during one of my summer temp typing jobs while in college, after a fieldwork project. The temp agency sent me to the Nestlé Company's regional office in White Plains, New York, near the house my parents bought when I was nineteen. In a large office, six women typed a form recording returns from wholesalers of Nescafé and Nesquik. There were only about twenty wholesalers and a couple sizes each of the products returned, at most a quarter of the lines on the twelve 8 x 14–inch pages, with eleven carbon sheets, bound in the form. After typing the entry, the typist was instructed to tear off the top five pages and discard the remaining seven pages and all the carbons. An office boy kept busy emptying the wastebaskets. I often finished my set of forms early in the afternoon and offered to help the woman assigned to file the forms in a row of cabinets. She explained to me that they had to be filed alphabetically. I replied that I could file alphabetically, I was a college student. She gave me a trial, was satisfied, and I helped file many afternoons. Supervising these seven women was a middle-aged man seated at a large desk overlooking the typing women and the file cabinets. On his desk perched an attractive red-haired young woman, knees up, skirt not quite covering them. For most of the day, the man's hand roamed under her skirt. She did no work, usually talked on his desk phone for an hour or so, to her mother in Czech, the typing women told me. No one had any comment

on the woman on the desk, and no one would dare comment on the man.

White male supremacy was unchallenged when I was young. The working-class man I married was accustomed to wives laboring with their men on the farms or in town jobs to help support their families. Our two-job household that included no housework by the husband was conventional for him. It enabled me to carry out fieldwork and to present my research independent of him. We had no quarrels about dividing up housework or child care; those were always, simply, women's tasks. Our marriage dissolved when untreated diabetes caused him depression and paranoid anxiety. By that time I was established as an anthropologist and archaeologist, although not funded for research. The generation of professional men who systematically kept women down was dying out. It took three generations of young women persisting in archaeology to swing the profession toward equality for us. I endured a lot of work and a lot of condescendence before a roomful of much younger colleagues enthusiastically applauded me.

# ACKNOWLEDGMENTS

My editor, Matt Bokovoy, at University of Nebraska Press, closely read my original manuscript and turned it right side up, pointing out it's a story of freedom and caring friendships. No need to name the mean-spirited, the stupid, the backstabbing careerists annoying like mosquitoes—nor risk defamation suits from those blackguards.

When I decided it was time, having passed my eightieth birthday, to record the years during which American archaeology passed from 17 percent women to majority women, a family friend in Milwaukee, Nancy Peske, used her knowledge as a freelance development editor to show me how to write in trade-book style. The first publisher's editor I showed it to, Allyson Carter, obtained encouraging positive recommendations that she shared with Matt when her own press refused to consider a memoir. These three, Matt, Nancy, and Allyson, understood that I wanted to write a description of my profession during its decades of major changes that would be factual as only firsthand engagement makes possible.

Matt suggested putting "sisterhood" in the title. It really should be "siblinghood," considering Matt and a number of other close, supportive colleagues and friends have a Y chromosome. The women in my own cohort of archaeologists have been a sisterhood, now narrowed by the deaths of Dena Ferran Dincauze, Betsey Baldwin Garland, Cynthia Irwin-Williams, Jane Holden Kelley, Ruthann Knudson, Sarah Milledge Nelson, Patricia J. O'Brien,

and Leslie Wildesen. Ruth Gruhn and Fumiko Ikawa-Smith are still with us as I write.

Because I hope with this book to illuminate some of the history of my profession, my own family gets short shrift. At their request, with concern for "social media" transgressions, I don't name my sons, nor do I mention escapades, trials and tribulations, or the wealth of joys they have brought me. I will name the others in our family so unstinting in their love and companionship: Dog Sam and the succession of cats—Amon when I still lived with my parents, then Kiki Mao in Sasktachewan, and in Milwaukee, Pitschi, Gwydion, Felicia, Paloma, Lacey, and now Susette. And my trusty Raleigh Superbe on which, for so many years, I have bicycled away from stress.

APPENDIX

*Books I Have Written and Why*

It discombobulates mainstream archaeologists to see the list of books I have published. Good archaeologists are supposed to spend most of their lives excavating one or a few sites in a particular region. In other words, *dedicated* to the archaeology of a region. This expectation narrows knowledge to what can be seen through tiny slits in the curtain over the past. It reminds me of what Blackfoot elders told anthropologist Clark Wissler when he instructed his interpreter to collect authentic original myths, not a bunch of variations: "A venerable old man pulled up a common ragweed, saying, 'The parts of this weed all branch off from the stem. They go different ways, but all come from the same root'" (Clark Wissler and D. C. Duvall, *Mythology of the Blackfoot Indians*, Anthropological Papers, vol. 2, pt. 1 [New York: American Museum of Natural History, 1908], 5). For me, the study of humans—anthropology—is the root, and archaeology is one of the branches growing from it, and branching and branching as it grows.

Here are the books I have written, growing out of the root planted when I read, as a high school student, Alfred Kroeber's 1948 *Anthropology*:

1962. *Hunters of the Buried Years*. Regina: School Aids and Textbook Co. 94 pp.

1978. *François' House, an Early Fur Trade Post on the Saskatchewan*. Regina: Saskatchewan Ministry of Culture and Youth. 162 pp.

1979. *Solstice-Aligned Boulder Configurations in Saskatchewan*. Canadian Ethnology Service Paper No. 48, Mercury Series, National Museum of Man, Ottawa. 62 pp. (With T. F. Kehoe).

1981, revised editions 1992, 2006. *North American Indians: A Comprehensive Account*. Upper Saddle River NJ: Prentice-Hall, Inc. 628 pp.

1989. *The Ghost Dance: Ethnohistory and Revitalization*. New York: Holt Rinehart Winston (Case Studies in Cultural Anthropology series). 155 pp. Second edition, 2006, Long Grove IL: Waveland. 186 pp.

1998. *Humans*, introductory anthropology textbook. New York: Routledge. 244 pp.

1998. *The Land of Prehistory: A Critical History of American Archaeology*. New York: Routledge. 288 pp.

2000. *Shamans and Religion: An Anthropological Exploration in Critical Thinking*. Prospect Heights IL: Waveland. 125 pp. CHOICE 2001 Outstanding Title.

2002. *America before the European Invasions*. London: Longman/Pearson Education. 259 pp. (Reviewed in *New York Review of Books*, June 12, 2003, vol. 50, no. 10, p. 53, by Tim Flannery.) Italian translation, *Il Nord America prima dell'invasione europea*, 2006, Genoa: ECIG (Edizioni Culturali Internazionali Genova). 319 pp., paper. Translated by Anna Tentindo. Second edition 2017, as *North America Before the European Invasions*. New York: Routledge. viii + 257 pp.

2005. *The Kensington Runestone: Approaching a Research Question Holistically*. Long Grove IL: Waveland. 103 pp.

2007. *Archaeology: A Concise Introduction*, coauthored with Thomas C. Pleger. Long Grove IL: Waveland. 125 pp.

2008. *Controversies in Archaeology*. Walnut Creek CA: Left Coast. 256 pp.

2012. *Amskapi Pikuni: The Blackfeet People*. In collaboration with Stewart E. Miller, based on manuscript by Clark Wissler. Albany: SUNY. 272 pp.

2012. *Militant Christianity: An Anthropological History.* New York: Palgrave/Macmillan. 194 pp.

2014. *A Passion for the True and Just: Felix and Lucy Kramer Cohen and the Indian New Deal.* Tucson: University of Arizona Press. 235 pp.

2016. *Traveling Prehistoric Seas: Critical Thinking on Ancient Transoceanic Voyages.* Walnut Creek CA: Left Coast. 217 pp.

### EDITED BOOKS

1990. *Powers of Observation: Alternate Views in Archeology.* Edited by Sarah M. Nelson and Alice B. Kehoe; includes introduction by Kehoe and Nelson (pp. 1–4) and chapter (pp. 23–37), "Points and Lines," by Kehoe. Archeological Papers of the American Anthropological Association No. 2 (Washington DC).

1999. *Assembling the Past: Studies in the Professionalization of Archaeology.* Edited by Alice B. Kehoe and Mary Beth Emmerichs. Albuquerque: University of New Mexico Press. Introduction, section introductions, and chapter "Recognizing the Foundation of Prehistory," pp. 53–68, by Kehoe.

2012. *Expanding Anthropology, 1945–1980: A Generation Reflects.* Edited by Alice Beck Kehoe and Paul L. Doughty. Tuscaloosa: University of Alabama Press. 295 pp.

2019. *Archaeologies of Listening.* Edited by Peter R. Schmidt and Alice B. Kehoe. Gainesville: University Press of Florida. 293 pp. Chapter 1 coauthored with Schmidt, chapter 12 authored by Kehoe.

The sap that flows through all these, and the many papers I've published, is empathy with humankind, present and past. Whether I was looking at small sherds and a stone knife and seeing through them Madame LeBlanc and the Saulteau woman working in the sunshine beside the fur trade post wall, or I was standing in the wind atop Moose Mountain, feeling the mysterious beauty of starlight in the dancing crystals of the boulders chosen for the solstice observatory, I couldn't be a cold scientist.

Living on the Blackfeet Reservation for three years, spending

so many weeks in Saskatchewan Indian reserve communities and with Indian people in the cities, heightened the empathy I felt with them, their peoples persecuted like mine by white Christians. Seeing white male supremacy in the raw vis-à-vis Indian people, men and women, heightened my consciousness of its noxious presence in Anglo America. All those edge-worn little hide-scraper blades on Moose Mountain weren't archaeologists' "utilized flakes"; they spoke of sweaty, weary women grubbing tendons and greasy fat off those massive hides. In sisterhood I felt how good that prairie wind felt on their shoulders. When we mapped and photographed tipi ring clusters, I heard in the rustle of grasses the faint voices of the people who had put those rocks down to hold their homes fast against storms. There was no mystique in this, nothing "spiritual," simply responding to what we had in common, as humans.

Let me map out my books, as they express my growth as an archaeologist and ethnohistorian anthropologist.

The first bloc is archaeology. Very first book is a slender one published as a textbook for Saskatchewan schools, *Hunters of the Buried Years*. Pun on "hunters," meaning archaeologists and also the people of Saskatchewan's past. As Tom and I worked with avocational archaeologists in the province, they mentioned the lack of a guide to its archaeology and precontact history. I could write such a book. Sketching it out, I talked with Nora, the neighbor whose kids were in school with mine, and she suggested going to the provincial minister of education about getting the book published. She went with me, the short walk from our homes through Wascana Park to the Parliament building, across its marble rotunda, to the minister's office. He was cordial and told me to go to Regina Textbook publishing downtown, tell its head he was recommending me. I did, when I had the manuscript ready (read over by Nora, with suggestions); the publishing company was a modest printing firm in an old downtown building. Simple transaction, manuscript published in a very plain nondescript little book, copies distributed to the province's schools. That was

that. Regina Textbook's owner retired. No further news of what is really a good book for middle-school readers.

Next I made my *bona fides* as an archaeologist with my monograph-length report on my excavation of François' House, the fur trade post on the Saskatchewan River. This was published by the province in what was planned to be a series of monographs on Saskatchewan archaeology. Five hundred copies were distributed to all the schools in the province, thereby exhausting the print run. It was never reprinted. In 2000 an edited volume prepared by students of my colleague Dena Ferran Dincauze included a chapter I wrote for it, summarizing my François' House work. That gave it a little notice in my professional world and let me share my point about recognizing women's work in the archaeological data.

A second bloc of my books begins with my large textbook, *North American Indians: A Comprehensive Account.* "Comprehensive" is the key word. No previous textbook on North American Indians had seamlessly begun with the "pre-" history and continued to the present. Most were a set of classic late-nineteenth-century descriptions of Indians, in vignette form, with a concluding short chapter on the reservation period. One or two had a separate chapter on archaeology. Mine was ethnohistory, beginning with earliest evidence of humans in America, near the end of the Pleistocene, through archaeological evidence and then that and historical data, to serious discussion of federal Indian policies and politics. By the third edition, it totaled 628 pages. I would never have considered such a massive undertaking were it not that my first sabbatical was coming up in 1979 and I could use it for writing the book. Other professors used sabbaticals to travel to research sites and archives, but I was tied down to staying home with my kids. Tom was incapable of caring for them, couldn't and wouldn't cook or do laundry or house-clean or grocery-shop, and anyway, had to be in the museum five days a week. When I got a phone call from Houghton Mifflin asking me to do an American Indian textbook, I saw a good project, provided I could use my *anthropo-*

*logical* standpoint to make it ethnohistory. The editor agreed, as a
gamble, as did the Prentice-Hall editor to whom I took my half-
finished manuscript after Houghton Mifflin's staff abandoned the
company under threat from a hostile takeover. With the develop-
ment of ethnohistory as a subfield of history and anthropology,
kicked up by tons of work for each side in Indian Claims Com-
mission lawsuits, my ethnohistoric approach became the model
for textbooks on North American Indians, and the book sold rel-
atively well for a textbook in a limited field. In recent years col-
leagues tell me they keep it handy as a reference, though survey
courses of North American Indians are no longer taught in most
colleges.

My *Ghost Dance*, next to be published, fits with the textbook
as ethnohistory. Years before, George Spindler, a senior anthro-
pologist who became known for urging study of "education" as
means of better understanding cultural transmissions, asked me
whether I would use my dissertation material for a Case Study in
Cultural Anthropology, a series of paperback short texts he devel-
oped for Holt, Rinehart & Winston publishers. George knew my
work through friendship from two summers he and Louise, his
wife and colleague, had spent camping just across the Canadian
border from the Blackfeet Reservation. They had been trying
out using Rorschach and TAT protocols (Thematic Appercep-
tion Test) from psychology, asking Blackfoot to say what they
saw in the blots and pictures. Two summers and they gave up,
no "themes of Blackfoot culture" had appeared in the responses.
We had driven up during the summers to visit with them in their
camp, for a weekend talking about our and their work and what
was happening in anthropology.

After George invited me to participate in the supplementary
textbook series he was developing and I sent him a prospectus for
a book on the 1890 Ghost Dance, the publisher's editor rejected
the proposal because, he said, "We only publish *tribes*. The Ghost
Dance is not a tribe." That editor retired, in 1985 as I recall, and
quickly, George phoned and asked me to submit the proposal

again. Now it was accepted. Teaching experience at Marquette made me realize that simply recounting the history of the Ghost Dance would make it esoteric; instead, I made its history and my Saskatchewan Dakota material into the first half of a book, with the second half discussing how the same data can be interpreted by trained scholars toward opposing conclusions. This can be a pedagogical challenge for instructors, as undergraduate students expect data-to-THE-conclusion to be straightforward and definitive, once the logic is presented to them. This unusual feature made the inexpensive text popular with many anthropologists, and although its modest price and limited market never brought me much in royalties, it continues to sell steadily.

The next two books contrast sharply. *Humans* is the course I taught at Marquette for thirty-one years, every semester, without any assistant, to classes at first of nearly two hundred then later of about ninety undergrads. Enrollment had dipped when Marquette's School of Nursing hired its own anthropologist to teach its students about cultural diversity. Not only did the bevy of freshman young women from nursing no longer appear in my class; neither did the gang of young men from business who attended to look over each year's crop of nice girls to date. Year by year I refined the course, until by 1990 I had written a helpful short textbook my students purchased at the campus photocopy shop. Using this, I could use my lecture's fifty minutes to clarify ideas and give some depth to examples. By 1996 I wanted to see this published, to make a better-looking, illustrated textbook and perhaps earn a little.

The other work I was writing in the 1990s was my research on the creation of a science of prehistory, in Scotland in 1851. That was what I followed out in Edinburgh during my sabbatical there in 1989, kids now grown. By 1996 I had a manuscript, *The Land of Prehistory: A Critical History of American Anthropology*. It's really a package of what I couldn't get otherwise published, papers rejected for being too challenging to mainstream archaeology. In addition to an account of Daniel Wilson's nineteenth-century

work constructing a science of prehistory modeled on geology—an account at odds with the mainstream version that it was Sir John Lubbock, London bank president and friend of Darwin, creating Prehistory—my book includes several chapters on taboo topics: Cahokia as a state, "chiefdoms" as an unjustified academic term, pre-Columbian voyages. What publisher would publish such an out-of-bounds book? Maybe Routledge, at that time an English scholarly press with many books on theory. I took my manuscript proposal to the Routledge booth at the American Anthropological Association annual meeting. Walking to it through the hall, I met a feminist colleague who studies food cross-culturally. She was going to check on her new coedited Routledge book on food. At the booth she introduced me, enthusiastically, to Bill Germano, the Routledge anthropology editor. Bill agreed to read my proposal. My friend then urged him to also read my proposal for an introductory textbook. "No, no," I said. "Routledge doesn't publish at that level." "I want to develop a series of undergrad texts for Routledge," Bill interposed. "Let me have both proposals."

To my surprise, Germano accepted both books. Not only that; he didn't send them out for review by other scholars, didn't even send them out for copyediting. Out of the blue, as I awaited dealing with a copyeditor, or two, came ready-to-go page proofs for *Critical History*. Upset, I phoned Bill. "What happened? Where's the copyediting?" "I like your style, forthright. You write well, no point bothering with a copyeditor." "But, but, you even included that first paragraph meant just for your eyes, where I thank also the 'arrogant bastards' who put me down, giving me insight into how power operates in archaeology." "Yep, that first paragraph will sell the book." So it did.

*The Land of Prehistory: A Critical History of American Archaeology* came out in 1998, along with *Humans*, the introductory text. Bill Germano had resigned, to become a dean at Cooper Union college in New York. Routledge never continued his idea of a series of introductory texts, and no one went to its booth to see textbooks at that level. After Routledge expanded its American

anthropology lists in the twenty-tens by buying up other, smaller publishers, its anthropology editor in London discussed updating *Humans*. We determined its audience today would be community colleges, and an updated edition should be written between me—not much updating for basic anthropology—and a biological anthropologist colleague who could update the genetics and evolution chapters, a daunting challenge today. Routledge hasn't asked me to update *Land of Prehistory*. The only change I can see is to put Lewis Binford references in the past tense, since that dominating man has died. Archaeology's mainstream story, imbued with the imperial colonialism viewpoint Sir John Lubbock gave it, still prevails; my critique is still pertinent. It could be updated by adding the history of Lubbock's nefarious schemes published by economic historian Marc Flandreau (*Anthropologists in the Stock Exchange: A Financial History of Victorian Science*, 2016).

About the time I retired, in 2000, I had become well enough known that some editors solicited work from me. One request came from England, where a professor who had studied with a historian of colonial America asked his mentor to look over a list of topics for a series of paperbacks to be used in British courses on American history. The senior professor pointed out lack of a book on precontact America; the Englishman said, "But that wouldn't be history"; senior man said it would; Englishman, "But no one could write it"; senior man said he knew someone who could, picked up his phone and asked me to write that book. About America before the European invasions, he said. That line became the title of the book. Because it was published in England and marketed there, it got little notice here at first. Somehow the editor of the *New York Review of Books* saw it and had it reviewed by the Australian naturalist Tim Flannery, coupling it in the review with a book by well-known archaeologist James Adovasio, who had been assisted by a novelist. Adovasio, a black-bearded man muscular from workouts, told the world in his book that he was a better scientist than his competitors in archaeology, though of course underappreciated. Dr. Flannery, who would later write

a bestseller about ecological disaster, *The Weather Makers*, tore apart Adovasio's claim, then turned to my book, praising it as sound and informative and, gratifying me greatly, pointing out the unstressed message that America's First Nations were the equals, if different, of nations on other continents. Routledge bought the book's English publisher about ten years after its 2002 publication and asked me to update and expand it, publishing it in 2017 as *North America before the European Invasions* and marketing it to instructors in history courses. It fits Peter Schmidt's campaign, "Death of Prehistory."

Meanwhile, Tom Curtin, the anthropology editor at Waveland, a Chicago publisher of textbooks that had taken over Spindler's Cultural Anthropology Case Studies series, suggested that I develop a conference presentation I did critiquing the popular notion of "shamans" as universal among "primitives." Writing a short book exhibiting the foolishness of that notion was fun, whether researching famed author Mircea Eliade and discovering most of his writings are flimflam, or men's movement gurus drumming to ecstasy. What I wanted readers to realize is that shamans are religious ritual practitioners in Siberia, among what the Russians call their Small Nations. For centuries these reindeer-hunting societies have been exploited and denied rights, including rights to religious practices. Empress Catherine the Great of Russia, at the end of the eighteenth century, wrote a humorous play about the weird, crazy "shaman" her explorers into Siberia described to her. She shared that with her friend, the German writer Johann Goethe, through whom "shaman" became a stock figure of "primitive society" in the racist hierarchy that puts western European men at the top. Curtin and I were happily surprised when my modest effort to counter a racist stereotype was selected by the university librarians' journal CHOICE as among the 10 percent best of books reviewed in 2001 for academic use.

Tom Curtin encouraged me to write more for Waveland, for its series teaching critical thinking. *The Kensington Runestone* was my next, compiling all the evidence—lots—for its authenticity

as a memorial to men murdered in 1362 while exploring interior America for a fur trade. Most university instructors are afraid to admit this might be so, so vehement is denial that anyone but Indians had been in America before 1492. The book sells slowly, to people interested in the "mystery." No mystery once you've read the book and learned what likely drew some Norse fur traders to try America, when their Russian fur trade was seized by soldiers hired by German merchants. Curtin also commissioned me to write a short introduction to archaeology, a task I shared with a younger colleague familiar with all the technical devices now in use. It's used in a couple of Wisconsin colleges. When a change of publishers left my Ghost Dance book out of print, Curtin was eager to publish it in an attractive updated edition, which continues to sell steadily if modestly.

Mitch Allen was the other publisher urging me to publish with him. Mitch is an archaeologist who became anthropology editor for a textbook publisher, then left it to found his own company, Left Coast Press in California. You guessed it from that title, Mitch is a New Yorker emigrated to the Bay Area. Unafraid to challenge mainstream archaeological conservatives, Mitch published appealing paperbacks of unorthodox, but legitimate, archaeology. From the beginning he begged me to write a book on pre-Columbian transoceanic voyages that might have reached the Americas. Always I replied that to do so would require a fat book citing hundreds of controversial data, in detail—not his usual paperbacks. By 2008 we had compromised with a book, *Controversies in Archaeology*, on which Mitch worked closely with me. Some of the controversies were silly, such as "pyramid power" and Atlantis, others such as contact between Maya and Southeast Asia had difficult-to-dismiss data, while later chapters discussed genes and population issues and the racism of Manifest Destiny unilinear cultural evolutionism. This book is more substantial and course-designed than many Left Coast books, but perhaps coming from that company, it hasn't been much used; only the same five professors use it each year. Our expectation that it

would lure students needing a curriculum core course has been disappointed. Archaeologists now talk a lot about "outreach" to "the public," while still huddling in their ivory tower corridors.

At last, after eleven years, I told Mitch I'd write that book about pre-Columbian voyages. My longtime colleague in geography, Stephen Jett, at last had completed his thick scholars' book on the topic, the fruit of years and years of collecting and collating data and interpretation. With Steve's book available to recommend for in-depth further reading, I could write a version at the undergraduate level as an exercise in critical thinking. Like my Waveland books and our *Controversies*, it would include sections expounding scientific method in the historical sciences. Not Lewis Binford's pseudoscience copied from physics, but the method taught by the great paleontologist and evolutionary biologist George Gaylord Simpson in the mid-twentieth century. For my book I drew upon my long-standing interest in early and non-European boats, begun in the seminar I took at Harvard with visiting British professor Stuart Piggott. Piggott was convinced that boats, particularly curraghs (hides stretched over wooden frames), had been developed early in the European past and extensively used; for my seminar paper, I explored this. Piggott showed my paper to Gordon Willey, Harvard's leading Americanist archaeologist, and although Willey refused to take any women students, he called me into his office and told me to publish the paper. Awed by his noticing me, I did, in a respectable journal, and later in a book of papers given in a Society for American Archaeology meeting. Along with working with American Indians and contributing to feminist studies, this acceptance of the probabilities of pre-Columbian ocean voyages taints my reputation as a scholar. That America was isolated totally until 1492 is an alt-fact impregnable behind that Anglo border Wall confining American archaeology. Rejection of the strong data supporting the Kensington Runestone's authenticity comes from this ideological commitment.

My paper for Piggott's seminar was published in April 1962. Tom brought the journal to me when it arrived in our mail; I was

in the hospital with our newborn second son. Neither of us, nor certainly our son, could get excited that day over a mere publication. No wonder Willey had no time for women students.

Three more books, and four edited volumes, complete my list as I write, in 2020. Two of the volumes I solicited and edited are about archaeological practice and interpretation, the first with my feminist comrade Sarah Nelson, like me a married woman with children when in graduate school, unlike me not married to an archaeologist, having to make her own way in the field; she pioneered Americanist archaeology in Korea, where its novelty gave her some respect. The second archaeological practice volume is with Peter Schmidt, quite our opposite in being a man in a leading research university, while very much our kind in working in unglamorous country (Africa for him) and actively against Anglo bias. Besides these two edited volumes, two others are compendia of papers about the history of archaeology and of anthropology. The first was a set of papers from a 1989 meeting of the Archaeological Institute of America, the second from a series of sessions of the Association of Senior Anthropologists at the American Anthropological Association, with the eldest members describing their professional work that had significant effects beyond academic anthropology. This present memoir of mine I consider another of my contributions to the history of my discipline.

Last to discuss are three books of ethnohistory, each strongly rooted in anthropology. *Amskapi Pikuni: The Blackfeet People* is the history of the southern Pikuni who live in Montana, just over the border from their cousins in Alberta. Interested and concerned with the nation's efforts to conserve their traditions and language while enabling their people to obtain worthwhile work, I saw that one lack in their struggling tribal college was a history of their people suitable for their students. The faculty and the Blackfeet THPO (Tribal Historic Preservation Office) agreed, so for several years, each summer while I was on the reservation, I worked with a member of the THPO staff who was collecting photographs and everything he could find on their history. At home

I researched archives and publications and wrote drafts, sending them to him and the college faculty on the project. At last we had a book attractive to students, readable, and true to their history. The publisher, SUNY Press (State University of New York), honored our verbal agreement to make the book available at minimal cost to Blackfeet Community College, selling it 60 percent off list price to all orders coming from 59417, Browning, Montana, the reservation zip code. Seeing the copies on the college bookstore shelf at an affordable price makes me feel I have been able to repay, to the best of my capacity, some of the kindnesses and caring with which I have been blessed by my Amskapi Pikuni friends and collaborators.

*A Passion for the True and Just: Felix and Lucy Kramer Cohen and the Indian New Deal* may appear to be far from *Amskapi Pikuni.* Not at all: Felix Cohen was legal counsel to the Blackfeet Tribe after he left the Department of the Interior, until his very untimely death at age forty-six. A photograph reproduced in several sources shows him, in a lawyerly raincoat and suit (just like my father wore), standing beside the Tribal Council chairman and a council member as the chairman breaks the lock the Bureau of Indian Affairs (BIA) agent had put on a shed legally owned by the tribe, said Cohen. Seeing, in a book about the 1934 Indian New Deal, that Mrs. Cohen had been a Boas student at Columbia, piqued my interest, especially because John Collier, the very WASP commissioner of the BIA, so vehemently denied any connection between that program and Franz Boas. More to the point, the history of the Amskapi Pikuni demanded I follow up Counsel Cohen's involvement with them. The overlap between the tribal history and the history of the Indian New Deal is obvious. What I hadn't expected was to find how powerfully the blatant anti-Semitism of the 1930s, in America as well as in Europe, twisted the published histories of the Indian New Deal, all by non-Jewish male historians. Lucy Kramer Cohen and the close relationships between her and Felix and Papa Boas were significant. My book ended up being as much about 1930s anti-Semitism, what my parents lived in but seldom

talked about, as about American Indians. The connection echoed my experiences with Indian people, when I mentioned I am Jewish and that we too have been fighting terrorism since 1492. Base line is that both Jews and American Indians suffered Holocaust efforts to extinguish us through unspeakable violence.

That leads me to my 2012 *Militant Christianity*. Back in the 1970s, Evangelical Christians renewed their efforts to ban the teaching of organic evolution. It hadn't been quashed in the 1925 Scopes trial in Tennessee. In fact, the Tennessee ban was upheld by the trial. One effect of postwar 1960s counterculture was a surge in liberalism coupled with Cold War work to upgrade science research and teaching. Organic evolution is basic to contemporary biology, so it must be taught in American schools . . . NOT! said Fundamentalist Christians. Here began the loudly proclaimed "battles" of the supposed War Against Christian America. I joined colleagues in speaking up for evolution, a memorable occasion being a suburban school board hearing on a proposed order to teach creationism in that school district. We listened as four of the school board members took oath of office, vowing to uphold the United States Constitution. Then, clearly against the First Amendment, as a lawyer in the audience told them, they voted to require creationism, against teachers' freedom of speech and separation of church and state. What a bare-faced example of culture overriding rational thinking. On went my anthropologist's cap.

For thirty years I observed Fundamentalist Christians' culture, sitting in their Milwaukee-area churches on Sundays, listening to them, reading their literature, reading the history of Christianity and discussing it with Daniel Maguire and other colleagues in Marquette's Theology Department. Interestingly, all this Christian stuff echoed what archaeologists were finding in the quest to identify the origin of the Indo-European language. My archaeologist colleagues David Anthony and his wife Dorcas Brown were happy to keep me updated when we met annually at the Society for American Archaeology meetings. Working with linguists and geneticists, the Anthonys discovered strong evidence that the

language appeared in western Asia by five thousand years ago, in communities labeled Yamnaya by archaeologists. From there it spread rapidly through most of Asia and throughout Europe, thanks to its cavalry—first use of horses in war and for conquest—and the wheeled wagons that revolutionized transport of goods. Linguists note that Indo-European languages embed a hierarchical patriarchal social structure, and early texts and folklore glorify masculine heroes in constant battle.

Once I retired and had time to work on the tantalizing similarities between Indo-European archaeology and linguistics and current Fundamentalist Christianity, I realized that these "warriors for a Christian America" show a remarkable persistence of the ethos and social structure of this ancient language stock. The book I wrote goes from that, through Christianity's establishment, to Martin Luther (very much a battling warrior), to Rockefeller's creation of a rich foundation that for decades worked behind the scenes to guard a Christian America, and then to the Evangelical movement to power beginning in the 1960s. My argument was built on data. Unhappily for me, that bumped up against precious myths, such as that Emperor Constantine had become a Christian when he won Rome at the battle on the Milvian Bridge—no, he staunchly refused baptism. Of course I raised the ire of Evangelical Christians, to whom the book was sent for review by book review editors who consulted a list of "Christian Anthropologists," not realizing that they were faith-committed to the pernicious contentions I had analyzed. It didn't help that the book came out in 2012 when Barack Obama won his second term, and liberal America rejoiced that the bad days of racism were over.

*Militant Christianity* didn't bomb, so much as it sank like a stone in muddy waters. Daniel Maguire, Marquette's professor of theology, had vetted the history-of-Christianity facts for me, his field of expertise. A friend gave it to retired archbishop of Milwaukee the Very Reverend Rembert Weakland, and he sent me a note praising the book, hoping it would become widely read. It doesn't even get sold from Amazon. Not even in the age of Trump. For

years this puzzled me. Now I know: to sell a book, or nearly any-thing in America, it has to be enthused over by a celebrity or influencer on social media. This I was told when I tried to get this book you're reading published by a trade, rather than an aca-demic, press. Consumer capitalism has been undermining Amer-ica while I've been distracted by questions of historical truth and concern for social justice.

Anthropology really is a deeply rooted weed with many and var-ied branches aboveground. Archaeology scrabbles around the root, ethnohistory describes the looks of the branches. From this stand-point I have consistently explored segments as they have come into my ken, ignoring the boxes and boundaries of mainstream academia—just as I paid no thought to the boundaries and pas-times decreed for girls when I was one. I haven't obtained pres-tigious employment in this man's world, but I have been able to enrich my own and many other lives, and that has been a good life.

CPSIA information can be obtained
at www.ICGtesting.com
Printed in the USA
LVHW011154110222
710694LV00005B/719